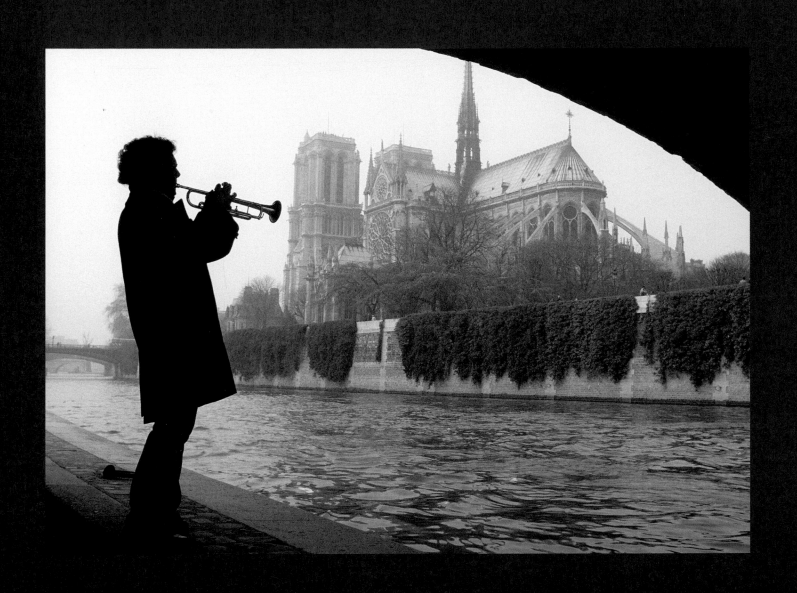

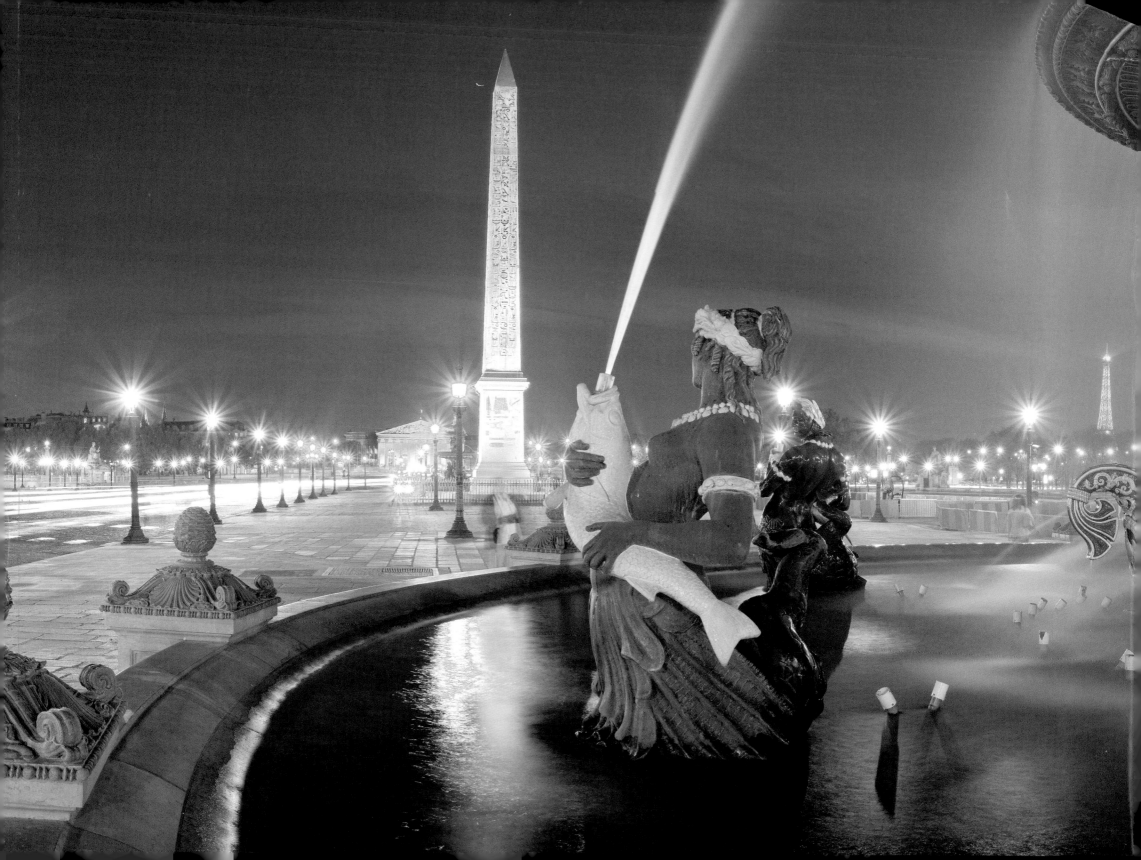

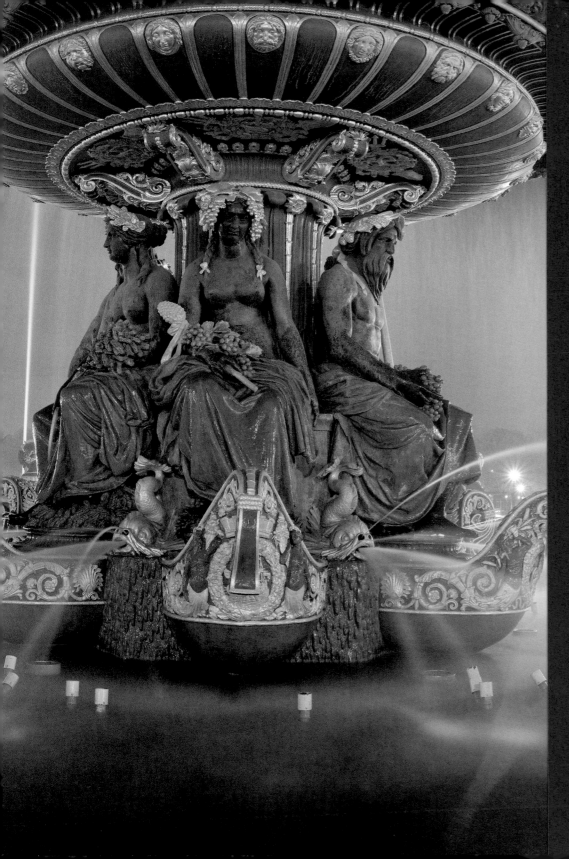

SPECTACULAR
PARIS

WITH TEXT BY
WILLIAM G. SCHELLER

PHOTOGRAPHS BY
JEAN-LUC BERTINI
ARNAUD FRICH
JACQUES LEBAR
ROSINE MAZIN
THIBAUD REBOUR
ERIC ROUGIER

UNIVERSE

Spectacular Paris

Published by Universe Publishing
A Division of Rizzoli International Publications, Inc.
300 Park Avenue South
New York, NY 10010
www.rizzoliusa.com

Book Designer:	Kevin Osborn, Research & Design, Ltd.,
	Arlington, Virginia
Project Director:	Ellin Yassky
Production Editor:	Melissa C. Payne
Copyeditor:	Deborah T. Zindell

2014 2015 2016 2017 / 10 9 8 7 6 5 4 3 2 1

Printed in China

ISBN-13: 978-0-7893-2736-9

Library of Congress Catalog Control Number: 2013949712

Photography Credits
Art Resource, NY: © Giraudon/Art Resource, NY: pp. 14 (center), 20; © Erich Lessing/Art Resource, NY: pp. 14 (right), 15 (top), 16 (bottom), 17 (bottom), 17 (top left), 18, 19; © Réunion des Musées Nationaux/Art Resource, NY: pp. 14 (left), 17 (top right); © Snark/Art Resource, NY: pp. 13 (top and bottom), 22, 23 (top).

© Jean-Luc Bertini (www.faces-presse.com): pp. 23 (bottom), 50 (bottom), 79, 81 (bottom left), 82, 109, 126 (left), 128 (left and right).

© Arnaud Frich (www.arnaudfrichphoto.com): Front Cover, pp. 2–4, 10–11, 24, 28, 32–34, 35, 36–37, 42–43, 44, 45, 47 (right), 50–51 (top), 52–53, 54–56, 62–63, 64–65, 67, 68, 76–78, 80–81, 90–92, 93, 94–95, 98–99, 100 (bottom), 102–103, 104–105, 112–114, 116–117, 130–131, Back Cover.

Courtesy Historic Cities Research Project, http://historic-cities.huji.ac.il, The Hebrew University of Jerusalem, The Jewish National and University Library: p. 15 (bottom).

© Jacques Lebar (www.jacqueslebar.com):
pp. 25, 29, 30 (left and right), 38 (right), 39, 41 (left), 48 (bottom), 57, 60–61, 69, 70, 71, 74–75, 75, 80 (bottom), 81 (bottom center), 81 (bottom right), 83, 88, 96, 97 (left), 106 (bottom left), 106 (bottom middle), 107 (bottom right), 108, 110, 111 (top and bottom).

Library of Congress, Prints & Photographs Division: p. 21.

© Rosin Mazine (www.pixoclock.com): pp. 1, 12, 16 (top), 26, 31 (top and bottom), 38 (left), 40, 41 (right), 66, 72, 85, 89, 101 (right), 122, 132, 123 (top left, top right, and bottom), 124 (left and right), 125 (left and right), 126 (top right and bottom right), 127 (left and right).

© Thibaud Rebour (www.rebour.fr): pp. 8, 9, 26–27, 48–49 (top), 58–59, 73, 84 (top and bottom), 86, 87 (top, middle, and bottom) 97 (right), 100 (top), 101 (left), 106–107, 119 (right), 120–121 (top), 121 (right).

© Eric Rougier (www.fromparis.com): 6–7 (top, middle, and bottom), 46–47, 115, 118–119, 120–121 (bottom).

(PAGE 1)

ECHOING IN TIME
A trumpeter's notes carry across the Seine toward the Cathedral of Notre-Dame, rising from Paris's ancient heart on the Ile de la Cité.

(PAGES 2–4)

REIGN OF GRANDEUR
Alive today with the play of water and light, the Place de la Concorde once witnessed the bloodiest excesses of the Reign of Terror. For nearly 200 years, its focal point has been a 3,300-year-old Egyptian obelisk.

(PAGES 6–7)

THE SPLENDID SEINE
The River Seine enters Paris at the city's southeast corner, turns northward and then bends, to exit the city to the southwest. The cityscape the river defines is not only one of the most historically rich but also the most visually stunning in the world. From the spires of Notre-Dame (top), which dominates the Ile de la Cité the river winds past cobblestone quays and the Museé d'Orsay (middle). Farther downriver, the modern Beaugrenelle buildings give way to Pont Mirabeau and the Eiffel Tower (bottom), Parisian landmarks that hark back to the turn of the twentieth century.

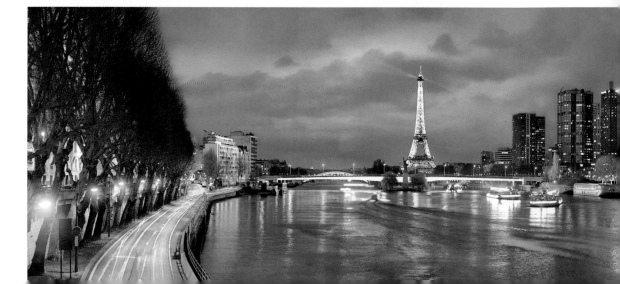

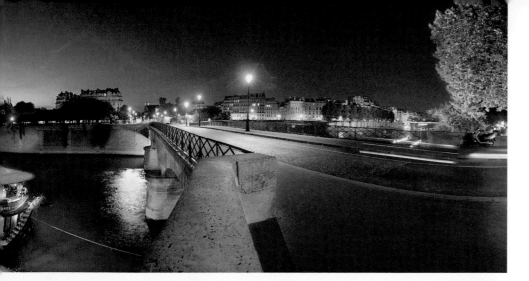

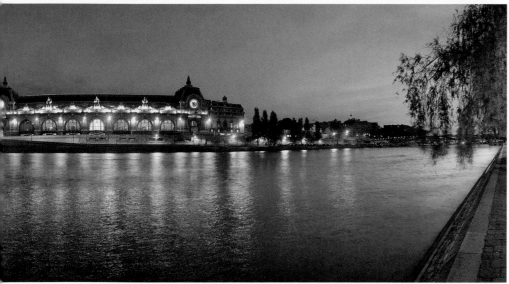

CONTENTS

CITY OF LIGHT

(ABOVE)

A RIVER CITY
The Parisian coat of arms, here emblazoned on the Petit Palais, reflects the city's age-old dependence on the Seine as a highway of commerce. "She is buffeted by the waves but sinks not" is the sense of the Latin inscription.

(OPPOSITE)

MILLENNIUM'S DAWN
Fireworks explode above the Eiffel Tower during turn-of-the-millennium celebrations, 2000. Over the 20 centuries of the Christian era, Paris has evolved from a rustic settlement on the islands of the Seine to a world capital of art, fashion, and finance.

"FRANCE," someone once remarked, "stands like a medallion on the chest of Europe." Paris, to continue the fanciful metaphor, is the jewel in the medallion. Epitome of French civilization, focus of Gallic pride, bejeweled with exquisite monuments by kings, emperors, and presidents alike, Paris was designed to be a capital in every sense of the word. It is not only a national but a world capital, for centuries a beacon to artists, intellectuals, lovers of beauty, and romantics of every style and inclination.

Paris has long been the ultimate expression of a certain urban ideal, the city as a place where grandeur makes no apology to purpose and purpose has never been obscured by grandeur. Paradoxically, it is at once a densely textured, multilayered city, and a capital planned and built on a monumental scale. People have been weaving neighborhoods here—and weaving them together—for some 20 centuries, and theirs is the organic Paris that grew in practical response to the needs of the moment. And for roughly a millennium, Paris as the French capital has been the canvas upon which rulers expressed their will, in grand schemes intended to reflect their own and the nation's glory.

The result is a city that blends serene, classical order with the serendipities of street life. The character of the city is one part grand boulevards, with mannerly vistas leading to stage-set focal points such as the Opéra Garnier or the Arc de Triomphe; and one part cheerful confusion, as in the jumbled alleys of Montmartre, the student quarters of the Left Bank, or the happily remembered cacophony of Les Halles when it was, in Zola's words, "the belly of Paris" and not a modern shopping mall. Through it all flows the Seine, more likely these days bearing tour boats than workaday barges, washing against the quais with the eternal indifference of water.

Each country has at least one city that exerts an inexorable pull on the visionaries and romantics of that nation's hinterlands. Americans are drawn to New York, Austrians to Vienna, Italians to Rome or Milan; individuals with ambition in Botswana, we must suppose, are drawn to Gaborone. But Paris takes this fact of life and goes it one better: the world is its hinterland. What other city has held such fascination for so many, for so long? The secret must surely lie with that remarkable combination of grandeur and livability, a Parisian currency that has never been devalued. It's possible for dreamers in all those hinterlands to imagine Paris as the scene for pinnacles of accomplishment, but just as easy for them to conjure agreeable afternoons in some anonymous café, surrounded by the life of an ancient and inscrutable neighborhood. That balance between the Olympian and the quotidian is their dream. Paris has always offered it freely, against the background of what is surely—partly by happenstance and partly by grand design—one of the most gorgeous built environments in the world.

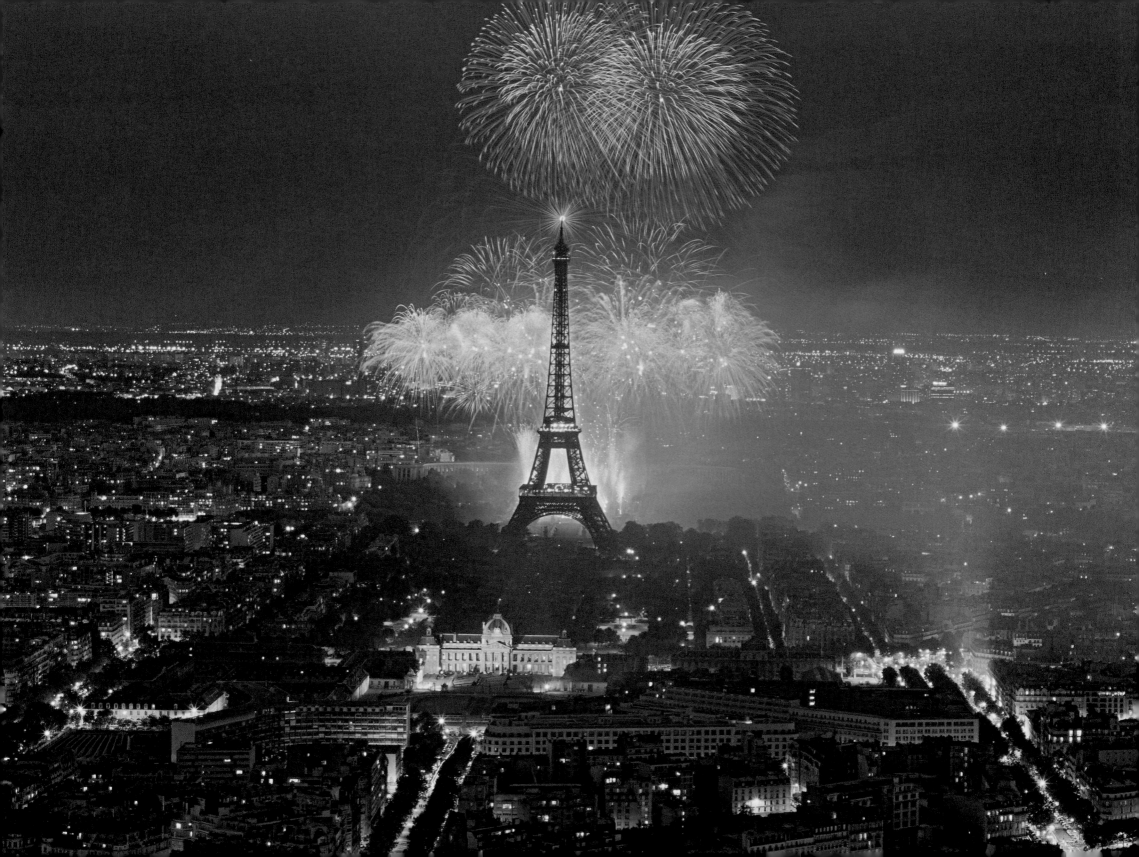

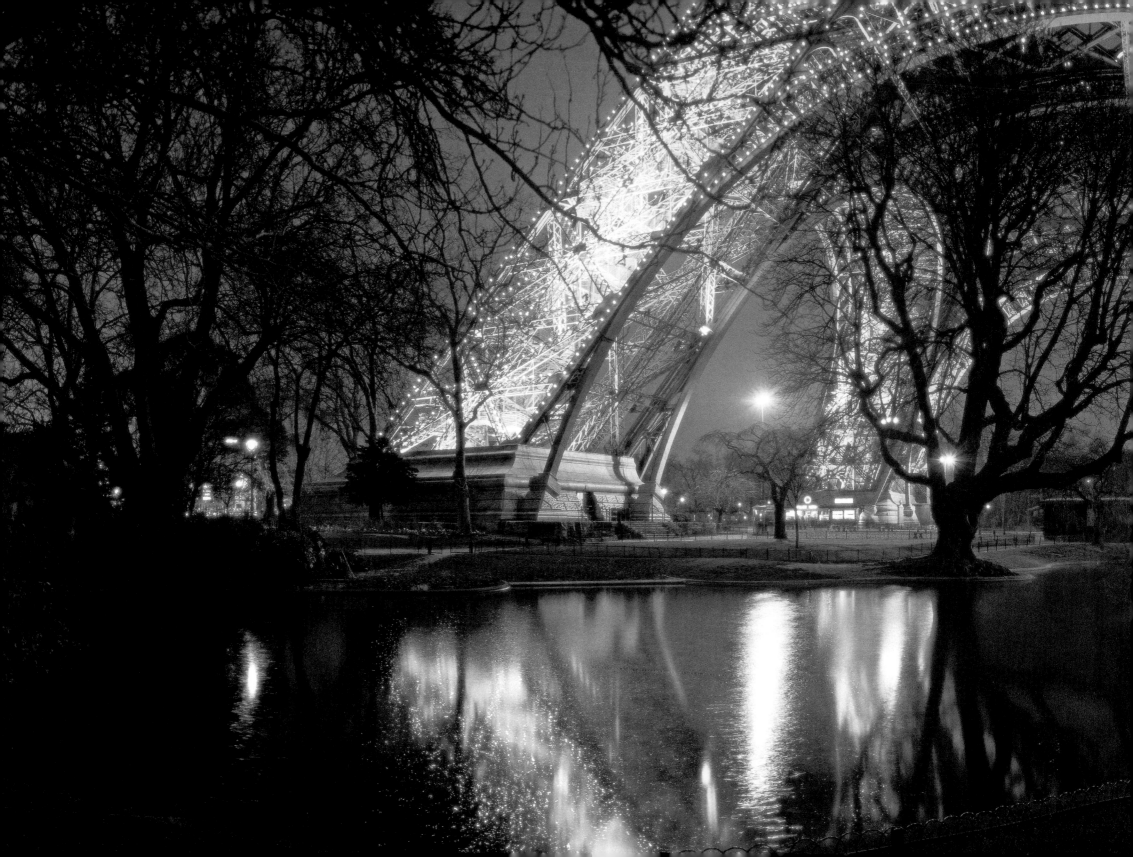

HISTORY OF PARIS

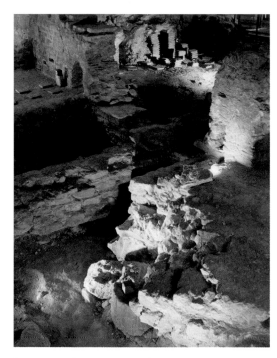

A GENTLE GIANT
A gossamer tracery of iron when seen from a distance, the Eiffel Tower is a colossus at close range. But despite its weight of more than 10,000 tons, it exerts a pressure of only 57 pounds per square inch upon the ground.

THE DISTANT PAST REVEALED
Remnants of the Roman-era village of Lutetia are revealed in excavations on the Ile de la Cité, near the Cathedral of Notre-Dame.

THE LURE of Paris dates to dim antiquity. The earliest Parisians recorded by history were Gauls, members of Celtic tribes that had migrated west from the Danube basin and occupied most of northern France by 350 B.C.E. One such tribe, the Parisii, eventually built their principal settlement on what is now the Ile de la Cité. Their town was named Lutetia—or at least it was so called by Julius Caesar, who described the Romans' 52 B.C.E. conquest of the Parisii in his *Gallic Wars*. Caesar had reached the Seine toward the end of the campaign in which he famously came, saw, and conquered, and he cemented the future French capital, along with all of Gaul, securely into the growing Roman Empire.

Lutetia remained a part of the Roman world for the next four centuries. It spread from the island to the south (now called the left) bank of the Seine; and it acquired the temples, markets, theater, and public baths that graced most prosperous provincial towns that lay within the orbit of Mediterranean civilization. As one of the more northerly outposts of the empire, though, Lutetia took the brunt of the successive waves of Germanic invaders that began to penetrate the old imperial boundaries during the third century C.E. (A century later, Emperor Constantine sent his son, the future emperor Julian, to defend the region; according to one legend, it was he who renamed Lutetia Paris.) The town contracted, abandoning the Left Bank and withdrawing to the safety of the Ile de la Cité.

Alamans, Burgundians, and other tribes far less civilized than the Romanized Parisii harassed Lutetia and its hinterlands. Finally, the lands around the Seine—and eventually most of Gaul—came under the rule of the Franks.

The Frankish king Clovis, head of the Merovingian dynasty, made Paris his capital in 508 C.E. The convert Clovis made Christianity the official religion of his realm, and France has ever since been a Catholic country. But Clovis's political accomplishments were not so long-lasting; following German tribal custom, his kingdom was divided among his sons. Childebert became king of Paris, a title later held by his nephew Charibert, but it would be centuries before the city would again assume the status of capital of the entire Frankish domain. One important legacy of Childebert, though, was the founding of an abbey on the left bank at the urging of St. Germain, bishop of Paris. Germain was buried there, and today St-Germain-des-Prés (not the original building) is the oldest church in Paris.

For the remainder of the first millennium, Paris was merely one of many northern French market towns, clustered on its riverbank with an anxious eye for Viking dragon ships. The era's most powerful Frankish king, Charlemagne, ruled from Aachen in present-day Germany. But in 987 Hugh Capet, count of Paris and founder of the Capetian dynasty, became king of France. Although the Capetians were at first weak monarchs, and despite the tendency of several future French kings to turn

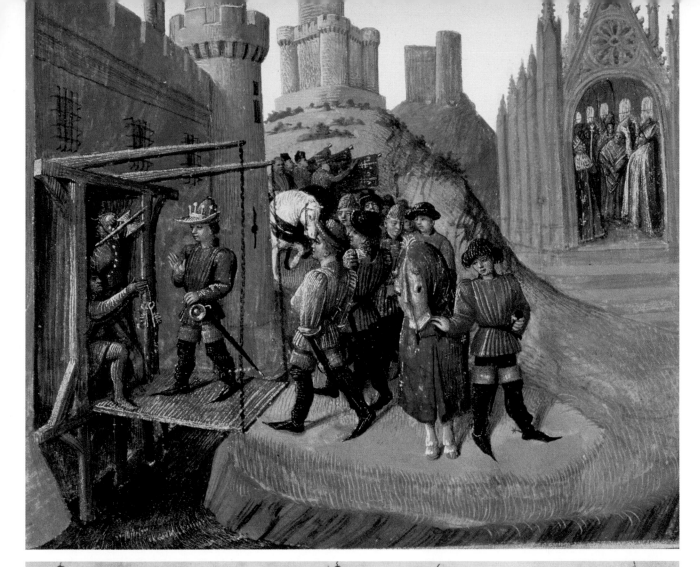

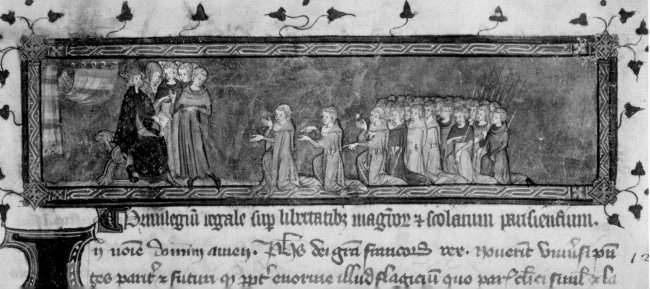

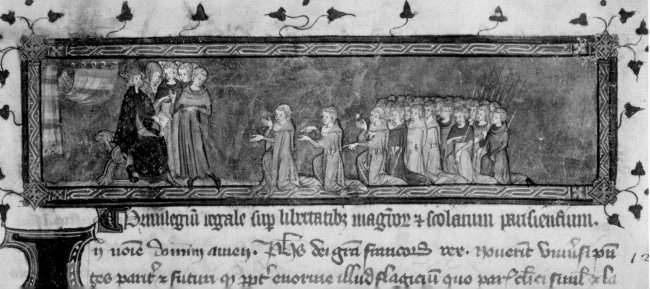

(LEFT TOP)
DYNASTIC TRANSITION

In a painting by the fifteenth-century artist Jean Fouquet, Hugh Capet receives the keys to the town of Laon. Having overthrown King Louis V in 987, Capet founded a dynasty that ruled France for more than three centuries.

(LEFT BOTTOM)
SEAT OF LEARNING

A fourteenth-century illuminated manuscript depicts King Philip Augustus granting the first royal privilege to the masters and students of the University of Paris, 1200. Originating as the cathedral school of Notre-Dame, the university remains the cornerstone of the Left Bank's Latin Quarter.

their backs on the metropolis, Paris's place as national capital dates from Hugh's accession.

As the first city of France, Paris in the High Middle Ages began to acquire the accoutrements of economic, cultural, and religious power as well as of political centralization. Shortly after 1000 C.E. the city burst out of its island fastness and spread across the left and right banks of the Seine. On the left, under the influence of the great scholar Abelard, the University of Paris grew out of the cathedral school of Notre-Dame and came to dominate the Latin Quarter neighborhood where the Sorbonne stands today. On the right, a rising class of merchants and artisans established their guilds and built their homes in what remains the city's commercial heart. And on the Ile de la Cité, the archbishops of Paris began in 1163 to build the Cathedral of Notre-Dame.

Paris's medieval expansion was particularly robust under King Philip Augustus (1180–1223), who consolidated royal power and raised a defensive wall around the city. He drained the *marais* or marshes on the right bank, built the original portions of the Louvre as a fortress, paved the streets of the core district, and ordered the construction of schools, hospitals, and churches. Meanwhile, Paris continued to grow outside its official urban precincts, with satellite villages—now long since swallowed by the city—around St-Germain-des-Prés and, on the Right Bank, the abbey of St-Martin-des-Champs.

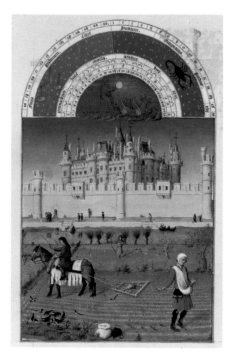

ROYAL RESIDENCE

Seat of kings since the 1360s, the Château du Louvre appears here in a calendar miniature from the *Très Riches Heures* of the Duc de Berry, 1416. As fortress, palace, and incomparable art museum, the Louvre has loomed large in Parisian history for more than 800 years.

ARRIVING IN STATE

King Charles V enters Paris, c. 1460. Jean Fouquet's contemporary portrayal shows the city fortifications, substantially extended by Charles, and also reveals the extent to which the fleur-de-lis was, by the fifteenth century, already a ubiquitous symbol of the French monarchy.

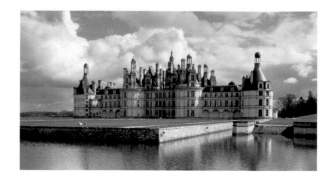

As it was throughout western Europe, the fourteenth century was a time of war, pestilence, and tribulation for Paris. In the year 1356 alone its citizens endured reversals in the Hundred Years' War against the English, resulting in the enemy's capture of King John II and the brief seizure of power in the capital by rebels; and the far more ominous arrival of the Black Death. The plague killed 50,000 Parisians over the next three years; in all, the population of Paris fell by half between 1320 and 1420. With the house of Valois restored to the throne, King Charles V refortified the capital, building new walls and constructing a fortress that would one day loom large in French history: the Bastille. Nevertheless, the English captured Paris in 1419, and several years later the English king Henry VI was actually crowned king of France. Only in 1436 was Paris restored to French control, and to its status as the seat of a monarchy that was soon to define, under Louis XI, the absolutist principle that would characterize French government until the Revolution.

The Renaissance arrived in Paris with the reign of Francis I (1515–1547). Francis made a splendid palace of the Louvre and built a handsome new Hôtel de Ville (city hall), while the new, classically influenced architectural style that had originated in Italy was manifested in scores of fine mansions built by wealthy nobles and a rising mercantile class. Francis, though, preferred to rule from his palaces in the Loire Valley, a tendency that diminished the stature of Paris at the same time the city was bursting from its medieval walls and suffering crises

(OPPOSITE, TOP)

SPLENDOR ON THE LOIRE

The château of Chambord was the largest and most beautiful of the Loire Valley retreats favored by King Francis I, a Renaissance monarch who spent much of his time away from the capital.

(RIGHT)

RELIGIOUS DIVISION

The Catholic League, shown here in procession on Paris's Place de Grève, arose in opposition to the French Protestant faction known as the Huguenots. Kings Henry III and IV eventually faced the League's hostility.

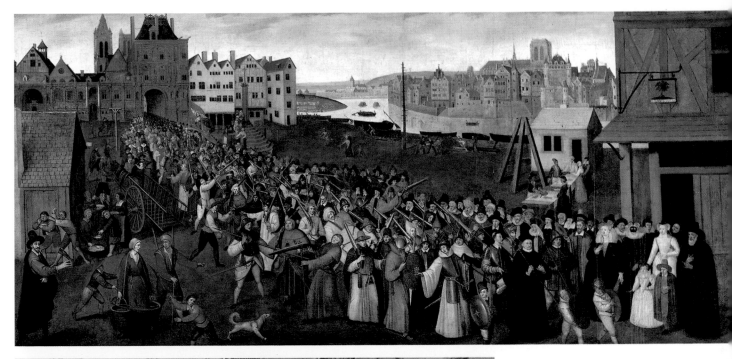

of sanitation and traffic that resulted from a resurgence in its population.

Religious strife soon added to the capital's woes. In the aftermath of the Protestant Reformation, Paris became a focal point in the struggle between Catholics and Protestant Huguenots that reached a bloody climax in the St. Bartholomew's Day Massacre of Huguenots on August 23–24, 1572. Over the next two decades, Paris was a religious battleground in which some 13,000 people died by famine alone, not counting casualties suffered during a siege by forces loyal to Huguenot King Henry III. It was his successor, the Bourbon King Henry of Navarre, who eventually brought peace by making a conversion of convenience to Catholicism and taking the throne as Henry IV.

The happily remembered reign of Henry IV, which ended with his assassination by a madman in 1510, was a time of tremendous improvement in the infrastructure of the capital. Henry created Place Royale and the Hôpital St. Louis on the Right Bank, Place Dauphine on the Ile de la Cité, and the elegantly simple Pont Neuf that still spans the Seine today. Along with his successor, Louis XIII, he began the program of building broad, straight boulevards that were replicated so successfully in the massive urban redesign of the nineteenth century. And it was during Henry's reign that the Marais began to fill with noblemen's mansions, the gracious *hôtels* that remain a hallmark of the district.

The physical appearance of seventeenth-century Paris was immensely influenced by a monarch who, ironically, ceased to

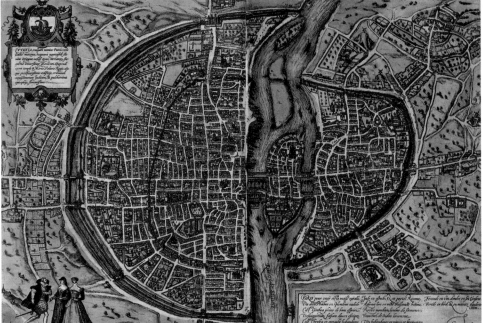

(LEFT)

A TIGHT FIT

By the late sixteenth century, when this map of Paris was drawn, the city was increasingly confined by its medieval walls. Urban expansion would eventually require the dismantling of the old fortifications, made obsolete by improvements in artillery.

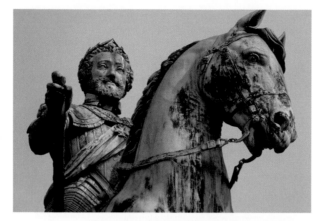

(BELOW)

FIT FOR A SUN KING

By 1668, when this view was painted, King Louis XIV's exurban retreat at Versailles was already the grandest palace complex in Europe. By concentrating the nobility at Versailles, Louis consolidated his absolute rule of France.

(RIGHT)

A POPULAR MONARCH

Henry IV, who converted to Catholicism to calm religious storms, was a well-loved ruler whose reign was cut short by assassination. "Le Vert-Galant" (meaning a gay blade, or debonair sport) is commemorated with this statue in the Ile de la Cité park of that name.

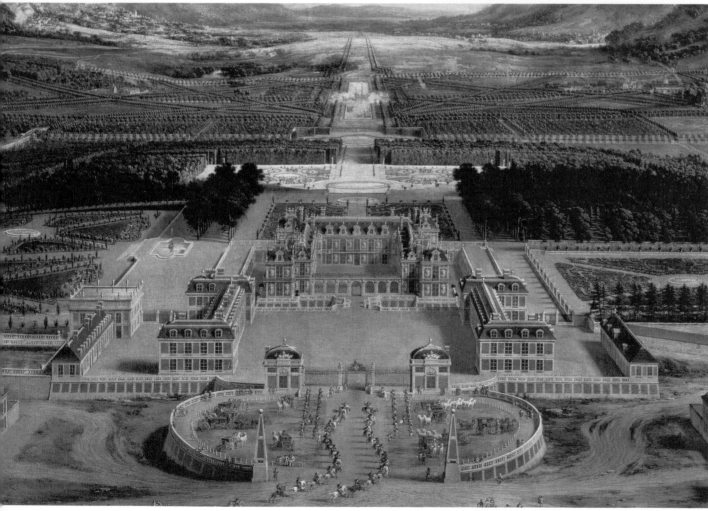

call the capital home and instead relocated his court to the vast exurban palace complex of Versailles. Louis XIV, the Sun King, ascended the throne in 1643 as a boy of five. As a youth he was frightened by the Paris-centered rebellion against royal authority known as the Fronde, and was so dismayed by the ill temper and disorder of the overcrowded capital that he determined to spend as little time there as possible. Nevertheless, Louis did as much as any French monarch to enhance the grandeur of Paris. He constructed the enormous, domed Hôtel des Invalides as a hospital for military casualties; cleared the slums from the vicinity of the Louvre; assigned André Le Nôtre the task of creating the Tuileries gardens; and gave his finance minister Colbert the authority to organize the city into the *arrondissements* that still exist. During the reign of the Sun King, Paris's city limits were expanded to encompass 750 acres beyond the previous 2,000; 125 new streets were opened; and some 6,500 street lamps were installed. Paris at the dawn of the eighteenth century was the largest city in Europe, with half a million inhabitants—and cavernous gaps between its opulent upper classes and the impoverished masses that formed the vast majority of its population.

Paris in the 1700s was the cultural and intellectual capital of Europe. "Paris is the world," wrote the dramatist Pierre Marivaux in 1734. "The rest of the earth is but its suburbs." Marivaux was speaking of a city that, though its population remained relatively static, saw a tripling of its theater seats (from 4,000 to 12,000) between 1700 and 1789; that took

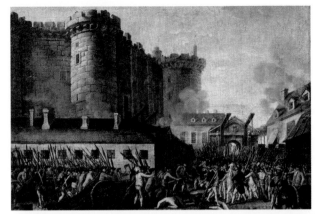

(RIGHT)

FATEFUL SIEGE

The storming of the Bastille, a medieval fortress used as a prison, has ever since been regarded as the signal event that launched the French Revolution—despite the fact that it held only a scant few prisoners, none political.

(FAR RIGHT)

HUMBLED AND SHORN

Queen Marie Antoinette, her hair cut to clear a path for the guillotine's blade, is carted off to her execution. The sketch is copied from a rendition by the great painter Jacques-Louis David, who witnessed the event.

(BELOW)

TAKING THE CROWN

Having mastered Europe in less than a decade, Napoléon Bonaparte became emperor of France, and Josephine his empress (as depicted in this painting by Jacques-Louis David), on December 2, 1804. By taking the crown from the pope and placing it on himself, Napoléon symbolically separated his rule from papal authority.

enthusiastically to the new institution of the café, which joined the salons of the wealthy as a focus for spirited conversation and new ideas among the *philosophes* and those who hung on their every word; and that set the tone for all Europe in fine artisanship and the manufacture of luxury goods. For a London lady of fashion, a Paris gown was already indispensable to each new social season. The prime residential areas were now the Faubourg-Saint-Germain, on the Left Bank, and the Faubourg-Saint-Honoré, on the Right; here, noblemen and members of the *haute-bourgeoisie* built the harmonious, Neoclassical townhouses that still help define the look of Paris.

But as the last decade of the eighteenth century approached, Paris, like all of France, was living on borrowed money—and its upper classes were living on borrowed time. The monarchy's habitual deficit spending, the harvest failures of 1787 and 1788, and spiraling inflation of the cost of food all helped contribute to the French Revolution.

Beginning with the storming of the Bastille on July 14, 1789, Paris became the cockpit of the Revolution. King Louis XVI was forced back to the capital from his Versailles hideaway, but the moderate faction that envisioned a monarchy held to account by democratic reforms was soon swept from the scene by Jacobin extremists. Louis, his queen Marie Antoinette, and nearly 3,000 others labeled enemies of the Revolution were guillotined in the great spasm of suspicion and retribution called the Terror; eventually, the plummeting blade claimed the Terror's chief architect, Maximilien Robespierre. The stage had been set for

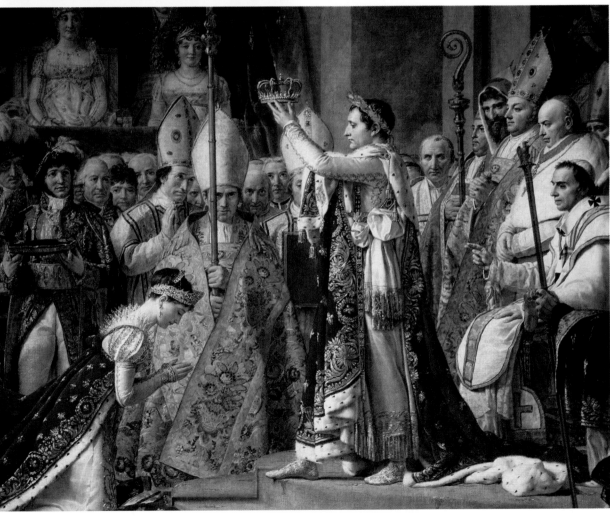

(BELOW)

AT THE BARRICADES

Three days of street fighting, glamorized here in Victor Schnetz's rendition of a skirmish at Paris's city hall, ended the brief Bourbon restoration in 1830. Louis Philippe, the "citizen king," commenced a corruption-tarnished 18-year rule.

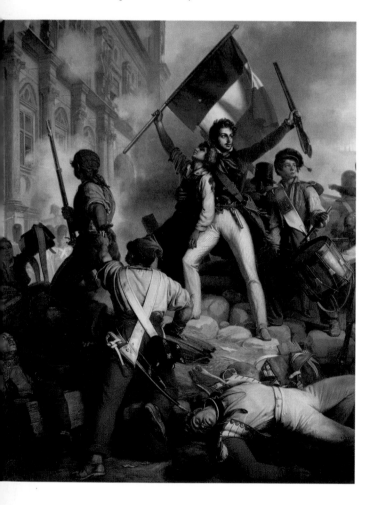

Napoléon Bonaparte's masterful seizure of power, and for a consolidation of authority within the capital that had not been known since the Bourbon kings decamped for Versailles.

Ever mindful of his own glory and posterity, Napoléon set about putting his own stamp on Paris. Among his great additions to the cityscape are the Arc de Triomphe, begun in 1808 but not finished for decades; the Neoclassical façade of the church of Ste-Marie-Madeleine, on which construction was resumed in 1806; and the victory column that stands in the Place Vendôme. But Napoléon sought to remake Paris not only with bricks and mortar, but through administrative and infrastructure reforms as well. He focused on providing a stable food supply and clean water as key components of public health, ordering the city's 56 fountains to run night and day, and building 15 more. He developed an ambitious engineering scheme, diverting the river Ourcq into the Villette Basin and linking it to the Seine via canals. And he made public the former royal hunting preserve called the Bois de Boulogne.

Napoléon also established new standards for food safety, which were institutionalized in five new slaughterhouses and a revamping of the central market, Les Halles, and smaller covered markets throughout the city (of which the Marché-Saint-Germain is the only one still operating). He set up a central grain market and a wine distribution center, the Halle aux Vins, along the quais in the 4th Arrondissement, and he stabilized the ever-volatile price of bread.

Napoléon sought to reorder the existence not only of living Parisians, but of the dead. As far back as 1785, when authorities realized that the city's churchyards were overflowing with corpses scarcely covered with earth, the skeletal remains of six

million individuals were carted to catacombs—now accessible to visitors via an entrance at Place Denfert-Rochereau—that had been quarried as far back as Roman times. And Napoléon saw to the future funereal needs of Paris by opening three cemeteries, Père-Lachaise, Montparnasse, and Montmartre (in those days, all located outside the city limits), in 1804.

By 1801, at the beginning of Napoléon's reign as emperor, the tumult of the Revolution had driven more than 100,000 people from Paris, though 547,000 citizens still called the capital home. But by 1817, two years after Napoléon's final defeat at Waterloo, the population had increased to 714,000. The city they inhabited was again a royal capital, with the Bourbons having been restored to the throne in the person of Louis XVIII and, after Louis' death in 1825, the reactionary Charles X. It was Charles's curtailment of suffrage and free speech that brought Parisian mobs back into the street; he was deposed in 1830 and replaced by Louis Philippe, Duke of Orléans.

Louis Philippe styled himself a bourgeois "citizen king," but although he expanded voting rights and made other small gestures toward democratization, his principal interest was in getting rich through investment in the industrial revolution which, along with the advent of railroads, was transforming Paris and other French urban centers. (In 1842, the first French railway linked Paris with St-Germain.) Economic crisis again forced a regime change in 1848, a year of revolution throughout Europe. Citizens of the capital rose in protest. Louis Philippe was forced from the throne—but unemployed workers struggled for months against a poorly organized interim government, and order was restored only after bloody street fighting.

YEAR OF REVOLUTION

The year 1848 brought revolution
and reaction throughout Europe.
In France, it was marked by the
deposition of Louis Philippe and
the advent of a short-lived
republic, here celebrated at
the Place de la Concorde.

By the end of that tumultuous year of 1848, Paris found
itself the capital of a republic. For the first time, a president
was elected by a population granted universal suffrage, an
innovation built into the new constitution so that conservative
rural voters would counterbalance the radicals of Paris. The
man chosen as chief executive, though, was anything but a
champion of constitutional rule. He was Prince Louis Napoléon,
nephew of Napoléon Bonaparte, and his ambition was not to
serve but to reign.

Louis Napoléon was forbidden by the nation's new consti-
tution to run for reelection. When the National Assembly
rejected his proposal to remove this obstacle, Napoléon and
his powerful backers staged a coup and put a rewriting of the
constitution to a vote. With victory in hand, the president
himself rewrote the document, giving him the broad powers
that paved the way for his assumption of the title of emperor
in 1852. He styled himself Napoléon III—the "III" was a
respectful nod to Napoléon I's son, who had never reigned.

Napoléon III's flamboyant reign was a time of economic
expansion and adventurous policy. The emperor extended
French railway lines, began building the Suez Canal, and fought
for Italian unification. But for Paris, his great legacy was in the
realm of what a later generation would call urban renewal, on
the grandest of scales. During the 1860s, Napoléon expanded
the surface area of Paris from roughly 8,600 to nearly 20,000
acres by dismantling its remaining ancient walls, and increased
the number of *arrondissements* to the present 20. But most
importantly of all, he assigned Baron Georges Haussmann, who
held the administrative title of prefect of the Seine, the task of
remaking the central city—in effect, demolishing the decaying

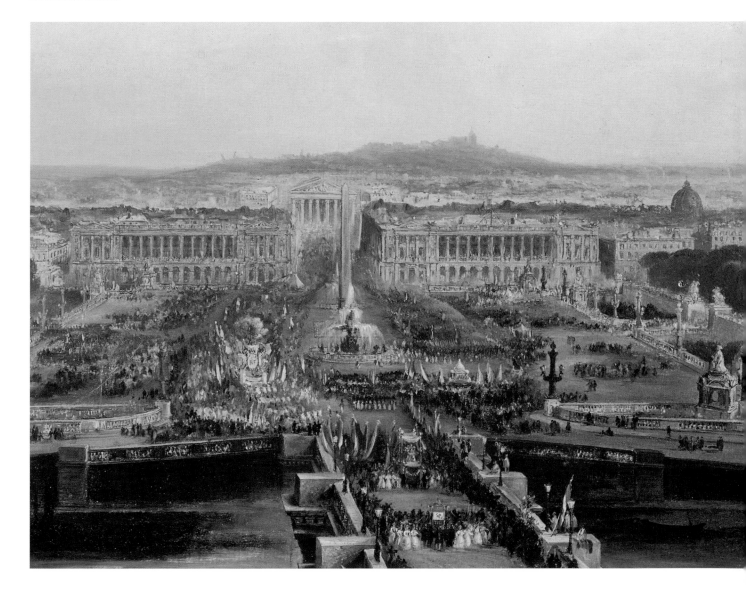

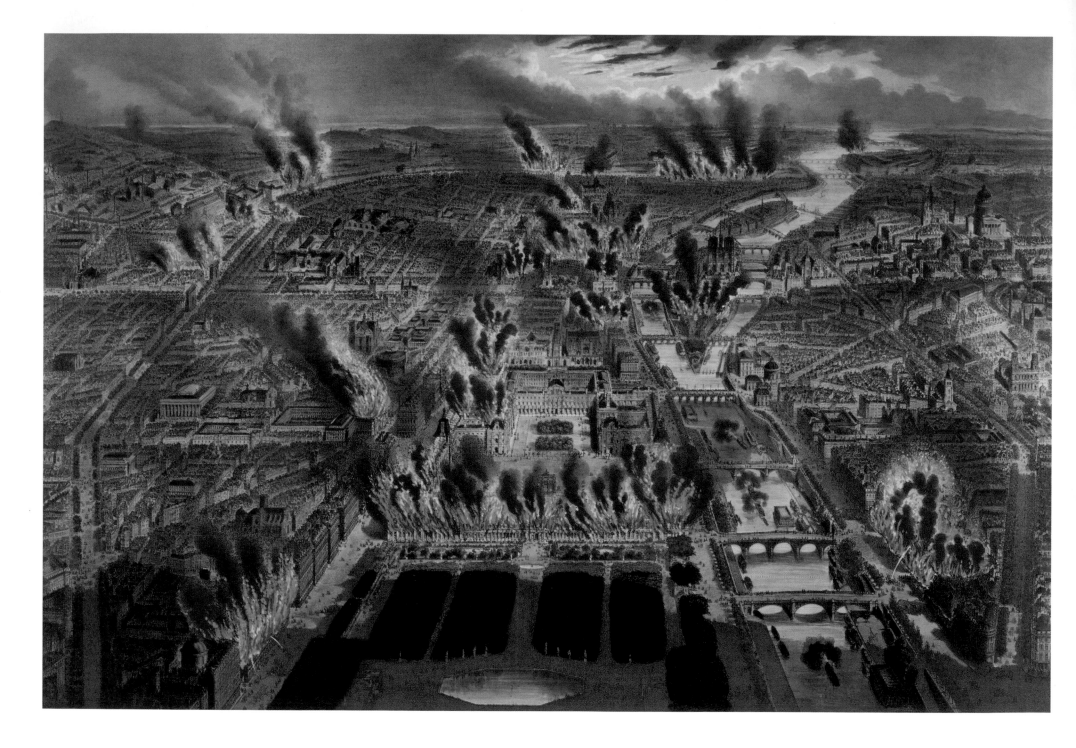

medieval blocks with their twisting warren of streets and alleys and replacing them with broad boulevards converging on spacious squares and *places.* Napoléon's motives were not entirely aesthetic: recalling what had been nearly a century of off-and-on riot and rebellion in the capital, the new ruler was eager to demolish neighborhoods easily barricaded and defended by mobs, and to replace them with clear lines of travel for government troops.

If this self-made emperor had focused his ambitions entirely on urban planning and left foreign policy to clearer heads, he might have spared Paris yet another spasm of violence—and the demise of his own nascent dynasty. But in 1870, he allowed Prussian Chancellor Otto von Bismarck to lure him into a declaration of war against the powerful German state. In little more than six weeks France was humiliated on the battlefield, Napoléon was driven from the throne, and Paris prepared for a Prussian siege under a new provisional government. The Prussians entered the city but only occupied it briefly; the real damage was done in the spring of 1871, when the two-month rule of the Paris Commune was ended by government troops. Thousands of communards were summarily executed, and Paris lost some 200 buildings, including the Tuileries Palace and the Hôtel de Ville, to fires set by the angry mob.

The new republican government was nervous enough to withdraw to Versailles—that least republican of environments—until 1879. But Paris remained peaceful during the closing decades of the nineteenth century, which culminated in the *belle époque* that might be said to have begun with its hosting of the World's Fair of 1889, an event

remembered today chiefly for its lasting contribution to the city's skyline, the Eiffel Tower. In the same year, the Moulin Rouge opened—not a signal historical event, perhaps, but nonetheless emblematic of the spirit of that Parisian era as the world remembers it.

Some two and a half million Parisians greeted the new century, and theirs was a city no longer easily negotiated by surface transportation. The first of the Métro lines, between Porte de Vincennes and Porte Maillot, opened in July of 1900. Fifteen million passengers rode the underground rails in the system's first year; today, that many riders navigate the Métro's 124 miles of track and 370 stations in a single work week.

Gorgeously lit by gas and electricity—a true "City of Light" at last—Paris and its three million inhabitants were a decade and a half into the twentieth century when the city and the French nation faced their most desperate struggle since the Napoleonic wars. Germany's master plan for victory in the First World War called for its troops to reach Paris swiftly, forcing a French surrender. But the capital never suffered a German siege and occupation, as it had in the Franco-Prussian War. French forces held off the enemy at the Battle of the Marne, early in the war, in part thanks to the efforts of Parisian taxi drivers who helped rush troops to the front. Nevertheless, the Germans used long-range artillery to strike the capital from as far as 70 miles away; in one such attack, there was massive loss of life when a shell struck the church of St-Gervais-St-Protais on the Right Bank on Good Friday 1918.

Like New York during the Jazz Age of the same era, Paris in the immediate postwar years took on such a *carpe diem,*

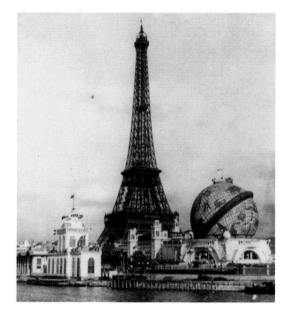

(OPPOSITE)
DESPERATE DAYS
France's defeat in the Franco-Prussian War led to the ouster of Emperor Napoléon III, and the brief ascendancy of the Paris Commune. Michel-Charles Fichot's depiction of the Commune's suppression shows Paris in flames, May 24–25, 1871.

(ABOVE)
SYMBOLS OF PROGRESS
Fin-de-siècle Paris was mad for world's fairs and expositions. The Eiffel Tower, centerpiece of the 1889 event, here stands next to the now-vanished globe that dominated the 1900 Exposition.

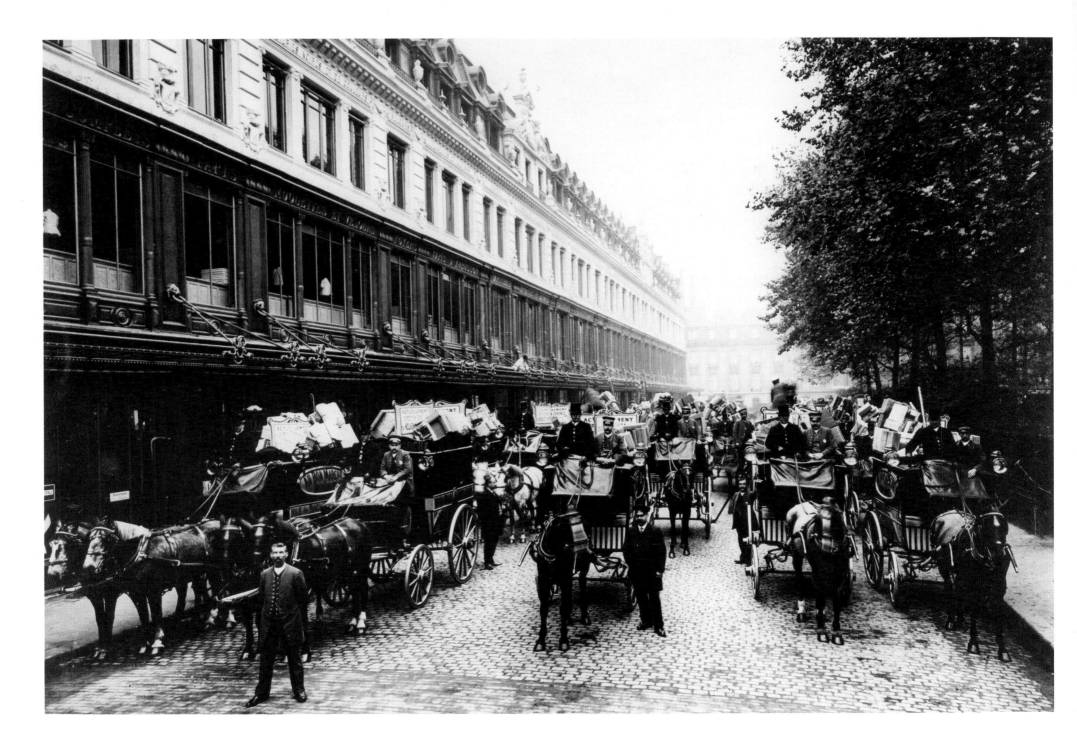

CONSPICUOUS CONSUMPTION
A fleet of horse-drawn delivery coaches serves customers of the Bon Marché department store, c. 1890–1900. The store remains a fixture on the Parisian retail scene, and is the only *grand magazin* on the Left Bank.

ALLIED TRIUMPH
American soldiers parade beneath the Arc de Triomphe to celebrate victory over Germany in World War I. *La Grande Guerre* cost France a generation of young men; every 1914 graduate of the French army's Saint-Cyr officers' school was killed.

PLACE OF HONOR
The 1883 statue personifying the French republic at Place de la République holds an olive branch and a tablet representing the rule of law. At the base are figures extolling liberty, fraternity, and equality.

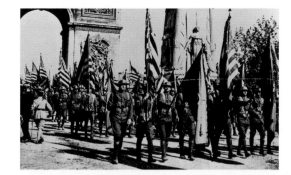

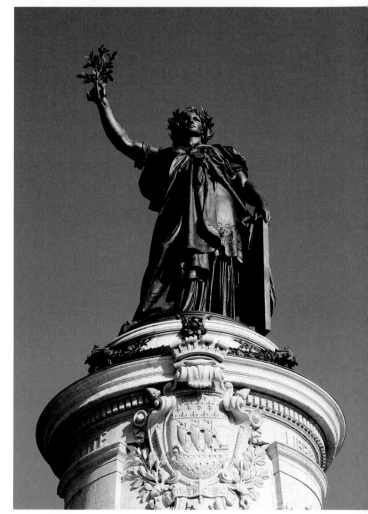

devil-may-care attitude that the phrase "Paris in the Twenties" still immediately conjures a happy combination of bohemianism and *bon ton*. But the party couldn't last—Paris in the 1930s was a city gripped not only by the worldwide Depression, but by political struggles that paralleled the rise of fascism throughout much of Europe. Increasing polarization between left and right was even marked by a 1934 coup attempt by a fascist coalition. The coup was unsuccessful, but demonstrated once again that the capital could become a tinderbox in times of hardship.

The ultimate hardship for Paris, though, was the German occupation that began in June of 1940, nearly a year after the beginning of the Second World War. Profoundly humiliating to the Parisian citizenry, the occupation was fatal to the thousands of Parisian Jews deported to Nazi concentration camps. They are remembered today at the Memorial of the Deportation, a haunting structure at the eastern tip of the Ile de la Cité, inscribed with the names of the victims.

The occupation might well have climaxed with the destruction of Paris, had German General Dietrich von Choltitz obeyed Hitler's orders to raze it with explosives and fire rather than capitulate to the advancing Allies. But von Choltitz knew that after surrendering he would no longer have to answer to Berlin, and it was a Paris left intact that greeted General Charles de Gaulle and the forces of liberation on August 26, 1944.

Postwar Paris resumed its role as a political storm center—since the liberation, a provisional government and two successive republics, the Fourth and Fifth, have governed from the capital. The greatest crisis of Parisian—and French—postwar political life came in May of 1968, when students and police clashing at barricades in the Latin Quarter seemed to summon the ghosts of 1870, 1848, 1830, and 1789. What had begun as a demand for university reform by disaffected students spread to include restive workers, and the entire nation was soon paralyzed by strikes. One towering casualty of the crisis was Charles de Gaulle, who resigned the presidency in 1969 after 11 years in office.

The politics espoused by residents of the Élysée Palace and the Hôtel de Ville have swung between left and right in the years since 1968, but neither faction has swerved from the core French notion of the capital as the great pride and showplace of France. At the dawn of the twenty-first century, sustaining the city's individuality and European—if not global—preeminence was admittedly somewhat more of a chore than in past eras, given the onslaught of American culture as represented by Disneyland Paris and McDonald's on the one hand, and the ascent of the European Union on the other. But Parisians have always known how to hold the world at bay, even if they pay for their morning coffee and copy of *Le Monde* in euros rather than francs, or occasionally keep to a tighter schedule than a two-hour lunch would permit. They know that Paris remains as central to the life of Europe and the world as any Bourbon or Bonaparte could ever have imagined.

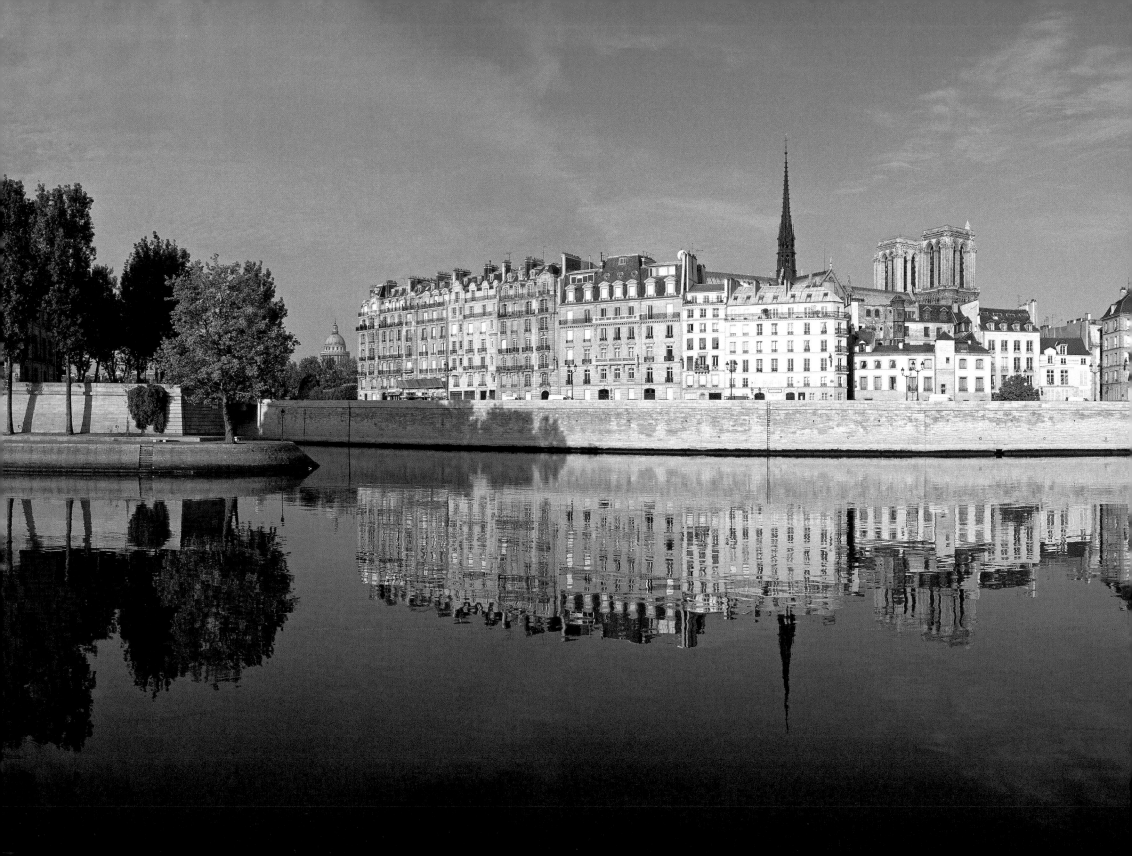

ILE DE LA CITÉ AND ILE ST-LOUIS

O N A MAP of Paris, the two small lozenge-shaped islands rising at a wide spot in the Seine look as though they might serve as little more than bridge footings, stopovers on the way from the Right Bank to the Left. But the islands—particularly Ile de la Cité, the larger of the two—are central to the life of Paris, to its history as well as its river-cleft geography.

The Ile de la Cité was the home of the Parisii, the earliest recorded denizens of Paris, in the days when being surrounded by water made very good defensive sense. The Romans recorded the name of their settlement, Lutetia, a Celtic term that may have meant "residences in the middle of the water." What little remains of Lutetia is visible in the Crypte Archéologique, an excavation of third-century C.E. buildings, including a Lutetian home, near the center of the island.

But it is Paris's most revered religious monument, the Cathedral of Notre-Dame, that is the great beacon for visitors—some 12 million each year—to the Ile de la Cité. The Cathedral of Notre-Dame is universally regarded as one of the towering masterpieces of Gothic architecture, and of an age of faith that sought to reflect the mystery and majesty of the divine in soaring edifices of stone and stained glass. Built on the site of two earlier Christian churches, Notre-Dame was the conception of Maurice de Sully, bishop of Paris, who launched what became a 200-year-long construction project in 1163. The twin-towered

façade dates to about 1200, and the first stained-glass windows were installed in the north and south transept walls between 1250 and 1258. The deep-hued windows, which create such a marvelous play of light inside the enormous structure, were designed to make biblical stories accessible to what was then a largely illiterate populace. The stone figures carved into the façade and the portals that frame the three main doors of the cathedral served the same purpose, illustrating (from left to right) the coronation of the Virgin, the last judgment and resurrection of souls, and the Virgin with Bishop de Sully.

Thirty-seven individual side chapels indent the cathedral's interior walls, which owe their soaring, uninterrupted height to the builders' ingenious use of double-arch flying buttresses, the graceful stone supports that flank the upper stories of the nave and transfer the immense weight of the walls and roof to the ground. From within the cathedral, 400 steps wind to a vantage point that reveals one of Paris's finest panoramas—and affords an up-close meeting with the famous Notre-Dame gargoyles.

Those gargoyles, and much of the other sculptures and statuary that adorn Notre-Dame, do not date from the Middle Ages but from extensive restoration work that was carried out during the mid-nineteenth century. By that time, the cathedral was in a state of near dereliction; in addition to the ravages of time, Notre-Dame had been subject to the rabid anticlerical and antimonarchist passions of the French Revolution. Even the

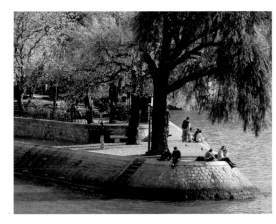

(OPPOSITE)
TIME AND THE RIVER
Seemingly adrift on a tranquil Seine, the Ile de la Cité was home to Paris's earliest settlement. Its pinnacle is the iron spire of the Cathedral of Notre-Dame.

(ABOVE)
ISLAND OASIS
The prow-shaped park named for King Henry IV, le Vert-Galant, lies at the western end of the Ile de la Cité. Parisians favor it for reading, relaxing, and watching the Seine.

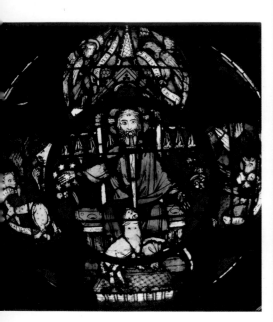

(ABOVE)

LESSONS IN GLASS

A detail of the rose window in the south transept of Notre-Dame shows Christ returning at the Apocalypse. In an age when few could read, stained glass and statuary explained the scriptures.

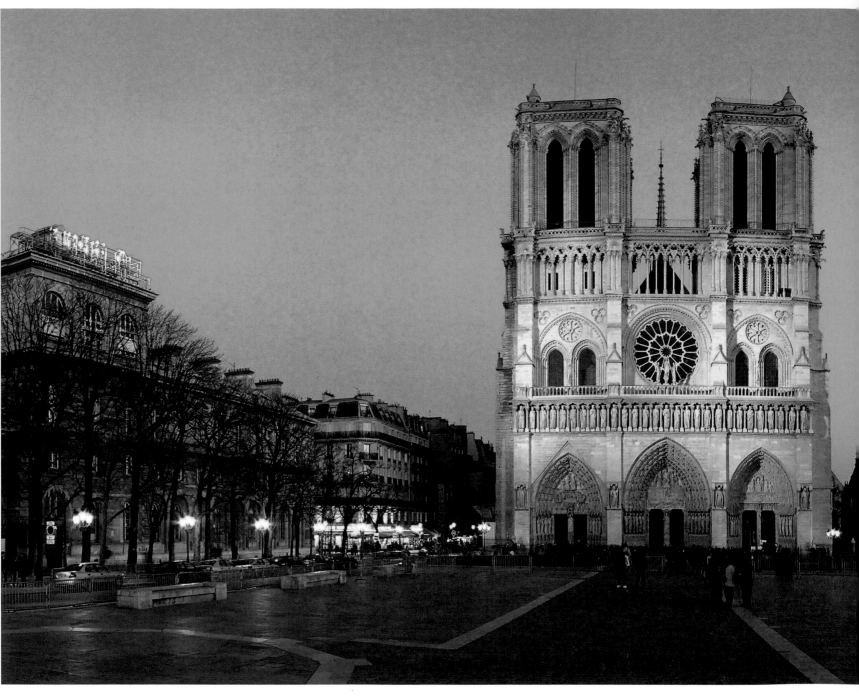

SACRED SITE
The Cathedral of Notre-Dame
stands on an Ile de la Cité site
previously occupied by a
Romanesque church, a Frankish
basilica, and—in pagan times—a
place of Celtic fertility worship.

statues of the kings of Judah mounted upon the west façade
had been destroyed; according to some accounts, the mob had
mistaken them for kings of France (the original statues' heads
have survived in the National Museum of the Middle Ages).

The cathedral's restoration was carried out during the
1850s by Eugène Emmanuel Viollet-le-Duc, an eminent
Gothic Revival architect and historian of the style.
Subsequent generations of critics and scholars have
questioned Viollet-le-Duc's freehanded approach to this
and other restorations, arguing that he tended to think in
terms of what should have been, rather than what could be
rigorously documented. But everyone who appreciates the
superb condition of Notre-Dame today is indebted to him,
at the very least, for the meticulous reconstruction of the
thirteenth-century rose window on the south façade. The
great cathedral, after all, has never been a finished, static
structure, but a palimpsest upon which has been written
more than eight centuries of Parisian history, from the piety
of medieval times, through the excesses of the Revolution
and the coronation of Napoléon, to the romanticization of
the Middle Ages in the days of Viollet-le-Duc and Victor
Hugo's *The Hunchback of Notre Dame*.

The kings of France lived in Paris even before it became
the nation's official capital. The palace they occupied as far
back as the thirteenth century still stands, as part of the Palais
de Justice complex. Located west of Notre-Dame and the
former barracks of the royal guards that now house the
Prefecture of Police (workplace of Georges Simenon's
beloved fictional detective, Inspector Maigret), the Palais
today is home to France's supreme court.

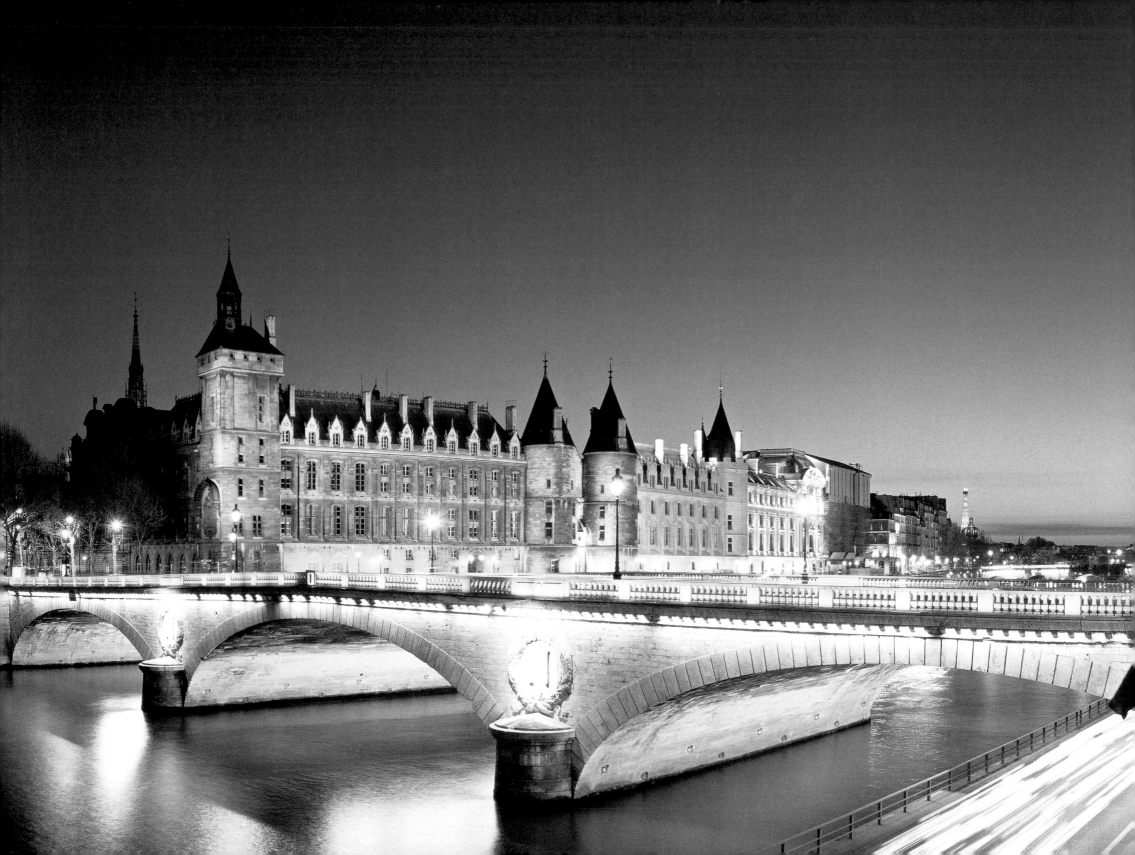

Much of the complex dates only to the nineteenth century, although its northeast wing comprises the Conciergerie, built between 1301 and 1315 by King Philip the Fair. Four round five-story towers loom over the façade of the Conciergerie: the Caesar Tower, named in remembrance of the Romans in Gaulle; the Silver Tower, an allusion to the royal treasury believed to have been kept there; the Bonbec Tower, which contained the room where prisoners were tortured (*bon bec* means "good beak," formerly slang for a tattler or squealer); and a clock tower, topped by France's first public timepiece. Beneath the towers, the ancient structure contains the Hall of the king's Men-at-Arms, nearly 200 feet long beneath its lofty vaulted ceiling, The Hall was used as a dining hall for a palace staff that numbered in the thousands; the men were served from four enormous fireplaces, in the days when all cooking was done over open hearths.

In 1391, King Charles V moved his quarters out of the Palais and installed his parliament and courts there. He placed the old building in the charge of a *"concierge,"* a royal housekeeper whose duties extended to tax collection and other functions well beyond making the beds and ordering provisions. Thus the name "Conciergerie," which remains today.

After the fall of the monarchy, the Revolutionary Tribunal made the Conciergerie the headquarters of its summary brand of justice. Within the short span of two years, more than 2,700 people sentenced to death waited here to be carted by tumbrel to what is now the Place de la Concorde, where the guillotine stood. Among them were Queen Marie Antoinette, the poet André Chénier, the 21 Girondist deputies found guilty of conspiracy against the Republic, Georges Danton, Antoine Lavoisier, the "father of modern chemistry,"

and, eventually, Robespierre, kingpin of the Terror. Today, visitors to the Conciergerie can whiff the brimstone of the Revolution in the Prisoners' Gallery, in the little courtyard where condemned women were allowed to walk, and at a replica of Marie Antoinette's cell. (By order of Louis XVIII, the doomed queen's original quarters were made into a chapel.)

The jewel of the Palais complex is Ste-Chapelle, the chapel built in 1248 by Louis IX, king and saint, to house Christ's Crown of Thorns. Louis had purchased the alleged Crown and other relics from Venetians, those master-traders in merchandise sacred and secular, while returning from a Crusade. The upper level of his two-tiered chapel (its smaller lower level was for palace staff) is easily the most exquisite example of the High Gothic style in all of Paris. The delicate ribs of its vaulted roof soar effortlessly from their supporting columns, while the whole of the space glows with light filtered through stained and gilded glass windows. Like Notre-Dame, the Ste-Chapelle was restored during the mid-nineteenth century by the tireless Viollet-le-Duc.

Just across the Boulevard du Palais from the Conciergerie and Ste-Chapelle is a bright bit of the natural world, its colors unaugmented by stained glass. The Marchés aux Fleurs, one of the last and largest flower markets in Paris, is held here each day beneath an open arcade. On Sundays, the space resounds to the twitter of birds—at the weekly Marché aux Oiseaux, Parisians can choose from among hundreds of species to cheer their flats and townhouses.

A fortunate few of those citizens might live a few steps upstream at Place Dauphine, the only part of the Ile de la Cité that still harbors private dwellings. King Henry IV was responsible for the unified decoration of this triangular space bordered by 32 brick-and-white-stone buildings, designed in

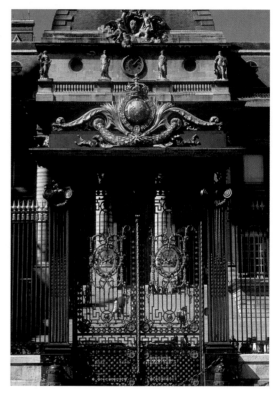

(OPPOSITE)

**MEDIEVAL
AT THE CORE**
The oldest portion of the
Palais de Justice complex is the
Conciergerie, seen here at center.
Built in the early fourteenth
century by King Philip the Fair,
the structure is sentineled by four
squat round towers.

(ABOVE)

**GATES
OF JUSTICE**
Ornate nineteenth-century gates
and grillwork frame an entrance
to the Palais de Justice, seat of the
French supreme court.

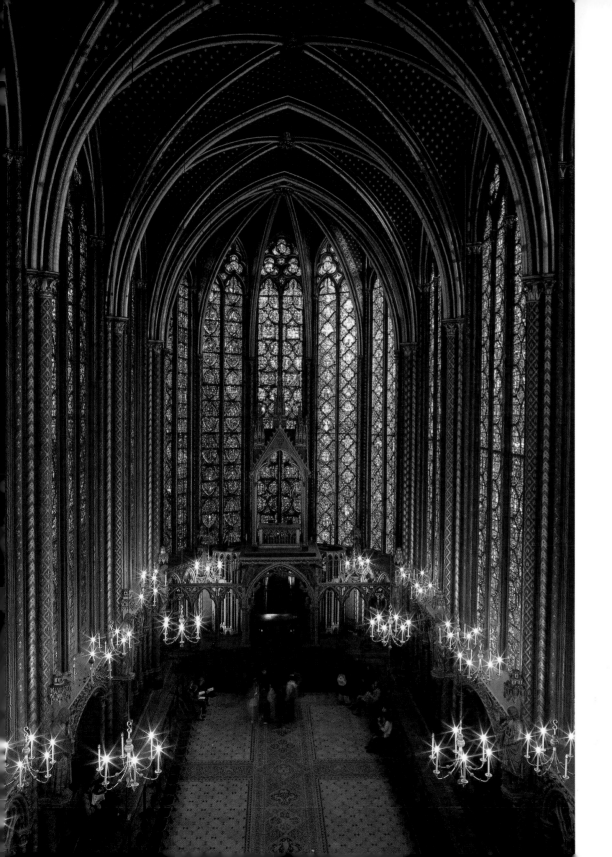
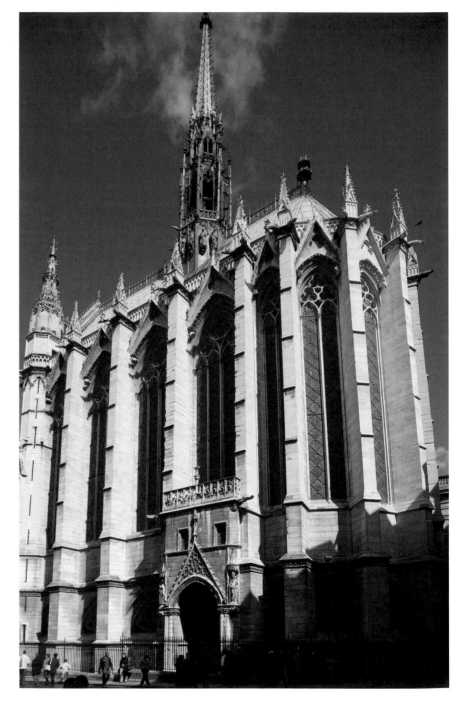

(OPPOSITE, LEFT AND RIGHT)

GOTHIC GRANDEUR

The Gothic style reached its Parisian pinnacle in the thirteenth-century Ste-Chapelle, built by France's saint-king Louis IX.

The building's otherworldly impression of weightless verticality is most evident in the interior, with its vaulted ceiling and exquisite, ribbonlike stained-glass windows.

1607 to provide a sanctuary from the carriage traffic that had already begun to shatter the city's calm. Under the shade of centuries-old chestnut trees, residents might engage in the ancient games of boules or pétanque, and little restaurants and open-air cafés draw lunchtime crowds from the Palais de Justice and Prefecture of Police.

Beyond Place Dauphine, the westernmost tip of the Ile is still the domain of Henry IV. This is the water-level garden that bears his nickname, le Vert-Galant (colloquially, "the gay blade"). It occupies the pointed prow of land created when Henry's engineers built the Pont Neuf, and provides a handsome setting for a statue of the beloved king who was assassinated in 1610. The park is a favorite spot for sitting and watching the Seine flow by, and serves as an embarkation point for sightseeing boats that cruise the river.

At the opposite end of the island, beyond Notre-Dame and the park named for Pope John XXIII, the rue Cloître de Notre-Dame—named for the cathedral's old cloister—leads to a house at 9 Quai aux Fleurs in which the most famous of Paris's many star-crossed lovers took refuge near the sad denouement of their scandalous twelfth-century romance. Soon after leaving here they parted ways, Héloise to a convent, and the scholar Abelard to a monastery. Their portraits, carved in stone after the house was rebuilt in 1849, flank the doorway; above is a marble plaque that tells their story.

A pedestrian footbridge, Pont St-Louis, leads from this eastern corner of the Ile de la Cité to a smaller island that many consider to be the city's best address. Unlike most organically evolved Parisian neighborhoods, the Ile St-Louis was the result of a deliberate residential development scheme. Starting in

1614, two small islands were joined to form the Ile St-Louis and were linked to the Right Bank via the Pont Marie. Many of the island's mansions date from the decades immediately following, as their calmly formal seventeenth-century façades easily suggest. Pont St-Louis deposits strollers amidst a lively gaggle of buskers, whose music and street theater is best enjoyed while sampling a treat from Paris's favorite ice cream shop, Berthillon, located just down rue St-Louis-en-l'Ile at number 31.

Attracted by its splendid private houses and balcony-lined quais, Paris's wealthiest and most influential citizens have long called Ile St-Louis home. The Duke of Lauzun helped set the trend by commissioning Le Vau to design a townhouse at 17, Quai d'Anjou, in 1656. The mansion still bears the Lauzun name, although it is better known for a temporary descent from propriety, when it was an opium den frequented by Baudelaire. A branch of banking's Rothschild family still keeps the seventeenth-century Hôtel Lambert, with its barrel-vaulted and painted Gallery of Hercules rivaling the Louvre's Gallery of Apollo, as a Parisian pied-à-terre. The south-facing Quai de Bethune has always had a special cachet: in 1934 Helena Rubinstein, the American cosmetics magnate, demolished the seventeenth-century Hôtel Hasselin at number 24, preserving only its carved oak door, and rebuilt an elegant, modern townhouse with a sumptuous terrace overlooking the Seine. And French president Georges Pompidou spent the last years before his death in 1974 a few doors away, at number 18. Like the ancient Parisii in their water-girt fastness of Lutetia, these and many other rich and famous Parisians understood the appeal of island living.

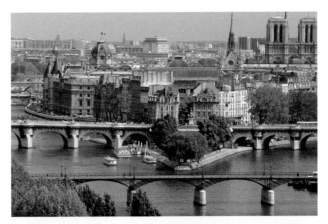

(TOP)

OLDEST PARISIAN BRIDGE

The 1603 Pont Neuf crosses the Seine and the Ile de la Cité, traversing the island just east of the Square du Vert-Galant. The spires of Ste-Chapelle and Notre-Dame rise in the distance.

(BOTTOM)

TOUCH OF COLOR

The outdoor flower market brightens each day on the Ile de la Cité. On Sundays, the market also offers caged songbirds for sale.

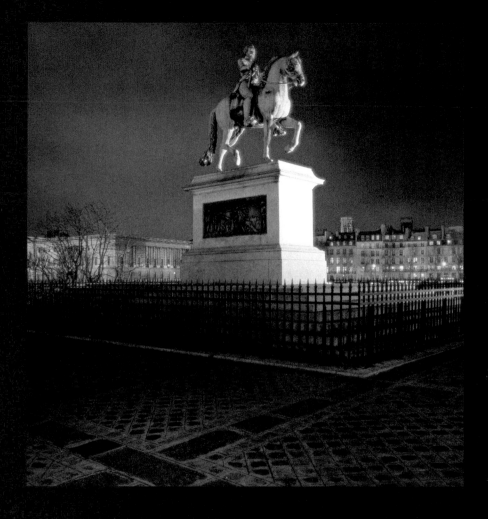

(PAGES 32–34)
SPANNING THE SEINE
Pont Louis-Philippe links the
Right Bank (foreground) with
Ile St-Louis. The lone tree at the
river's edge marks the narrow
waterway separating this largely
residential island from the
larger Ile de la Cité, where the
spire and towers of Notre-Dame
loom to the right.

(ABOVE)
LE VERT-GALANT
An equestrian statue of France's
well-loved King Henry IV
dominates Place du Pont Neuf,
just east of the tranquil little
park that bears his nickname,
Vert-Galant.

(PAGES 36–37)
PARIS BY BOAT
The hardworking barges that once
plied the Seine have largely been
superseded by tour boats, popular
with Parisians as well as visitors to
the capital. Ile de la Cité is at right.

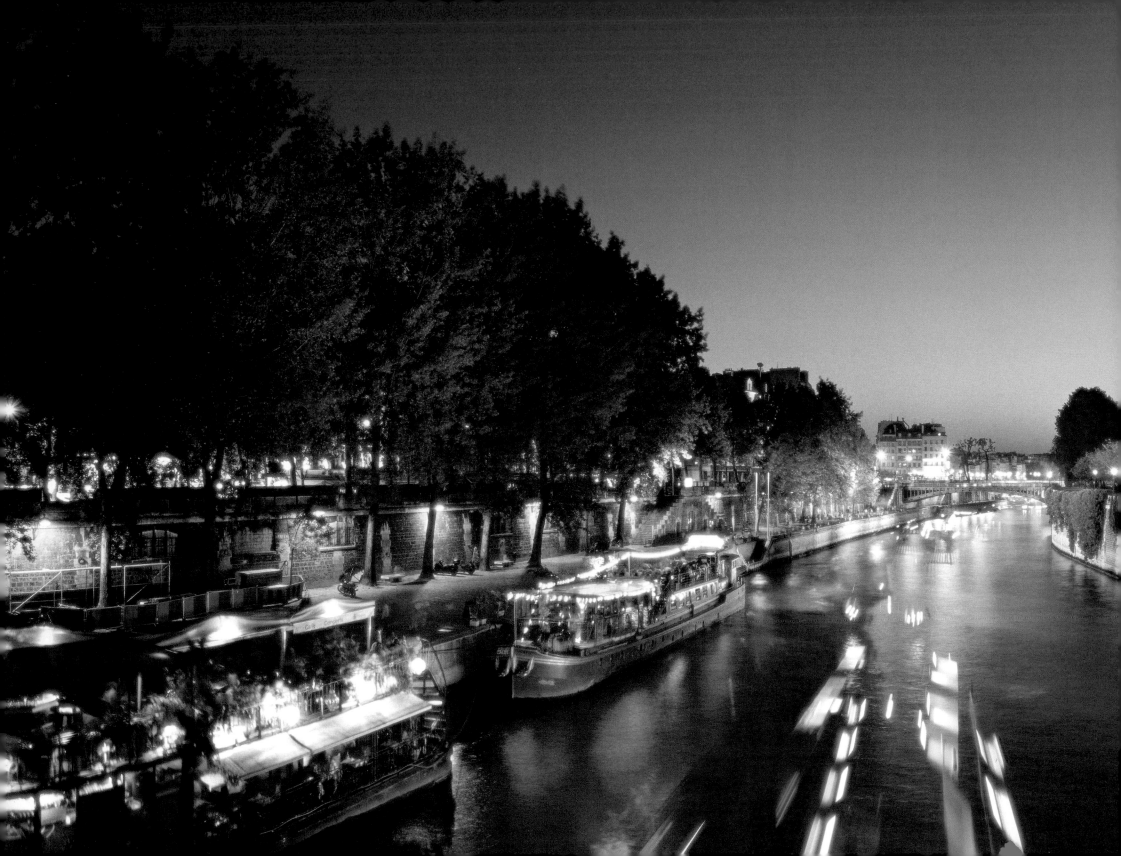

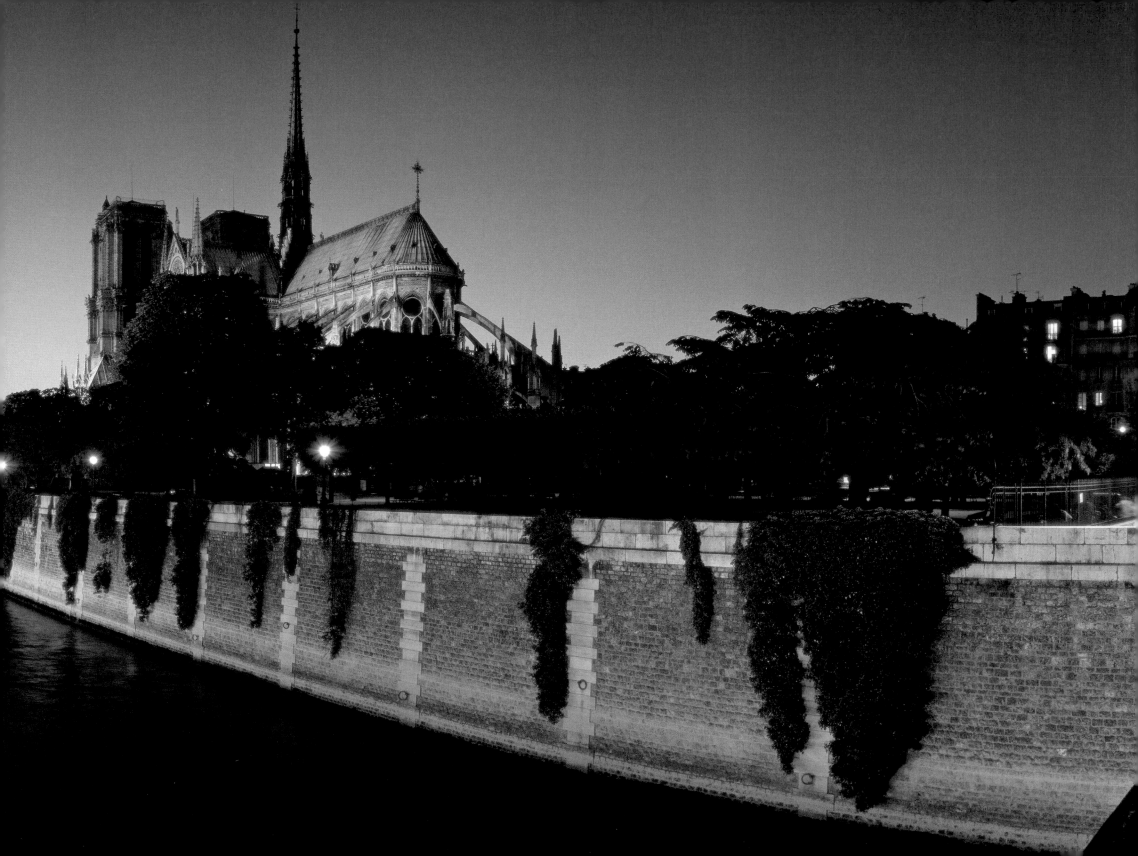

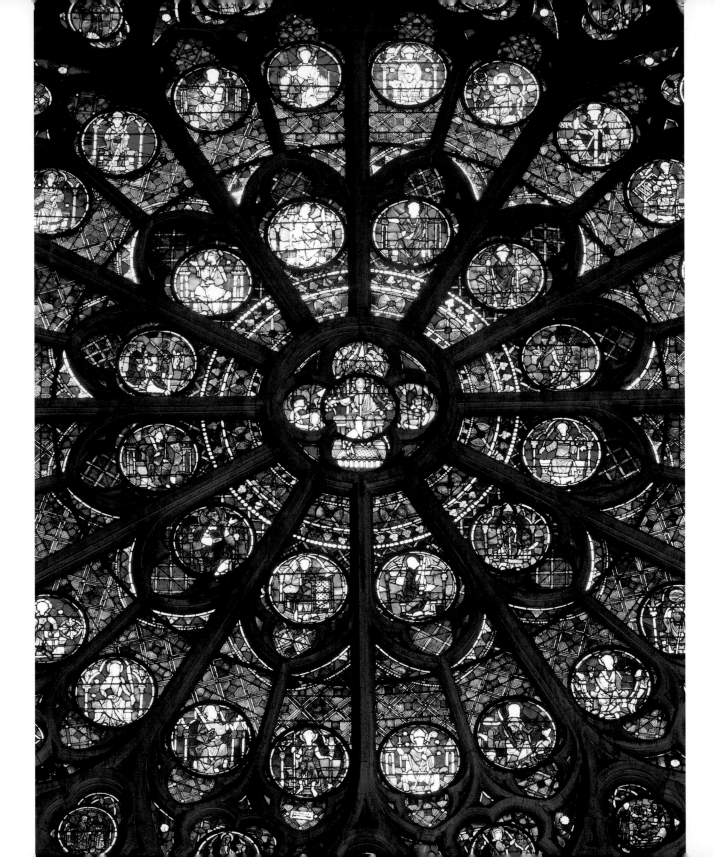

(ABOVE)

FROM THE RIDICULOUS ...

For centuries, amateur entertainers have made use of the broad plaza facing Notre-Dame.

(RIGHT)

...TO THE SUBLIME

The rose window in the south transept of Notre-Dame dates to the thirteenth century. Unlike its counterpart in the north transept, which retains most of its original glass, the south window was extensively restored by Viollet-le-Duc.

(OPPOSITE)

THE WORK OF CENTURIES

Nearly 200 years in the making, Notre-Dame was the first great cathedral to employ flying buttresses to help distribute the weight of its roof. The central steeple, or "flèche," was added by Viollet-le-Duc during his nineteenth-century restoration.

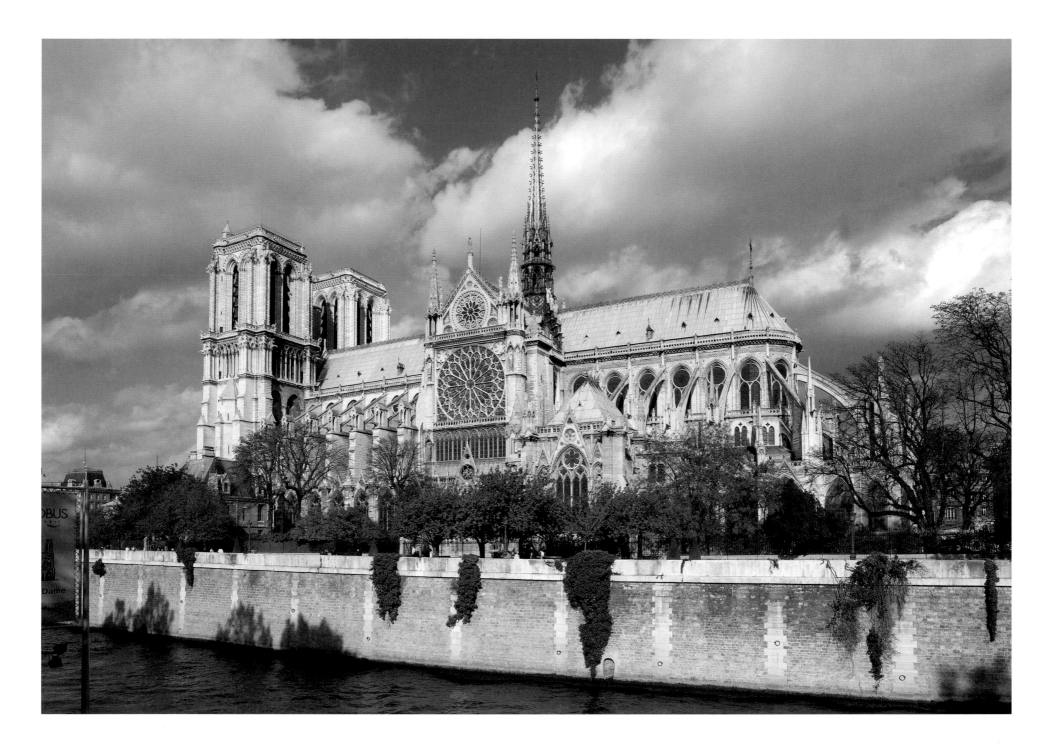

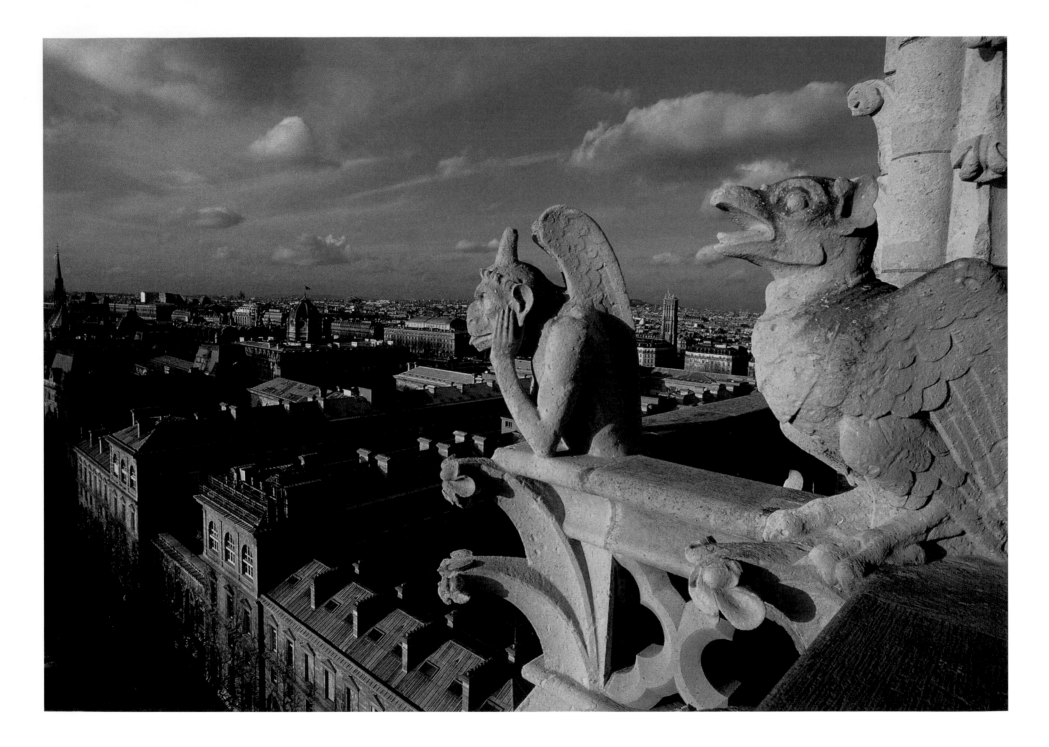

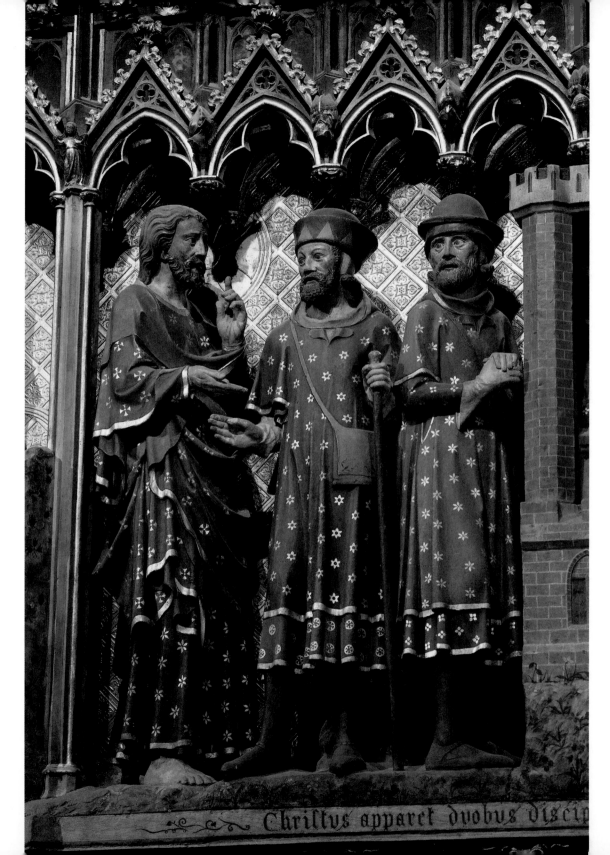

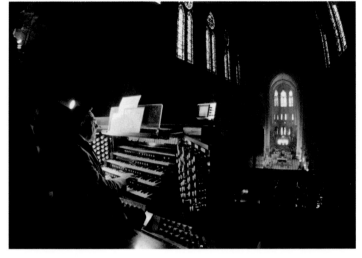

(OPPOSITE)

WATCHING OVER PARIS

Hundreds of gargoyles adorn Notre-Dame. Originally used as spouts for carrying off rainwater, these Gothic trademarks evolved into purely ornamental fixtures; on the Paris cathedral, many are nineteenth-century replicas installed by Viollet-le-Duc.

(LEFT)

VISUAL BIBLE

As in all Gothic cathedrals, sculpture told the tales of the scriptures to a mostly illiterate populace. Here, Christ appears to his disciples after his resurrection.

(ABOVE)

HEAVENLY CHORDS

Although it has been computerized, the 109-stop organ of Notre-Dame still possesses pipes installed in the early eighteenth century. The position of organist at the cathedral (there are four) is one of the most prestigious in France for members of the profession.

(PAGES 42-43)

SIMPLE AND FUNCTIONAL

Built during the reign of Henry IV, whose statue stands in the background, the Pont Neuf was the first Parisian bridge built without the clutter of highly flammable shops and houses along its span.

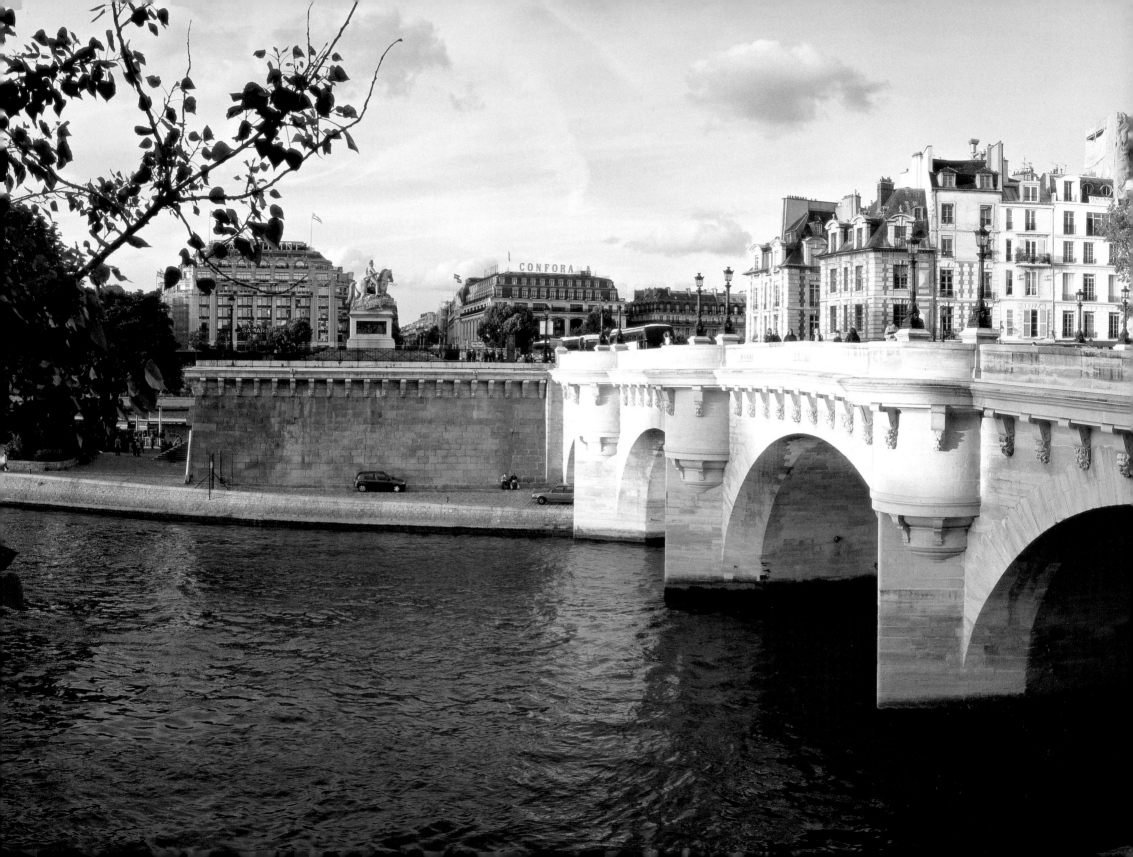

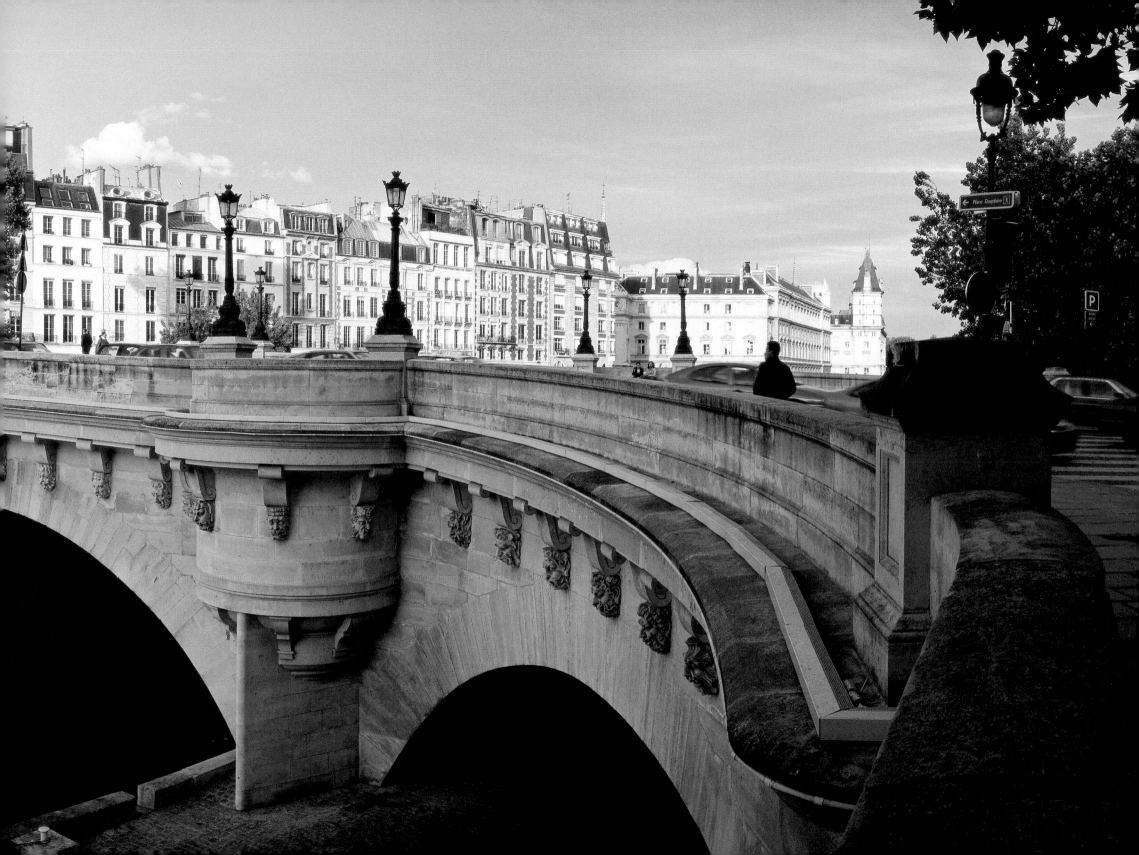

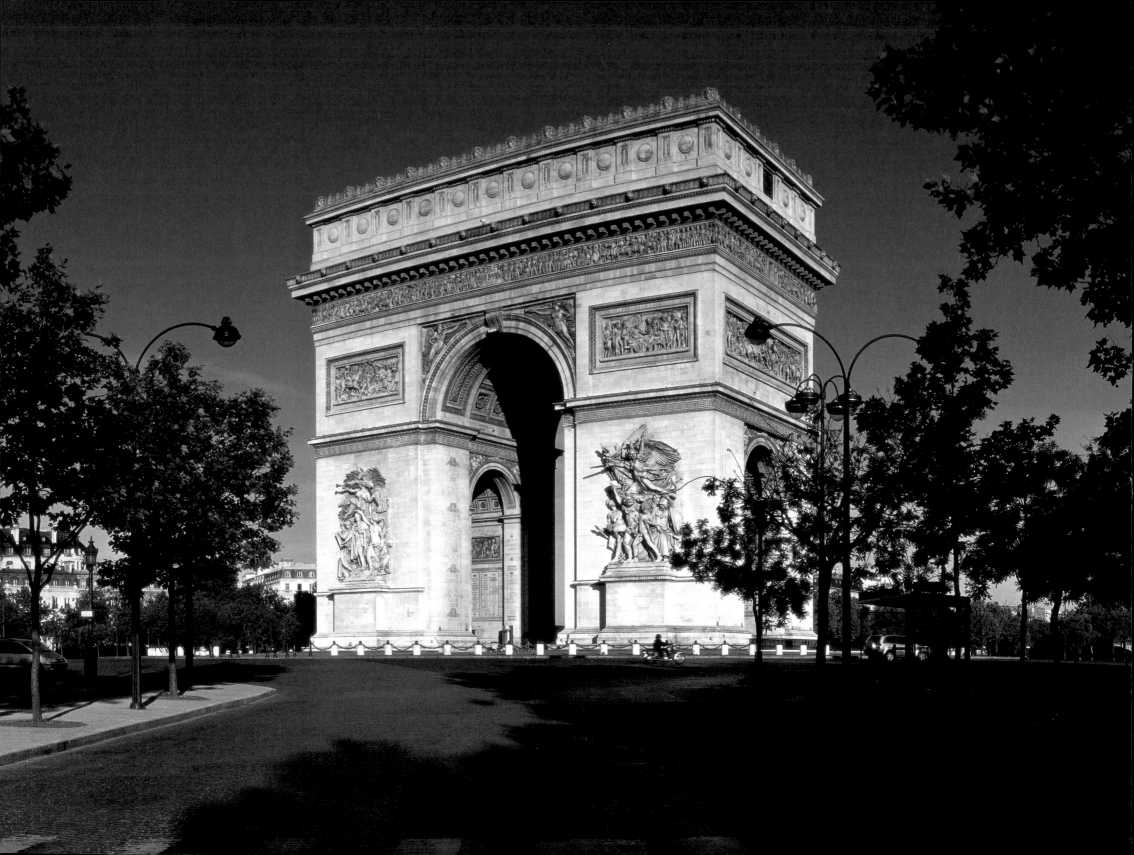

THE RIGHT BANK

THE Right Bank of the Seine is part of Paris that bears the deepest imprint of the old French monarchy, but it is also where nobles and citizens alike have created some of the city's most famous and vibrant neighborhoods. Except for the Eiffel Tower and the Cathedral of Notre-Dame, virtually all of the icons that conjure Parisian magic are on this side of the Seine. The Louvre, the gardens of the Tuileries, the sumptuous Ritz and Crillon hotels, the Champs-Élysées, the Arc de Triomphe—all ornament the Right Bank, as do the quirky alleys of Montmartre and the swank Ancien Régime townhouses of the Marais.

Much of the Right Bank—really, the north bank of the Seine—was once swampland, or *marais*, the name that still clings to a sprawling, rejuvenated neighborhood today. The marshes were drained around the end of the twelfth century by King Philippe-Auguste, who, about the same time, began building a fortress that would one day evolve into the greatest art museum in the world: the Louvre.

The Louvre exemplifies Paris's gift for perpetual reinvention. Philippe-Auguste's rude medieval fortress was restyled as a royal residence by Charles V in the 1360s, and its story over the next three centuries was one of near constant demolition, reconstruction, and expansion. Francis I and Henry II added late sixteenth-century wings whose façades are characterized by a rigorous Renaissance order, and Louis XIV—

before he decided to move his court to Versailles—commissioned the classical east façade, and the barrel-vaulted Gallery of Apollo, with its solar-themed ceiling glorifying Louis's favorite subject—Louis. Those equally obsessive builders, Napoléon I and Napoléon III, made further additions and alterations. But the most dramatic departure from tradition came in 1988, when I. M. Pei's glass pyramid rose from the courtyard just east of the Place du Carrousel. The pyramid contrasts so starkly with the stone classicism that surrounds it that a final verdict may take centuries: is this a misbegotten anachronism, or a sparkling prism through which to focus on the whole vast compound?

French kings had long been hoarding artworks in the Louvre. It was Francis I who bought the *Mona Lisa* when the paint was hardly dry. But the Louvre made its debut as a public museum only in the immediate aftermath of the Revolution, first as a showplace for confiscated royal treasures and later as a repository for the artworks that Napoléon pilfered from other European capitals. By the twentieth century, the Louvre's collections were unrivaled by all but a few of the world's museums.

There is no single best way to explore the Right Bank, although it is hard to look west from the Louvre and not be drawn into the long prospect of immaculate lawns, pools, and promenades that leads to the Place de la Concorde and beyond. Afterward, having made a beeline progression through the royal

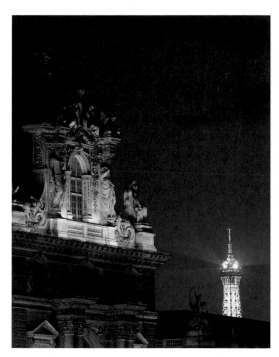

(ABOVE)
PARISIAN ICONS
Two treasured monuments glow against the night sky. The Louvre incorporates centuries of architectural taste, and has evolved from fortress to palace to museum; the Eiffel Tower, built in a span of months, has always been an iron paean to engineering.

(OPPOSITE)
ENDURING SYMBOL
Built to reflect Napoléon's glory, the Arc de Triomphe has witnessed low and high points of French history. Four years after Nazi conquerors paraded here, General Charles de Gaulle led liberators beneath the arch and the *place* that now bears his name.

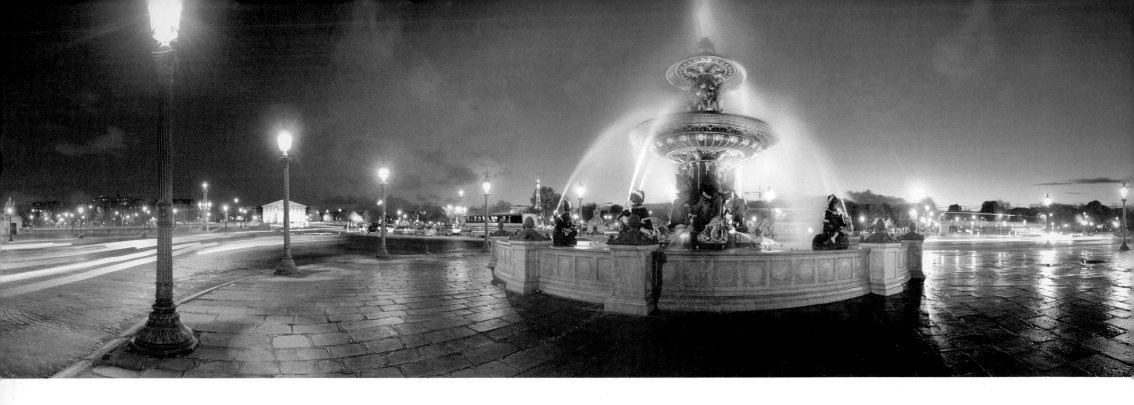

(ABOVE)

RIGHT BANK CROSSROADS

A wraparound view of the Place de la Concorde, focal point of the Right Bank's elegant urban geometry. The Tuileries gardens are to the east, the Avenue des Champs-Élysées to the west, all laid out in classic French symmetry.

(OPPOSITE)

WHEEL OF LIGHT

Adding an incongruously whimsical and kinetic note to the stately Place de la Concorde, Paris's gaily lit Ferris wheel glows against the early evening sky.

and stately aspects of the district, it's pleasant to meander east by a far less direct route, discovering the random attractions that lie farther from the Seine.

The greenspace spreading west from the Louvre is the Garden of the Tuileries. Enter through Napoléon's 1808 Arc de Triomphe du Carrousel, the first of the emperor's forays into imperial self-congratulation. It's not as big as the more famous Arc de Triomphe at the far end of the Champs-Élysées, but it does serve more appropriately as a portal—in this case, to the exquisite Tuilieries gardens. André Le Nôtre, the seventeenth-century's master landscape architect, here created a perfect example of the formal, geometrically precise French garden aesthetic. Less formal, of course, are the lazing throngs of Parisians who take in the sun around the Tuileries' ornamental pools on a warm summer day.

The gardens were originally an adjunct to the seventeenth-century Tuileries Palace, which survived the Revolution but was burned during that next great egalitarian uprising, the Paris Commune, which ruled the city for two tumultuous months following France's defeat in the Franco-Prussian War. Fortunately, the communards spared two later additions to the Tuileries site, Napoléon III's 1851 indoor royal tennis (*jeu de paume*) court and 1852 orangerie, where citrus trees were grown indoors. The twin structures today serve as museums, the former housing rotating exhibits of contemporary art and photography, and the latter as a setting for the splendid *Nymphéas* panels of water lilies donated to the state by Claude Monet in 1922. Monet's water lilies, along with an impressive collection of canvases by Matisse, Renoir, Cézanne, Picasso, and other nineteenth- and twentieth-century masters, have unfortunately been kept from view in recent years because of delays in renovations caused by the discovery of portions of the city's medieval walls.

Beyond the Tuileries, a 3,300-year-old obelisk, an 1829 gift from the Viceroy of Egypt, rises from the Place de la Concorde. The Place got its placid name some 40 years after it played a

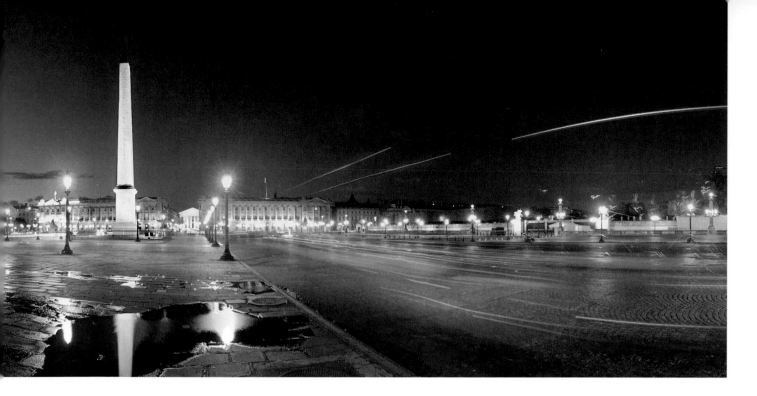

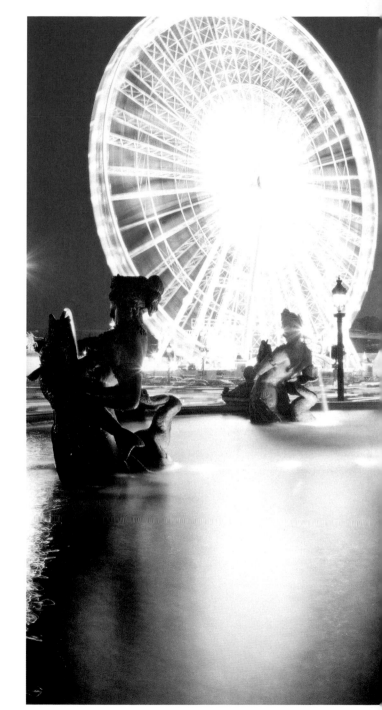

horrific role as the site of some 2,000 executions by guillotine in the days of the Terror. King Louis XVI and his queen, Marie Antoinette, were both beheaded there.

Stately rue Royale leads directly from Place de la Concorde to the church of Ste-Marie-Madeleine, which spectacularly reflects the turns Parisian history can take within the time span of a single construction project. Work on the Madeleine began in 1764 but was stopped during the Revolution, with only the foundations finished; when Napoléon resumed construction in 1806, he decided that instead of a church, the building would be a temple dedicated to the glory of his armies—and, of course, to him. By the time it was finished in 1842, the Madeleine was a church once again, after nearly becoming a railway terminal. What does survive from the Napoleonic period is the Parthenon-like Neoclassical exterior, dominated by 52 65-foot columns, and an interior that many critics consider somber and overwrought, but which is nevertheless popular for high-profile weddings.

The Place de la Concorde marks the beginning of the most famous of Parisian boulevards, the Avenue des Champs-Élysées. For generations, foreigners dreaming of Paris have imagined themselves lounging smartly at outdoor cafés on the Champs-Élysées, seeing and being seen. Thanks to a 1990s renewal program, the old boulevard is again worthy of such daydreams, following years of drab commercialization. And it culminates at that monument to French glory, the Arc de Triomphe, finished long after Napoléon dedicated it to his own *triomphes*. The Arch stands in a place named for France's greatest modern hero, Charles de Gaulle.

One look at a map will easily show why Place de Gaulle was originally named Place d'Étoile: Baron Haussmann's broad avenues radiate from the Arc like 12 points of a star, (*étoile*). For a quick respite from all this formal geometry, though, follow Avenue Hoche northeast from Place de Gaulle to Parc Monceau, an island of informal landscaping in the heart of the city.

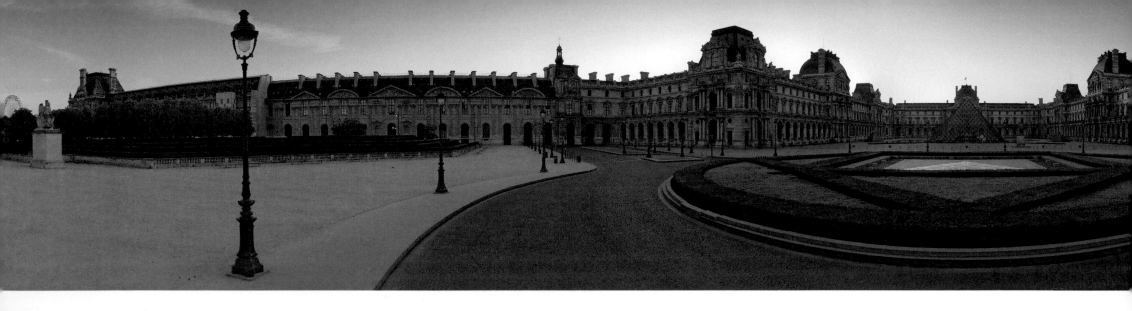

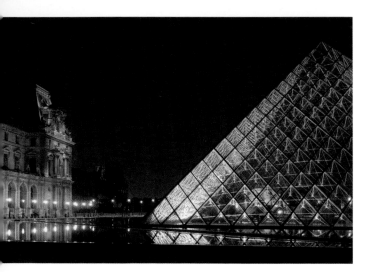

The park was begun in 1769 by Phillippe d'Orléans, Duke of Chartres, an anglophile who wanted to create a naturalistic, English-style garden. He succeeded with curved walkways and randomly placed statues, and added a quirky collection of small-scale architectural follies, including a pyramid, a Dutch windmill, and Corinthian pillars. The park became public after the duke was guillotined during the Revolution, and has long been popular with children and with adults such as Claude Monet, who portrayed it on canvas.

North of Place de la Concorde, Place Vendôme stands at the heart of fashionable Paris. Originally a setting for an equestrian statue of Louis XIV and named Place Louis-le-Grande, the square (actually an octagon) now takes its name from the Hôtel Vendôme, an adjacent aristocratic residence designed by the great seventeenth-century architect Jules Hardouin-Mansart. Place Vendôme's chief ornaments today—aside from the Trajanesque victory column Napoléon erected in Louis' place—are the famed Ritz Hotel and the shops of ultra-luxe jewelers and couturiers such as Cartier, Bulgari, and Dior. Chanel, perhaps the most famous purveyor of Parisian high fashion, occupies eighteenth-century quarters on rue Cambon, between the Madeleine and Place Vendôme.

Paris's most extravagant Second Empire confection stands just north of Place Vendôme, by way of the rue de la Paix. This is the Paris Opéra, now called the Opéra Garnier after its architect, Charles Garnier, to distinguish it from the 1989 Opéra Bastille. With no surface left undecorated, Garnier's building has been called "a triumph of molded pastry"—and as such, it is a monument to an era that celebrated splendid excess. Its architecture falls generally within the realm of Beaux-Arts, that Renaissance- and Baroque-influenced trend favored by late nineteenth-century tastemakers trained in the academic tradition. But the flattery-minded Garnier aptly described it to his patron as being in the "Napoléon III style."

Two other cultural landmarks that grace the Right Bank are the Bibliothèque Nationale and the Comedie-Française, both just north of the Louvre. As the longtime national library, the Bibliothèque once housed every book published in France since 1500. Most have now been moved to a newer facility, but the handsome old edifice still exhibits a Charlemagne Bible and volumes that belonged to some of France's greatest writers.

The Palais-Royal was begun in 1624 as the sumptuous home of prelate-statesman Cardinal Richelieu. It acquired its royal designation when, in 1642, it became the residence of the boy prince who ascended the throne a year later as Louis XIV. Just

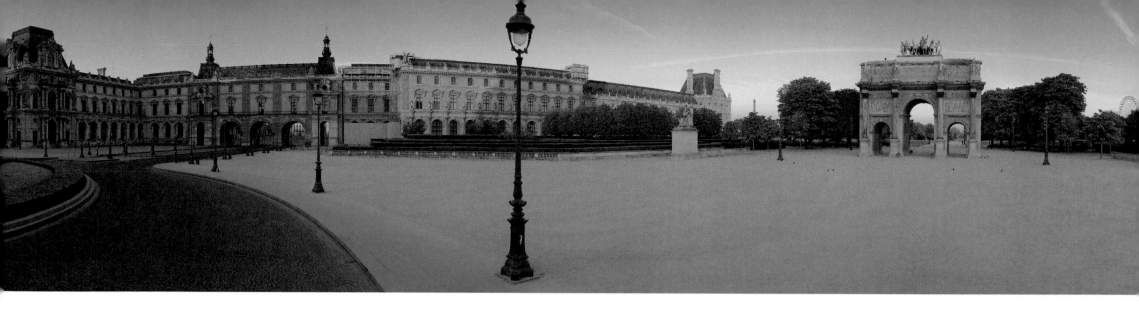

prior to the Revolution it was given a courtyard and wraparound arcades by Philip, Duke of Orléans, and the shops, restaurants, and casinos within the arcades were popular gathering places during the Napoleonic era. Since 1986, the suave formality of the palace's façade has been echoed in the precise arrangement of 250 black-and-white-striped columns, none more than a few feet tall, installed in the courtyard by conceptual artist Daniel Buren.

Slightly east of the Bibliothèque and the Palais-Royal, the Place des Victoires serves as a setting for a bronze equestrian statue of Louis XIV. The *place*—another of Jules Mansart's commissions from his patron the Sun King—is enclosed today by boutiques bearing the names of some of France's most renowned designers. The great Louis, lover of finery that he was, would surely have approved.

Hardly anyone except city planners approved of the demolition of the great iron arcades that sheltered Les Halles, farther east beyond Place des Victoires. From 1183 until 1969, Les Halles was the city's principal food market, where homeward-bound nightclubbers used to rub elbows with butchers and greengrocers over 3:00 a.m. bowls of onion soup. A vast shopping mall has taken the place of the old market, a picturesque vestige of which lingers in the food shops and cafés of nearby rue Montorgueil.

Opposite the beginning of that narrow pedestrian street stands a lovely foil to the old workaday neighborhood of Les Halles. The church of St-Eustache might at first seem reminiscent of Notre-Dame, with its flying buttresses, but the overall spirit is Renaissance—construction took place between 1532 and 1637. After a revolutionary-era stint as a "temple of agriculture," St-Eustache fell back into the Catholic fold. Its gargantuan pipe organ, once played by Liszt and Berlioz, is still in regular concert use.

A stroller heading south from St-Eustache can opt for a historic route from the Right Bank to the Left, by way of the rue du Pont Neuf. This elegantly simple structure, one of the city's first forays into the classical revival, was the first Seine crossing to be built without houses on it—a novel idea at the beginning of the seventeenth century.

The pedestrian who remains on the Right Bank and continues east, though, will soon enter one of Paris's most distinctive urban "villages," the sprawling Marais. Perhaps more than any other Parisian neighborhood, this onetime marshland represents the continual turnaround in fashion that has always characterized the city's inner quarters. Before the expulsions of the Middle Ages, the Marais was Paris's main Jewish quarter. Jews began returning to the area during the eighteenth century,

(ABOVE)

LEAVING HIS MARK

Flamboyant Napoléon III, the last monarch to rule France, was one of a long line of kings, emperors, and presidents to put his stamp on the vast complex of the Louvre.

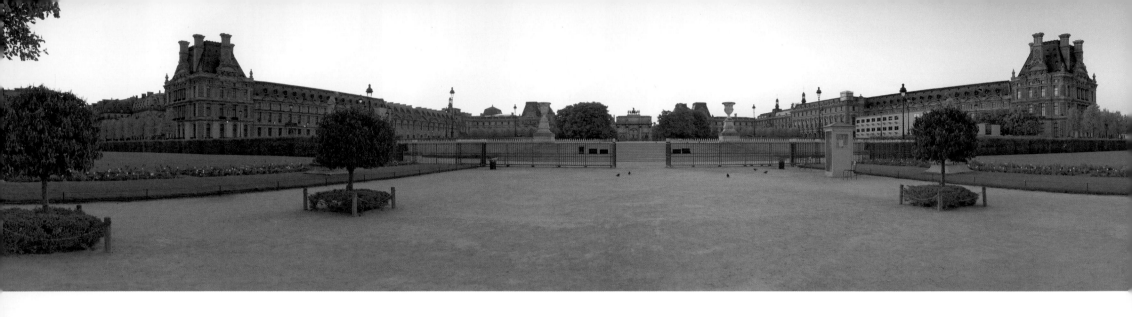

A LONG ALLÉE
French garden design, as exemplified here in the Tuileries, emphasizes long, arrow-straight sight lines—even if the alignment is with the sightless eyes of statuary.

and especially after they were granted full French citizenship in the aftermath of the Revolution. Today, the Marais harbors the fine Museum of Jewish Art and History in the Hôtel de St-Aignan on rue du Temple, and the post–World War II monument to the Unknown Jewish Martyr near the Seine.

Beginning in 1609 when Henry IV centered his court upon the Place des Vosges (then Place Royale), noble families outdid each other in the construction of elegant hotels throughout the Marais. Many of these fine old residences are today home to museums and civic institutions. On the western fringe of the neighborhood, the Baroque church of St-Gervais-St-Protais occupies the site of Christian houses of worship dating to the fourth century C.E. The present structure, completed about 1620, looms large in French musical history: for 173 years, its organists were members of the Couperin family, including composer François Couperin. The fine instrument so familiar to the Couperins is still in use for concerts and at masses—but it was abruptly silenced during one such service in March of 1918, when a German shell crashed through the roof and killed 100 parishioners.

The Hôtel de Sens, one of Paris's scant few medieval dwellings, houses a historical and fine arts library beneath its steep turrets. A toy castle in the city's midst, the hotel harks

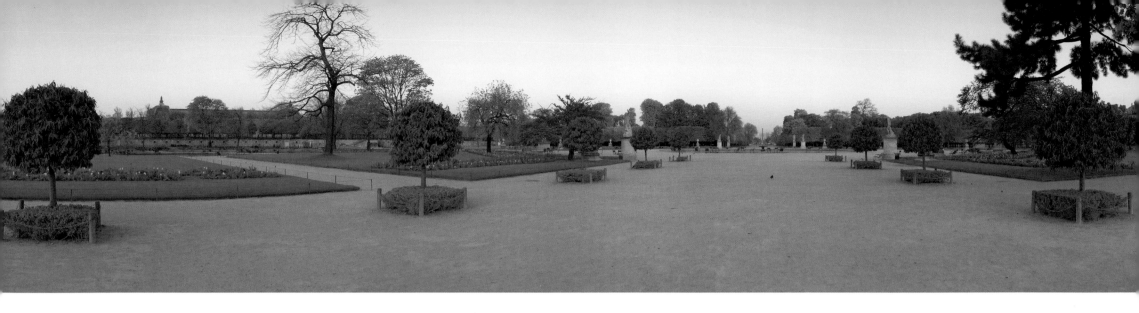

back to the days, before Haussmann and his boulevards, when the heart of the capital was a shadowy tangle of narrow streets and alleyways. The Hôtel de Sully and Hôtel de Beauvais—the latter built by one of Louis XIV's mistresses—are among the finer local reminders of the Sun King's heyday, while the history of Paris from Roman times to the present is chronicled at the magnificent sixteenth-century Hôtel Carnavalet. And two of the capital's most celebrated cultural lions, Victor Hugo and Pablo Picasso, are honored in a pair of classic hotels. The Maison de Victor Hugo was, in fact, the writer's residence, and stands today as a museum containing many of his personal effects. Picasso never lived in the magnificent seventeenth-century Hôtel Salé, the mansion that houses his museum. In lieu of the painter's shade, though, the museum possesses a spectacular collection of his paintings, sculptures, and drawings.

The Marais fell on hard times when fashion dictated a move to more westerly parts of the city. It became a shabby district of laborers and small tradesmen, forgotten by Paris's waves of urban renewal. Substantial portions even lacked running water as recently as the 1950s. But in 1962, federal minister of culture André Malraux targeted the area for redevelopment. Over the next 30 years, the Marais acquired not only the necessities of modern life, but a cachet as a hip urban frontier.

Today, it's a polyglot of clubs and cafés, pricey apartments, and a lively gay scene.

No ramble through the "villages" within Paris would be complete without the uphill climb to Montmartre, north of the Right Bank proper. A semirural outpost of farms, vineyards, and windmills well into the nineteenth century, Montmartre has since become one of those Parisian neighborhoods most likely to supply a mind's-eye image of the city for millions who have never been there. That image might be of Utrillo painting streetscapes when this was a true artists' quarter, of risqué floor shows at the Moulin Rouge, or of soldiers on leave cruising Place Pigalle. Like most clichés, all of these pictures are rooted in reality—but just as real are the quiet, obscure, and thoroughly respectable side streets of Montmartre, grown out of country lanes, or the working vineyard that still yields wine near the timeworn café (and haunt of Renoir and Picasso) Au Lapin Agile. Over all, and literally over all of Paris, hover the egglike domes of Sacrè-Coeur. The church has been here only since 1914, and its neo-Byzantine architecture has been a topic of continuing controversy. But it is the snowy white exclamation point to the vast panoply of state, of church, and of busy humanity that is the Right Bank of the Seine.

(ABOVE)

IN THE FRENCH MANNER

The Renaissance façades of the Louvre seen from the Garden of the Tuileries, with the Arc de Triomphe du Carrousel in the center distance. The Tuileries gardens, adjunct to a now-vanished palace, typify the French approach to landscape architecture as a rigorous re-ordering of nature. The gardens were restored during the 1990s, to André Le Nôtre's original design.

(PAGES 52–53)

URBAN HARMONY

Looking across the Garden of the Tuileries to the rue de Rivoli, one of the grand boulevards dating to Napoléon III's massive urban renewal project. The cool symmetry of Le Nôtre's garden design is reflected in the adjacent residences.

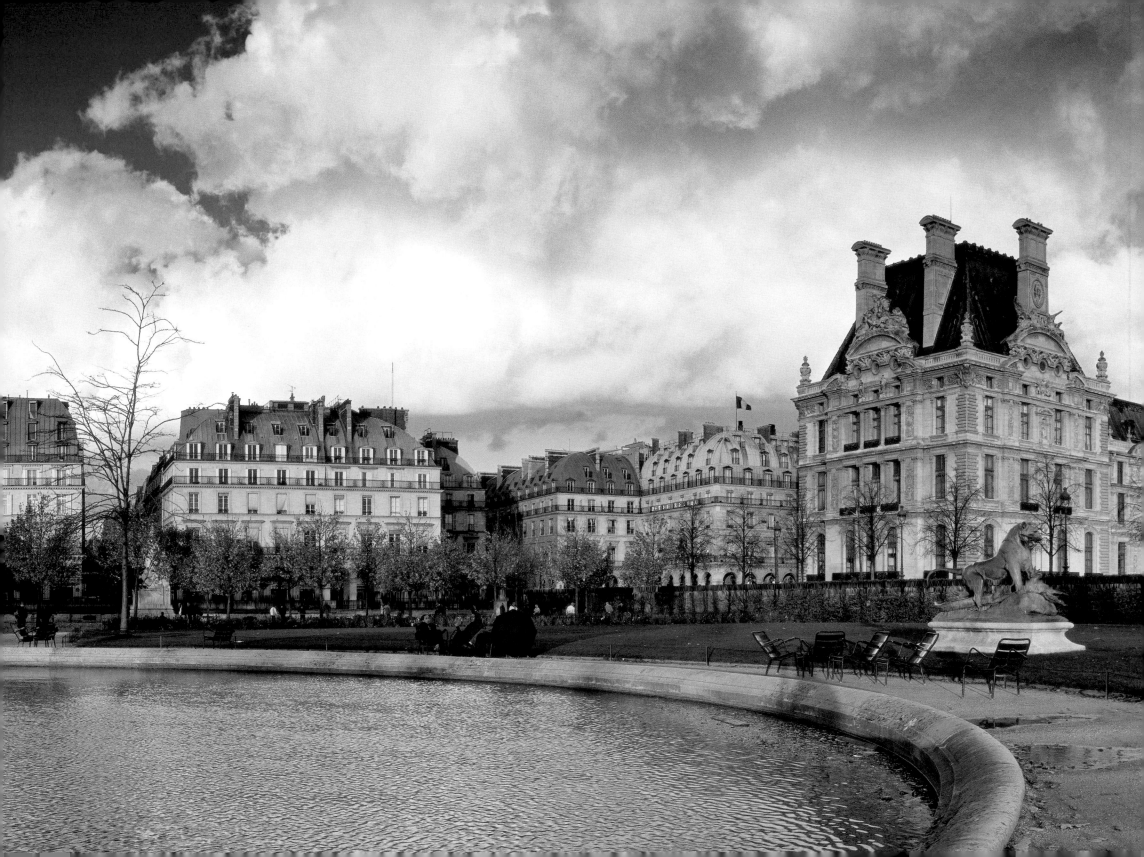

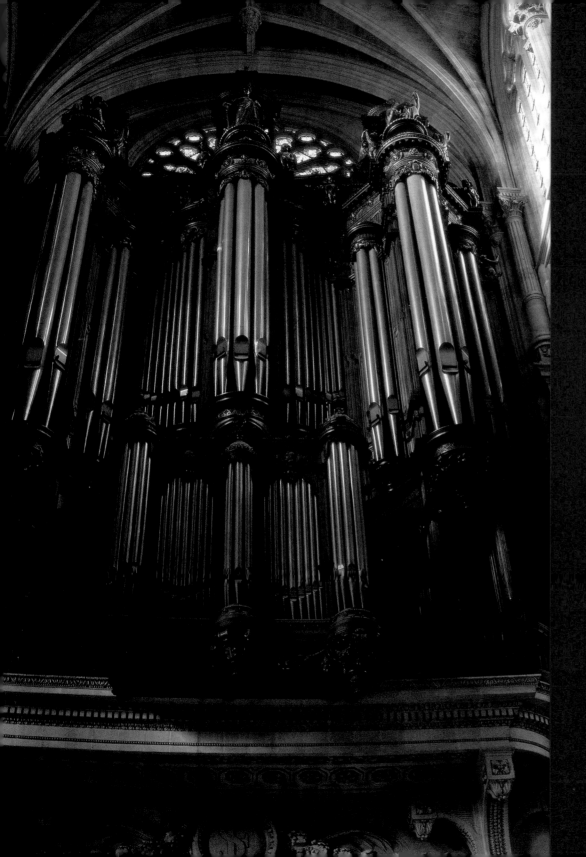

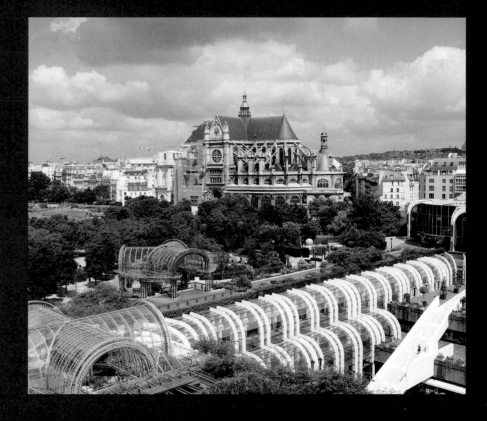

(PAGES 54–56)	(ABOVE)	(PAGES 58–59)
ECHOES OF GENIUS	**URBAN RENEWAL**	**CHIC ADDRESS**
Listz and Berlioz were two of the master organists who performed ̶r̶e̶c̶i̶t̶a̶l̶s̶ ̶i̶n̶ ̶t̶h̶e̶ the Right Bank church of St-Eustache.	The church of St-Eustache looms over a transformed neighborhood, ̶o̶n̶c̶e̶ ̶h̶o̶m̶e̶ ̶t̶o̶ ̶t̶h̶e̶ ̶l̶a̶r̶g̶e̶ ̶f̶o̶o̶d̶ markets of Les Halles but now dominated by a modern shopping complex.	The Place des Vosges, surrounded by 36 arcaded townhouses, is one of Paris's most prestigious places to live. Mozart gave his first recital here, and Victor Hugo lived in a corner of the square.

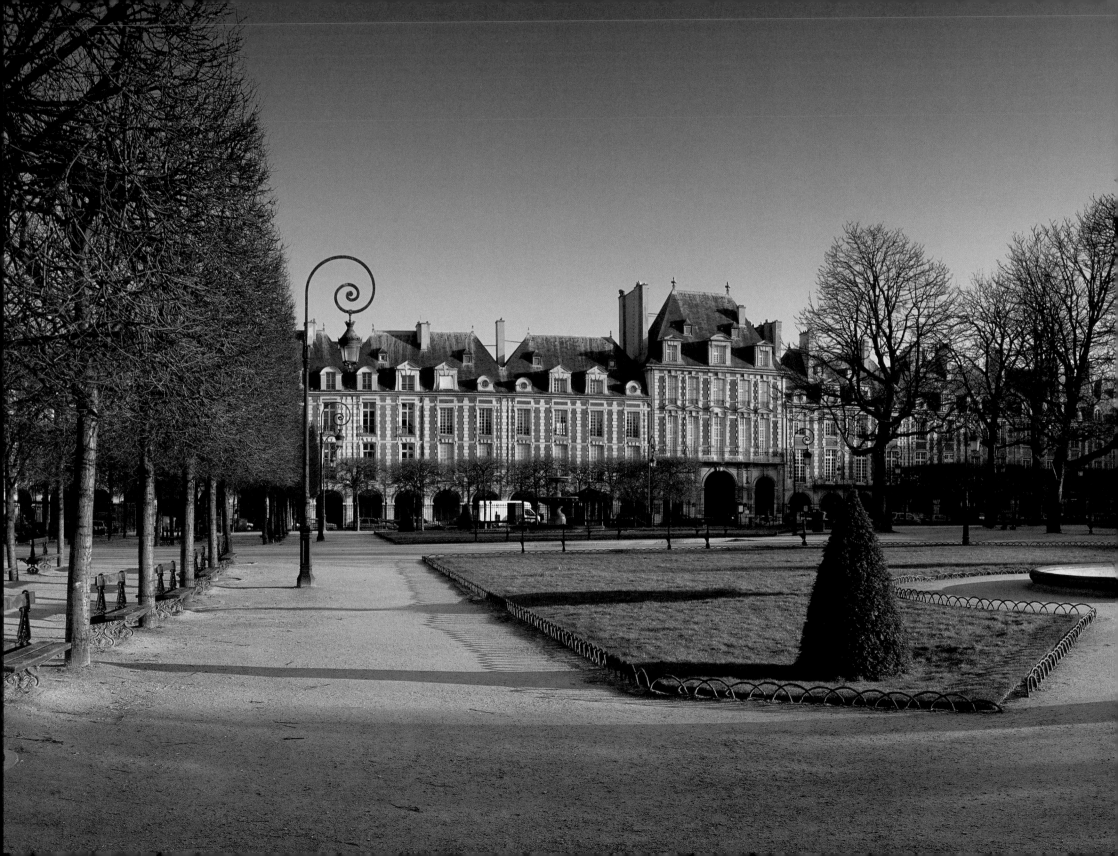

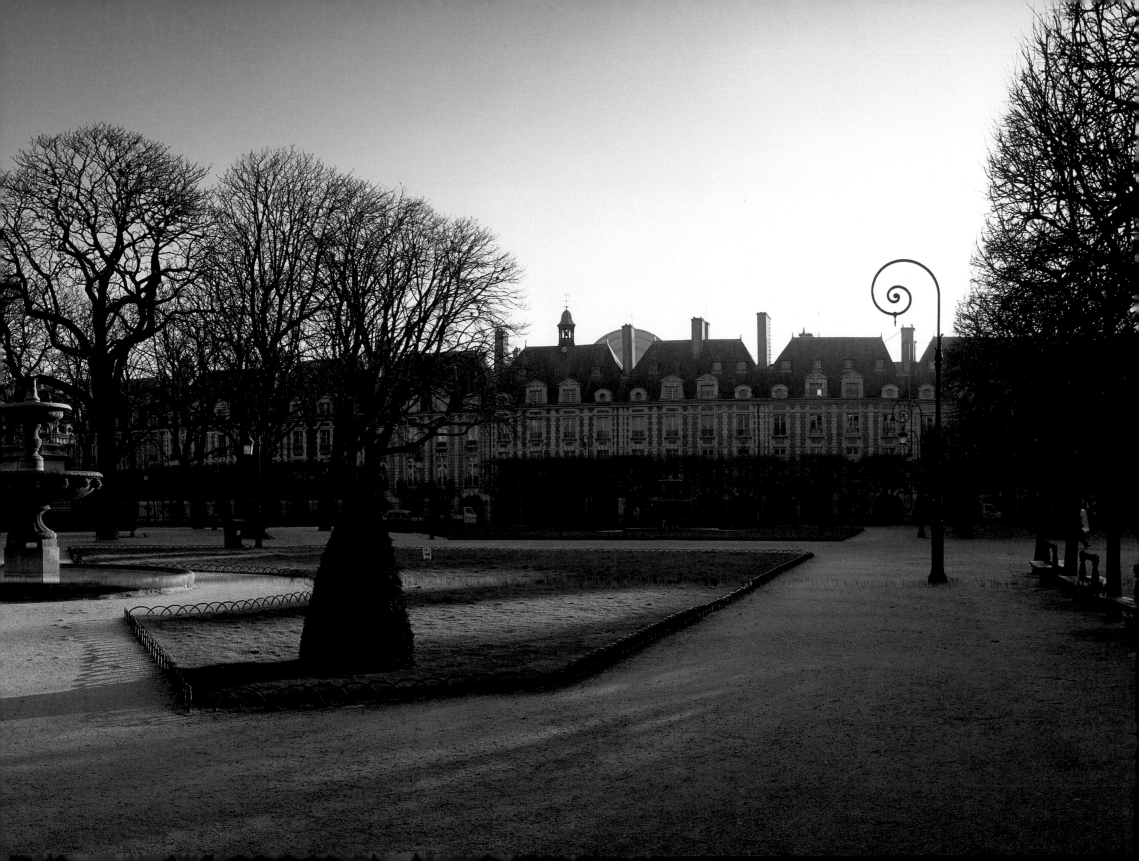

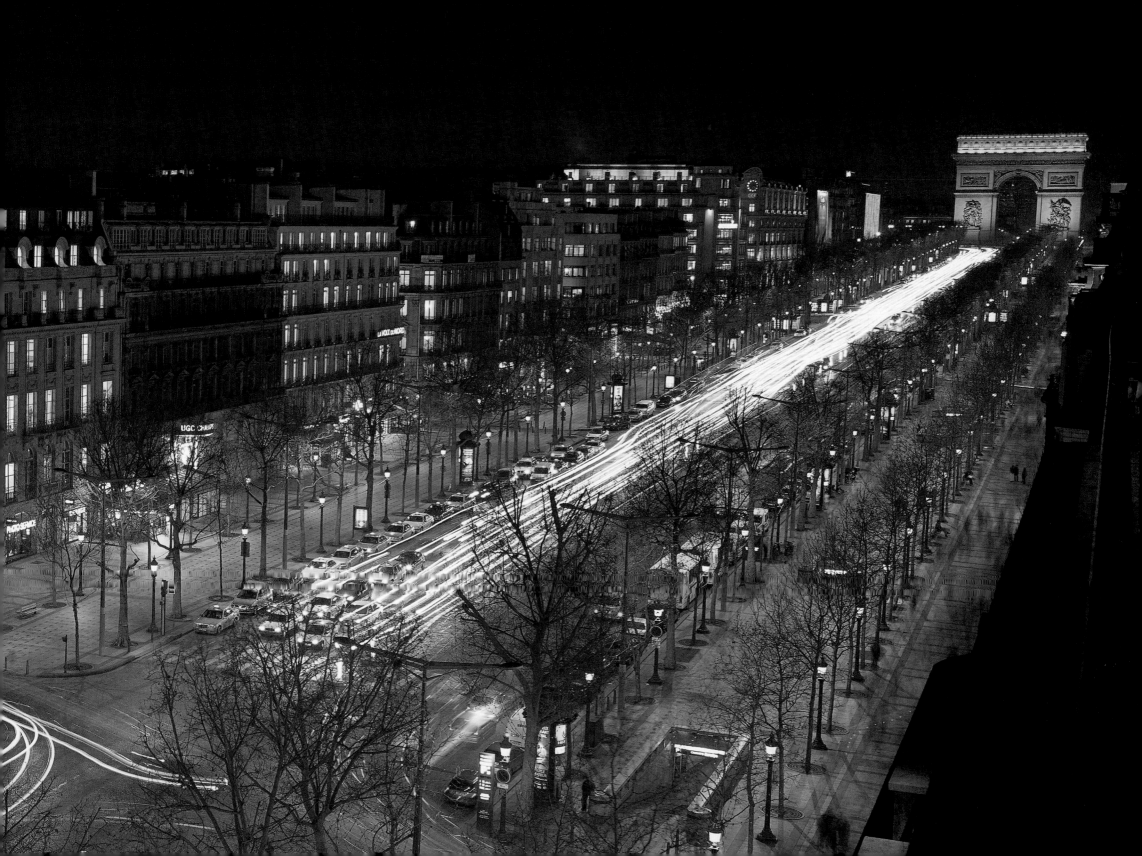

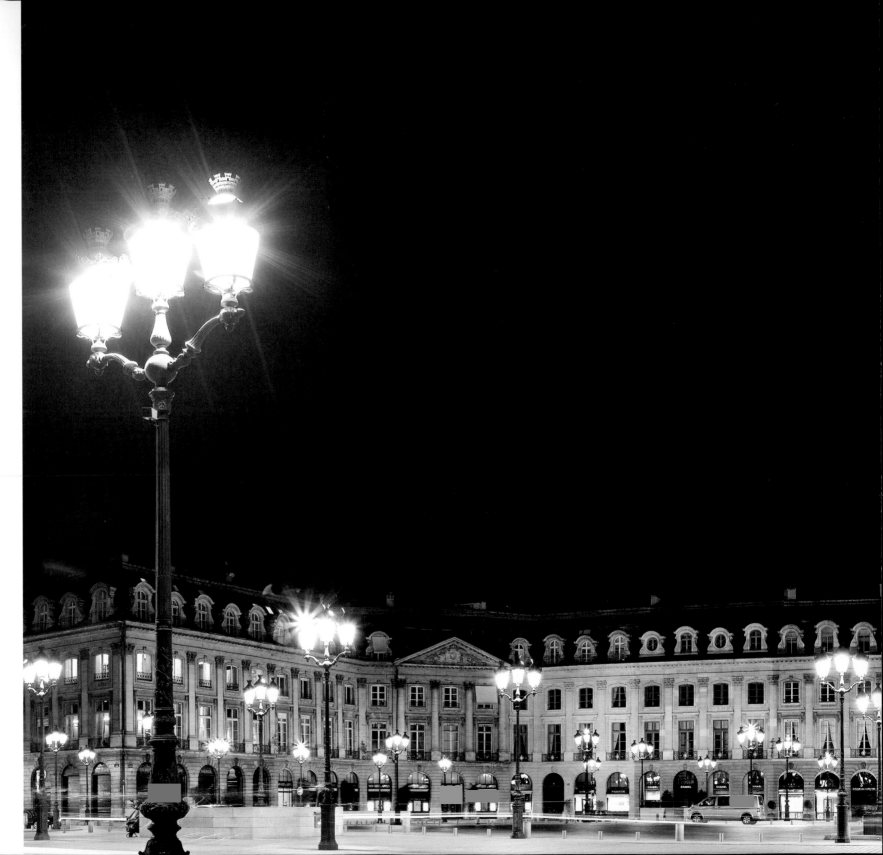

(PAGES 60–61)

Paris's Main Street

The Avenue des Champs-Élysées, the most famous of Parisian boulevards, was first laid out by André Le Nôtre in the 1600s, but was expanded to its present stately proportions with the completion of the Arc de Triomphe in 1836.

(RIGHT)

Opulent Square

Centered around a column erected by Napoléon to celebrate his victory at the battle of Austerlitz, fashionable Place Vendôme now seems more a monument to luxury than conquest. Anchored by the Ritz Hotel, the square brims with exclusive boutiques.

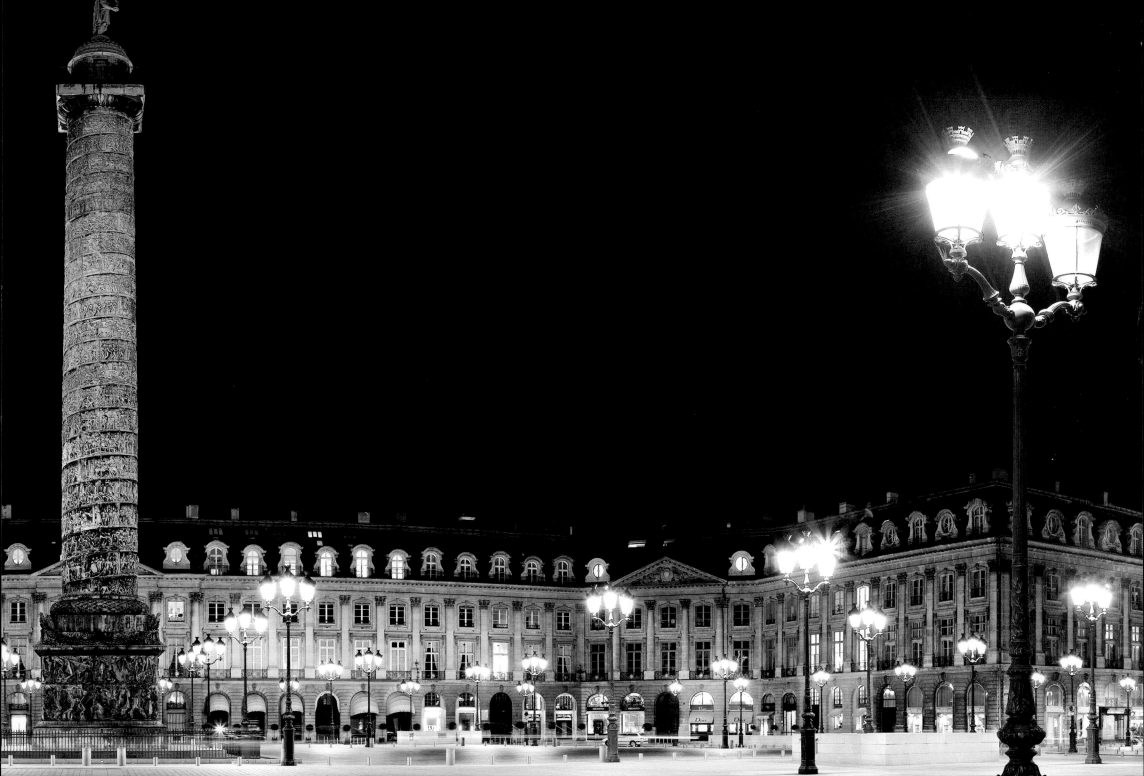

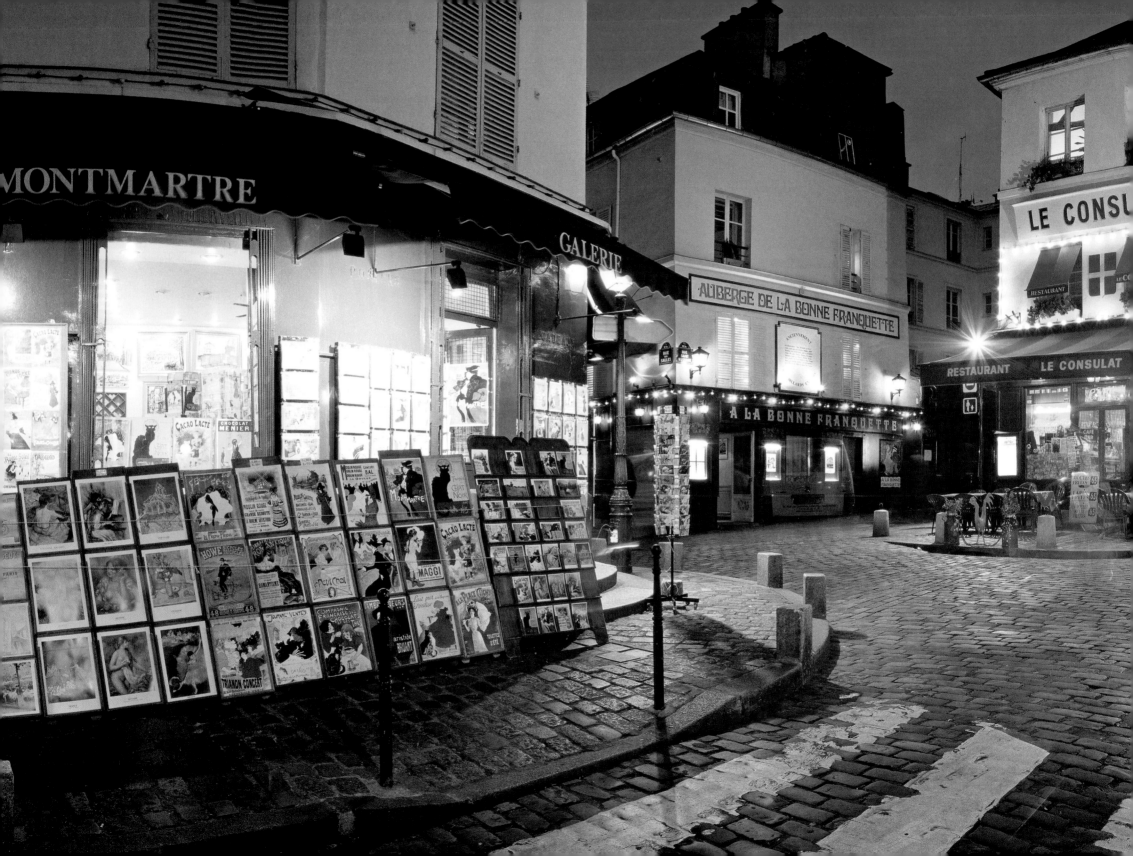

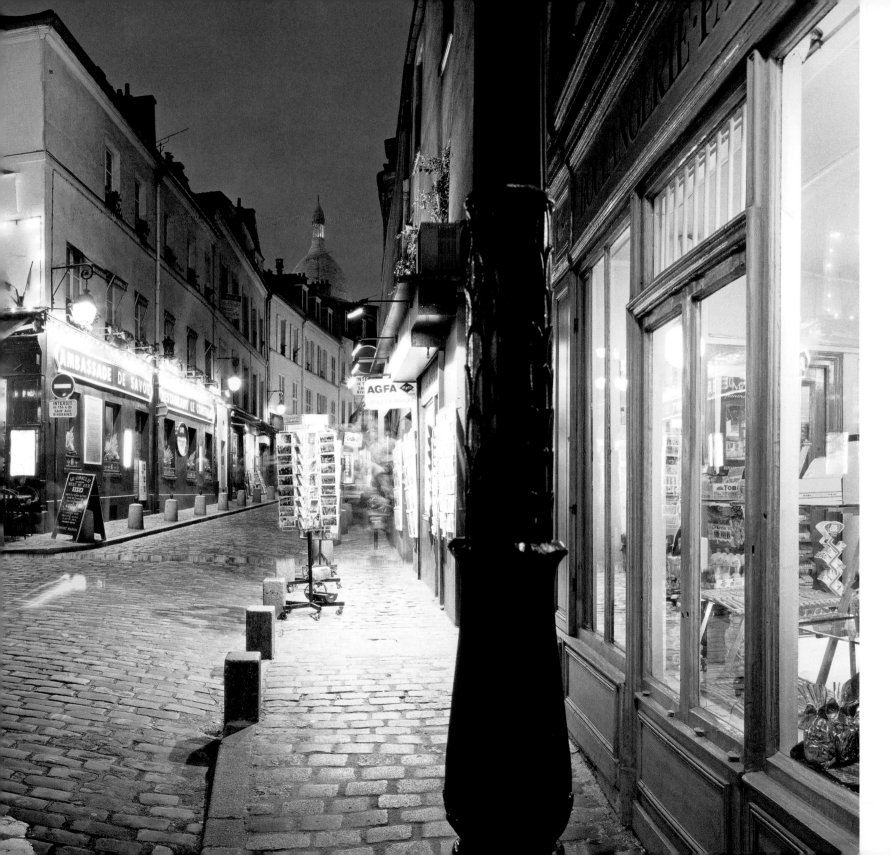

(LEFT)

ENDURING ATTRACTION
Reproductions of posters by
Toulouse-Lautrec and other *belle
époque* artists crowd a street corner
in Montmartre, attesting to the
neighborhood's popularity with
tourists. Despite its raffish image,
Montmartre still contains quiet
residential areas.

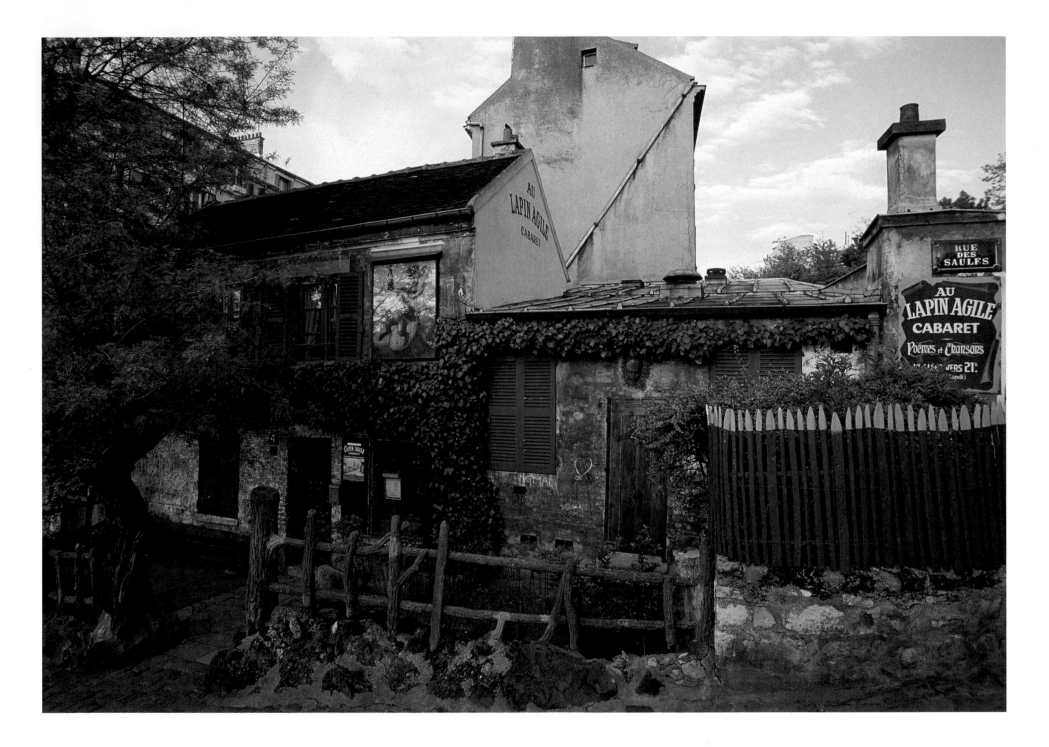

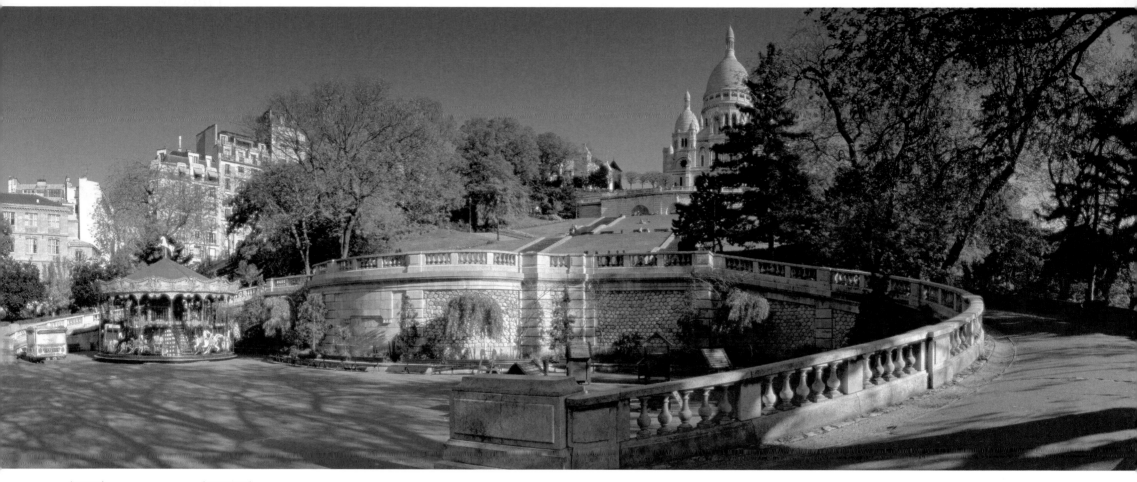

(ABOVE)

PINNACLE OF MONTMARTRE

Begun in 1875 and not completed
until 1914, the church of Sacré-
Coeur is approached by terraced
Square Willette or by an adjacent
funicular. A climb to the dome
offers Parisian panoramas excelled
only by the Eiffel Tower.

(OPPOSITE)

RUSTIC SURVIVOR

Au Lapin Agile, a Montmartre
cabaret frequented by avant-garde
artists and writers a century ago,
still offers evening entertainment.
The setting is a reminder that
Montmartre was once a country
village on the capital's outskirts.

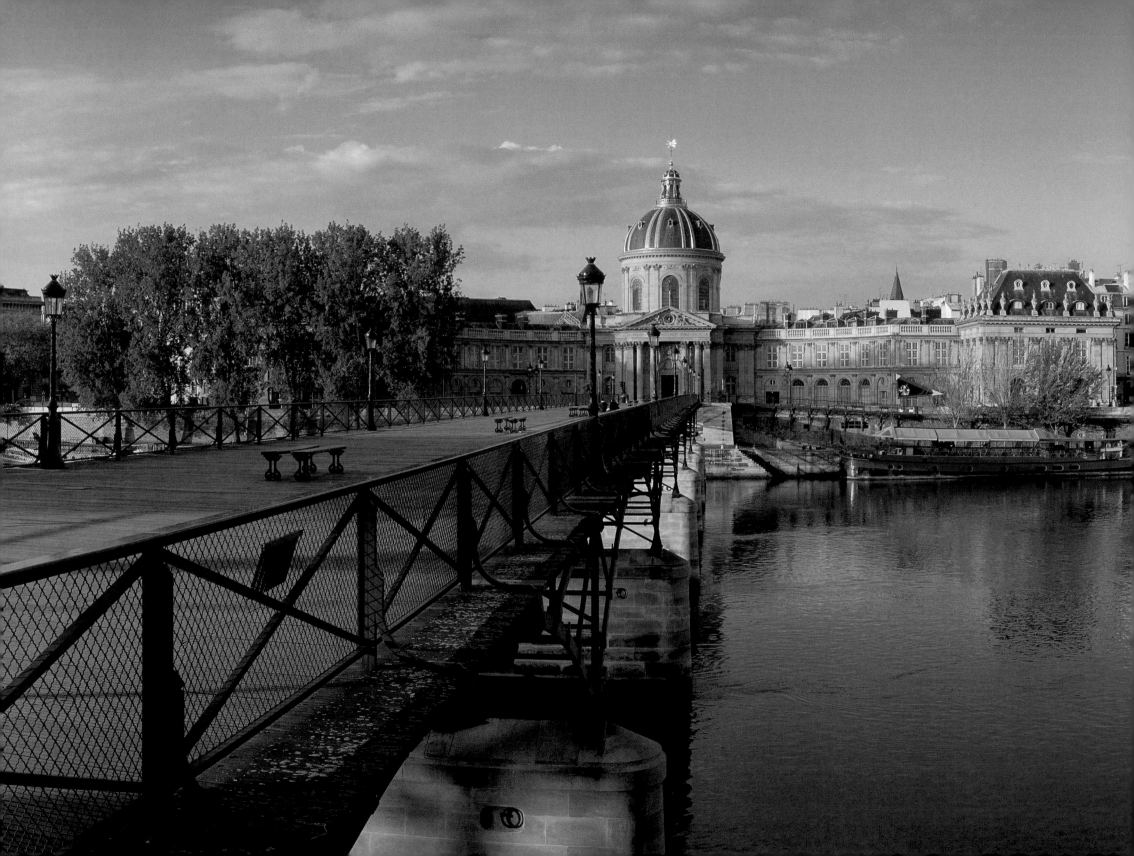

THE LEFT BANK

IN THE popular imagination, the Left Bank of the Seine is the Paris of scholars and bohemians, writers and philosophers. No matter that today's Left Bank can be every bit as chic and expensive as fashionable *arrondissements* elsewhere in the capital: for outsiders and for more than a few Parisians, the neighborhoods south of the Seine summon images of the fractious students of 1968, of nicotine-fueled existentialists leaning on the words of Jean-Paul Sartre at the Café de Flore, and, perhaps most vivid for Americans, of what Gertrude Stein called the "Lost Generation" of expatriate writers, artists, and hangers-on. One member of that generation that looms far larger than the rest was a young newspaper stringer who rented his first Paris apartment at 74 rue du Cardinal Lemoine, haunted the bookshop Shakespeare and Company, and frequented cafés called the Select and the Dome. When Ernest Hemingway wrote that Paris was a "moveable feast," he was remembering his days on the Left Bank.

Hemingway and Sartre may be long gone, but the students—still sometimes quite fractious—remain, at the institution that first put the Left Bank on the intellectual map of Europe. In 1253 Robert de Sorbon, confessor to King (later Saint) Louis IX, was granted the right to establish a school of theology in crown-owned buildings just south of the Seine. The Sorbonne, as it has since been known, became one of the first important colleges of the University of Paris, founded more than a century earlier as an outgrowth of the cathedral school of Notre-Dame. Today, three of the universities into which the University of Paris was divided in 1970 use "Sorbonne" in their name, and four share the old campus on rue des Écoles in the Left Bank's Latin Quarter. Latin, of course, was the language of scholarship in the Middle Ages; hence the name for the neighborhood where it was then spoken freely.

Most of the Sorbonne campus dates from the late nineteenth century, although one outstanding survivor of the destruction that took place during the Revolution is the Richelieu chapel, part of the cardinal's building campaign of 1627–1642. Sorbonne alumnus Richelieu lies in a marble tomb within the chapel, which faces the campus's main courtyard.

Across the rue des Écoles from the Sorbonne stands the Hôtel de Cluny, built toward the end of the fifteenth century and once home to the Benedictine abbots of Cluny. As the National Museum of the Middle Ages, the flamboyantly Gothic hotel displays a splendid collection of medieval art and artifacts, most notably religious furnishings and sculptures that escaped the anticlerical vandalism of the Revolution and the Commune. Outstanding are the 21 heads of the kings of Judah, sculpted for Notre-Dame in 1220 but broken from the cathedral walls. The heads were secretly buried by a royal sympathizer and were found accidentally in 1977 during construction work on a Paris street. The prize of the collection, though, is the series of six

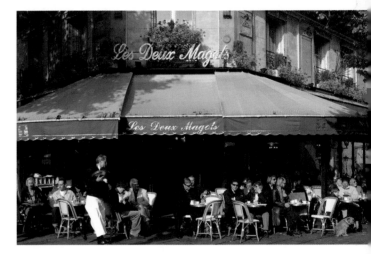

(ABOVE)
LITERARY LEGEND
Left Bank cafés such as Les Deux Magots are a perennial destination for literary pilgrims. The Dome, the Select, the Rotonde, the Flore—all enjoyed a heyday as haunts of renowned twentieth-century writers.

(OPPOSITE)
PEDESTRIAN SPAN
Linking the Right and Left Banks of the Seine between the Louvre and the Institut de France (shown), the Pont des Arts carries foot traffic above a graceful tracery of iron arches.

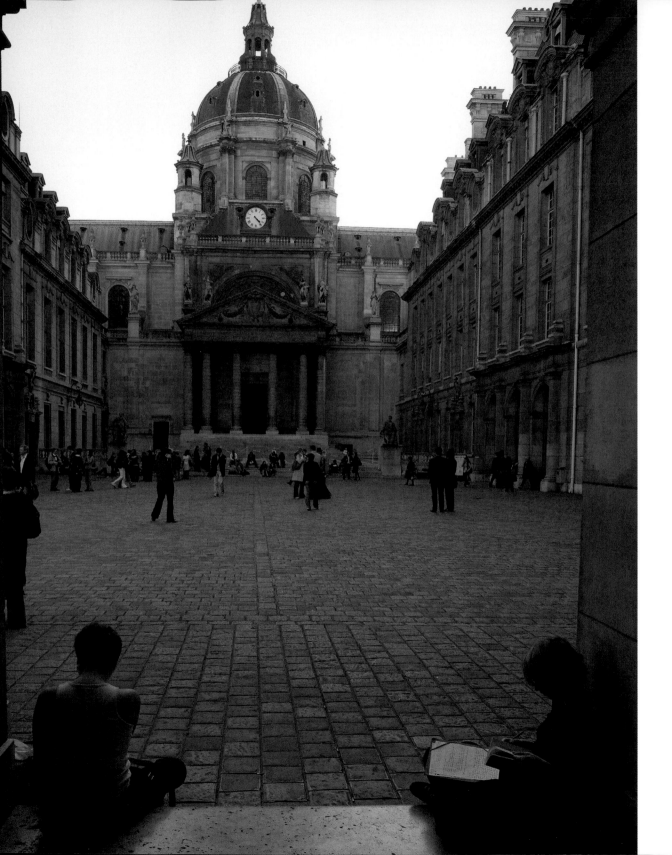

exquisite tapestries called *The Lady and the Unicorn*, woven prior to 1500 and representing an allegory of spiritual triumph over worldly things.

The sacred and the secular vie for attention in a pair of buildings on a hilltop just east of the Sorbonne. The church of St-Étienne-du-Mont, dating to 1225 but rebuilt in 1492, contains the tomb of St. Genevieve, patron saint of Paris. When Attila the Hun threatened the city in 451 C.E., Genevieve is said to have rallied the population to prayer; the Huns subsequently circumvented the city and were soon defeated in battle. The far more imposing structure that shares the Left Bank's highest point is the Panthéon, modeled after the eponymous Roman temple and intended by Louis XV to be a church honoring St. Genevieve. Completed during the reign of his doomed successor, Louis XVI, the domed, rigorously Neoclassical structure appealed to the revolutionaries' republican mindset; they rededicated it as a secular "panthéon" to their heroes, and so it came to be the resting place of Voltaire and Rousseau. At various times restored to use as a church, it has since 1885 been the tomb of, and temple to, France's most illustrious sons and daughters. Victor Hugo, Émile Zola, Pierre and Marie Curie, and the World War II Resistance leader Jean Moulin are all interred there.

Paris is a city of spacious public parks, most exemplifying the French tradition of formal, geometrically precise landscape architecture. Like the gardens of the Tuileries on the Right Bank, the Left Bank's Luxembourg gardens are a legacy of aristocratic luxury. This roughly 40-acre greenspace was originally the grounds of the Luxembourg Palace, begun in 1615 for Marie de Médicis, widow of assassinated King Henry IV. Modeled on the Pitti Palace in Marie's native Florence, and built on the site of a town home belonging to the Duke of

Luxembourg, the palace today is the seat of the French Senate. The gardens belong to the people of Paris, who take great pleasure in their meandering walkways, 200 varieties of trees, tennis courts, and lake dotted with children's sailboats. At least one American expatriate found a more prosaic use for the park: Ernest Hemingway claimed that during his penniless early days in Paris, he stealthily crept up on Luxembourg pigeons, and added squab to the meager fare at his flat on rue du Cardinal Lemoine.

Had Hemingway been a herbivore, he might have ventured farther east to surreptitiously stock his larder. The Jardin des Plantes, a botanical garden dating to the early seventeenth century (medicinal herbs were raised here for Louis XIII), contains thousands of living specimens within its nearly 70 acres of outdoor plantings and greenhouses. On the grounds are a maze, a zoo, flower-lined promenades, and a museum of natural history that incorporates the impressively comprehensive Grand Gallery of Evolution.

With the same zeal with which Enlightenment naturalists assembled and preserved their specimens of the natural world, French intellectuals of the same era sought to husband the nation's cultural and linguistic heritage. On Quai de Conti stands the Institut de France, seat of the Académie Française, since 1635 the guardian of the French language and arbiter of entries into its official dictionary. The Institut, housed in a 1688 Baroque edifice designed by Le Vau, also incorporates the Academy of Sciences, as well as France's first public library, the Bibliothèque Mazarine. The library, which counts among its treasures 12 notebooks of Leonardo da Vinci, opened in 1643 and was built around the collection of Cardinal Mazarin, effective ruler of France during Louis XIV's minority.

(ABOVE)

LIVING MUSEUM
The 70-acre Jardin des Plantes dates to the earliest days of modern botany. A false-acacia planted here in 1635 is considered to be the oldest tree in Paris.

(OPPOSITE)

ANCIENT REALM OF SCHOLARSHIP
Its name nearly synonymous with the University of Paris, of which it is a component, the Sorbonne helped give the name "Latin Quarter"—after the language of medieval scholars—to its portion of the Left Bank.

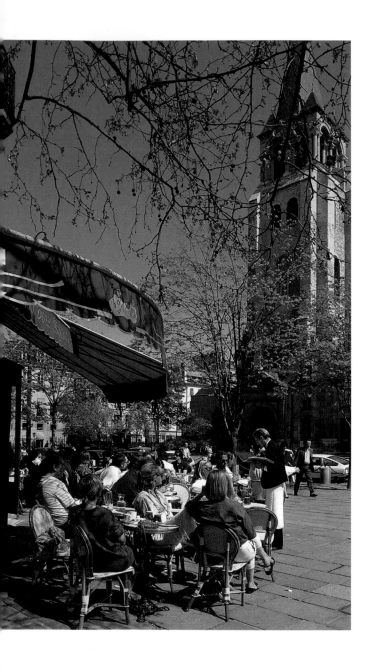

Young Louis, a sun king even in his dawning years, had a special duty to perform in 1645. At the age of seven, he laid the cornerstone for the church of Val-de-Grâce, three blocks south of the Luxembourg gardens. The church, which remains Paris's best example of Baroque architecture, was built by his mother, Anne of Austria, in gratitude to the Blessed Virgin Mary. The Virgin had appeared to a Parisian monk and predicted that the 36-year-old Anne—still a childless queen—would safely deliver an heir to the throne of France. Louis, destined to become the greatest of French monarchs, was born in 1638.

A chapel within Val-de-Grâce once contained the urns that held the hearts of France's kings. Transferred to a different church in 1696, the desiccated organs—the Sun King's among them—were ground into painters' pigment during the Revolution.

Paris's oldest church is St-Germain-des-Prés, on Boulevard St-Germain several blocks south of the Institut de France. It stands on the site of a sixth-century basilica and is named after St. Germain, an early cardinal of Paris. The present church dates to about the year 1000, but its appearance is anything but the classic Romanesque of that era—the choir was added in 1163 and the cloister nearly a century later, with further improvements in the 1360s. Then, like so many of the capital's ecclesiastical structures, St-Germain was all but razed during the Revolution. Its restoration was undertaken in the early nineteenth century, and the result is a curious amalgam of historical styles.

Depending on the sort of sustenance desired, a visitor to St-Germain-des-Prés can either cross the square to the café Les Deux Magots, onetime haunt of Picasso, Ezra Pound, John Dos Passos, and other lions of literature and the fine arts in the years between the wars; or turn in the other direction to quickly reach the Musée National Eugène Delacroix, on the fashionable Place de Furstenberg. The great Romantic painter moved here in 1857 when he began painting the murals, including the superb *Jacob Wrestling with The Angel*, at the church of St-Sulpice nearby.

Another artist intimately associated with the Left Bank was Auguste Rodin, who was born in the Latin Quarter in 1840. At the western end of rue de Varenne, the handsome Neoclassical Hôtel Biron was the sculptor's home from 1908 until his death in 1917. Now the Musée Auguste Rodin, the building and its adjacent rose garden display bronze and marble masterpieces including *The Thinker*, *The Burghers of Calais*, *The Kiss*, and many more. Rodin's Impressionist-painter contemporaries are amply represented in the nearby Musée d'Orsay, a former railway station on Quai Anatole France along the Seine. The museum's works by Monet, Manet, Renoir, Cézanne, Van Gogh, and other powerhouses of the movement are of course the main attraction, but the building itself—a gracefully airy *belle époque* construction of iron and glass that was nearly demolished before its transformation into a museum in 1986—is a work of engineering art in its own right.

The dominant landmark of the Left Bank is the Hôtel des Invalides, which belies the modern notion of a military hospital as a nondescript complex set somewhere in the suburbs. Louis XIV did nothing nondescript, and the golden-domed Invalides was his idea of a proper place to house the wounded and retired veterans of his incessant wars. Built between 1671 and 1676 in Classical style, the Invalides and its adjacent structures also did duty as the royal arsenal, and was a ready source for the weapons rioters used to storm the Bastille in 1789. Napoléon, whose campaigns made institutions such as this a grim necessity, ended his own earthly wanderings here in 1840, when his body was placed in an ornate sarcophagus after being sent back from

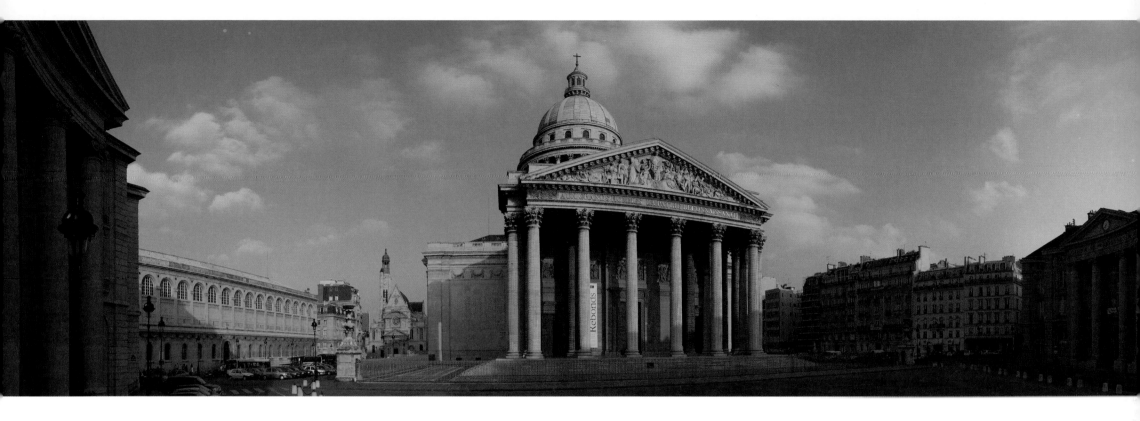

St. Helena, where he had died in exile nearly 20 years earlier. The emperor's tomb is today the main attraction at the Invalides, which also contains museums of war and of the French Resistance during the Nazi occupation.

The rather somber experience of a visit to the Invalides can be leavened with a stroll along its grand esplanade, which leads from the complex directly to the Seine at Quai d'Orsay. Immediately to the left, at riverside, is the Palais-Bourbon, home of France's lower house of parliament, the Assemblée Nationale. The palace's name harks back to the ruling house of French kings, overthrown by the revolution that paved the way for today's democratic legislature—but fittingly, Napoléon intervened in its architecture, adding a colonnade to the palace to complement his Neoclassical church of Ste-Marie-Madeleine on the opposite side of the Seine.

Equally attractive for strollers are the broad gardens of the Champ de Mars, named not as some fanciful exercise in classicism but because this was indeed the realm of the god of war. The park with its arrow-straight allées was once a parade ground that could accommodate 10,000 soldiers; appropriately, its eastern flank abuts the 1752 École Militaire. Founded by Louis XV, this is still an academy for training French soldiers.

Opposite the école, near where the gardens meet the Seine, Paris displays its best-known triumph of civilian architecture: the Champ de Mars ends at the Eiffel Tower. La Tour Eiffel, though, belongs not to the Left Bank but to the city at large.

(ABOVE)
HALL OF FAME
Built as a church, the Panthéon eventually became a shrine to France's icons of culture, science, and national honor, many of whom are entombed here. During the chaotic aftermath of the Franco-Prussian War, it was the headquarters of the Commune.

(LEFT)
SEE AND BE SEEN
In pleasant weather, the cafés along the Left Bank's Boulevard St-Germain have long offered that choicest piece of Parisian real estate—a good table on the sidewalk.

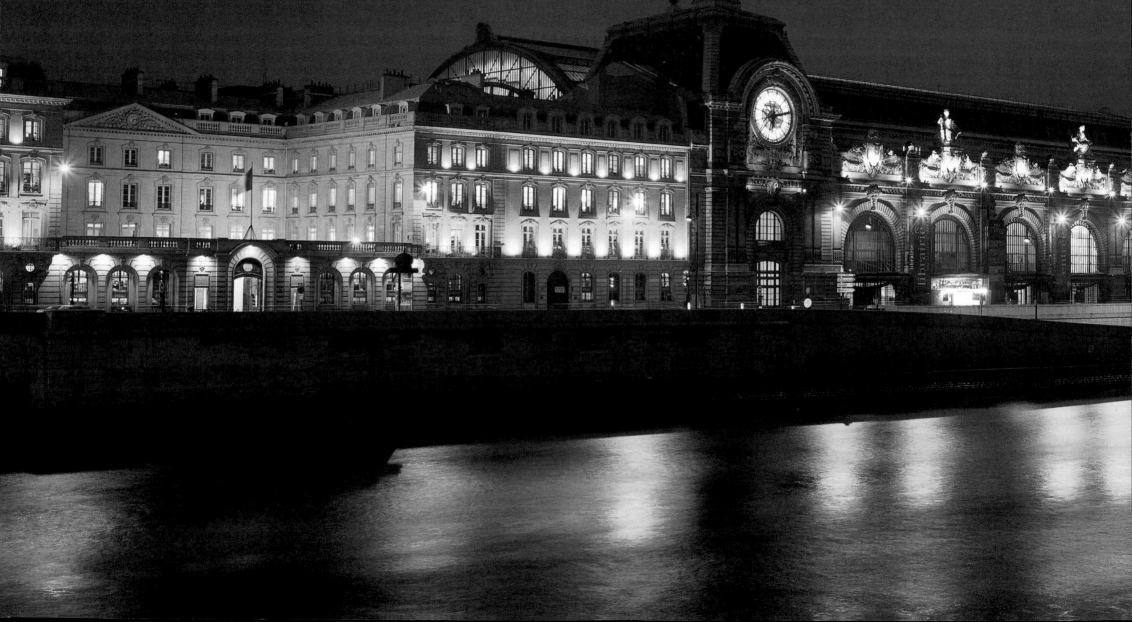

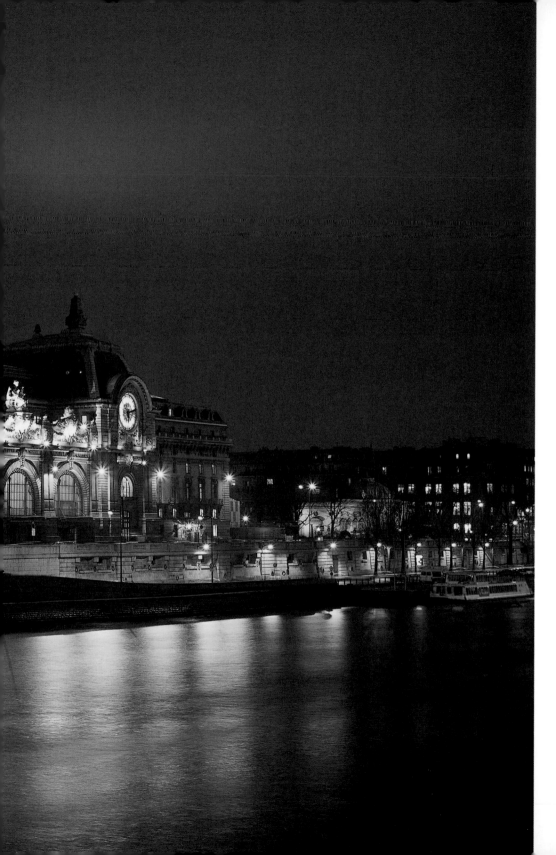

(LEFT)

PROPHECY FULFILLED

When a new riverside railway station was opened in 1900, painter Édouard Detaille remarked that the building would make a better museum. Eighty-six years later, it was recycled as the Musée d'Orsay.

(RIGHT)

LIGHT-FILLED GALLERIES

Italian architect Gae Aulenti made maximum use of the d'Orsay's vast arched windows in redesigning the old station's interior as a museum. Five levels rise above a great central concourse. Nearly all of the artworks exhibited are French.

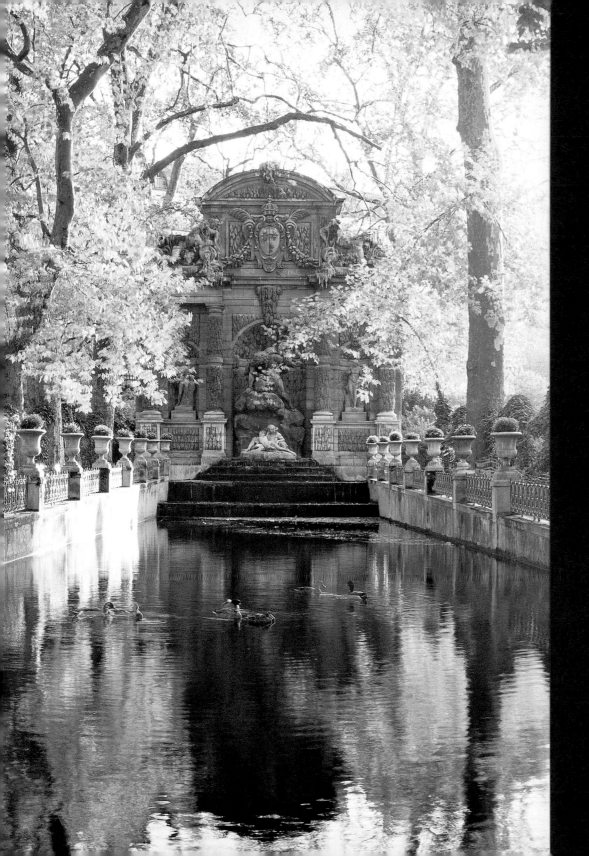

(PAGES 76–78)

ITALIAN INFLUENCE

Shaded by plane trees, the Baroque Medici Fountain in the Luxembourg gardens is a reminder of the park's connection to Marie de Médicis, the Italian aristocrat who was married to King Henry IV.

(ABOVE)

SCULPTURE GARDEN

More than 100 sculptures ornament the Luxembourg gardens; most represent scenes from classical mythology, or famous individuals in French cultural history.

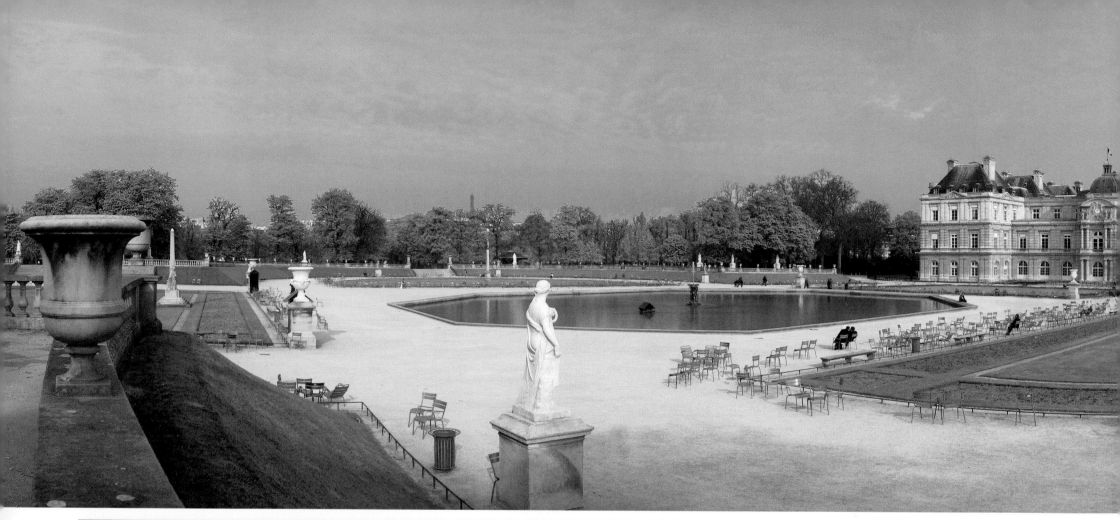

(PAGES 80–81)

FAVORITE RETREAT

The broad lawns, fruit trees, and manicured flowerbeds of the Luxembourg gardens are a welcome retreat for Parisians and visitors alike. Children sail model boats on the lake, students and pensioners play outdoor games of chess, and there is even a working apiary. The bust of Henri Murger (p. 81, bottom center) honors the nineteenth-century author of *Scènes de la Vie de Bohème*, the portrait of life among Paris's poor artists and writers that served as a source for Puccini's opera *La Bohème*.

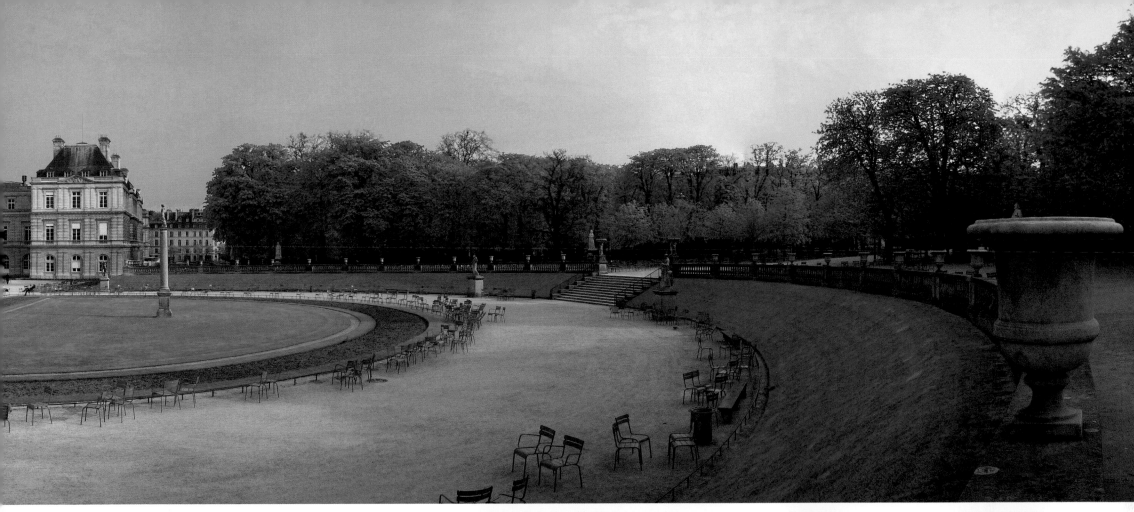

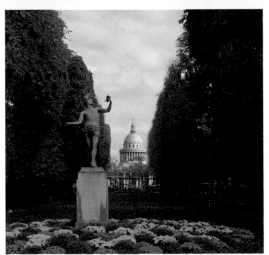

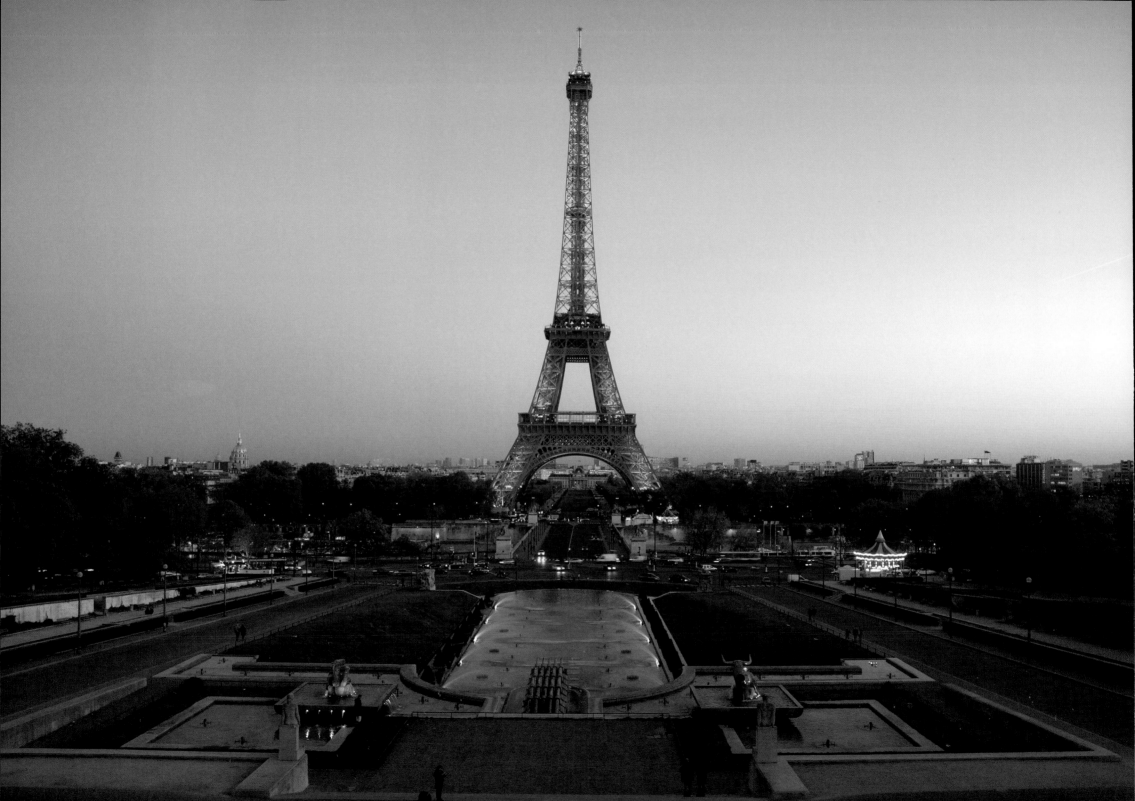

CHAPTER 5

THE MAKING OF MODERN PARIS

THE Paris the world enjoys today is largely the creation of the past century and a half. Monuments of the more distant past certainly endure—it's impossible to imagine Paris without Notre-Dame, the Louvre, the Invalides, and any number of such testaments to long-ago royal and ecclesiastical glory. But these treasures have been fit into an urban fabric given its texture in the modern era.

Like its physical infrastructure, Paris's cultural fabric— the grand tapestry that has given the city its cachet as a world capital for art, literature, music, and the interplay of ideas—is in large part the legacy of movements and individuals that called the French capital home in the days since the latter part of the nineteenth century.

Consider that familiar Parisian stereotype, the *boulevardier.* A boulevardier needs boulevards, and these were created over a period of nearly two decades by Baron Georges-Eugène Haussmann under the direction of Napoléon III. Trained as a lawyer, Prefect of the Seine Haussmann later remarked, "I was chosen as a demolition artist." But what Haussmann accomplished was far more than simply ridding Paris of its ancient slums (and, said contemporary detractors, destroying much of its history and character). His work also went beyond giving Napoléon's troops east access to potential urban trouble spots. Haussmann's most lasting legacy was the creation of the Paris that exists today in everyone's mind's eye, regardless of

whether they have ever been there—a city of spacious tree-lined thoroughfares such as the rue de Rivoli, traversing the Right Bank as it passes the Hôtel de Ville, rebuilt in fine Mansard style after an 1870 Commune mob destroyed the seventeenth-century original; and the Boulevards St-Michel and de Sebastopol, allowing traffic to leap from the Left to the Right Bank by way of the Ile de la Cité. The Avenue de la Grand Armée radiates with 11 other stately boulevards from the Place d'Étoile, but Parisians are still a bit uncertain about the fact that the most famous of those *grandes allées*, the Champs-Élysées, has at its Place de la Concorde terminus a big Ferris wheel left over from 2000's millennium celebrations. Haussmann and his planners and developers lined the new avenues with harmonious, academically styled buildings of uniform height and setback, and created long, clear lines of sight ending in vistas centered upon imposing public squares and monuments such as the Arc de Triomphe and the Opéra Garnier.

The Opéra, of course, stands for everything that was spectacular about the scale and character of Napoléon's Paris. The triumph of molded pastry that architect Charles Garnier was commissioned to create in 1860, and which remained unfinished until well after Napoléon's reign ended, is a massive Beaux-Arts structure dedicated as much to the audience as to the opera. Speaking of its riotously ornate marble grand staircase, Garnier himself remarked that "everything is designed so that the parade of spectators become themselves a show."

(ABOVE)

SOME ASSEMBLY REQUIRED
The Eiffel Tower is held together with some 2.5 million rivets, and requires as much as 40 tons of paint every seven years. On hot days, expansion of the ironwork can cause it to grow six inches.

(OPPOSITE)

SYMBOL OF PARIS
"France will be the only country with a 300-meter flagpole," boasted Gustave Eiffel regarding his masterwork. The Eiffel Tower long ago lost its place as the world's tallest structure, but remains the supreme symbol of France and its capital.

(RIGHT)

RIOT OF ORNAMENT
The labyrinthine interior of Charles Garnier's great "pastry" of an opera house, the *ne plus ultra* of Second Empire extravagance, harbored the fictional *Phantom*.

(BELOW)

OPERA'S NEW HOME
The new opera house at Place Bastille marks a major stylistic departure from the ornate Opéra Garnier. At left is the Colonne de Juillet, marking the burial place of casualties of revolutionary uprisings in 1830 and 1848.

(OPPOSITE)

DARING STYLE
A century ago, Hector Guimard applied the exciting new visual vocabulary of Art Nouveau to otherwise utilitarian fixtures such as street lighting and the entryways to the *Métropolitain* subway system.

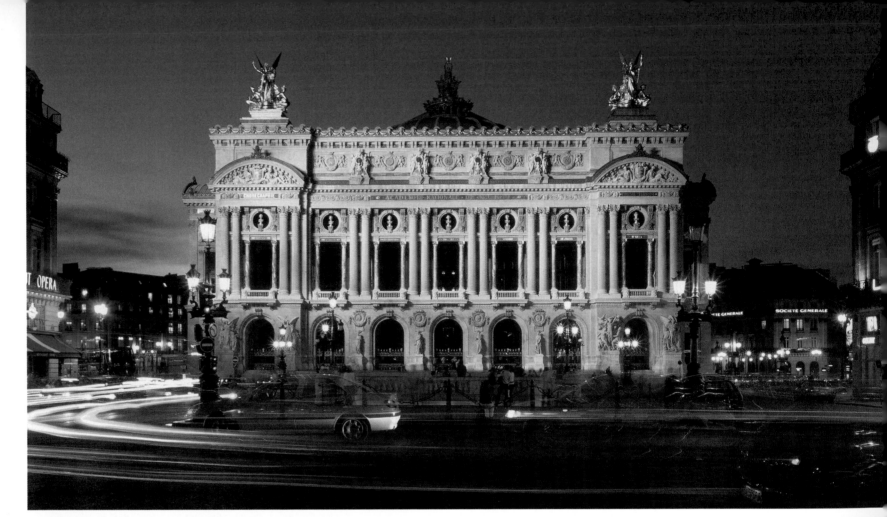

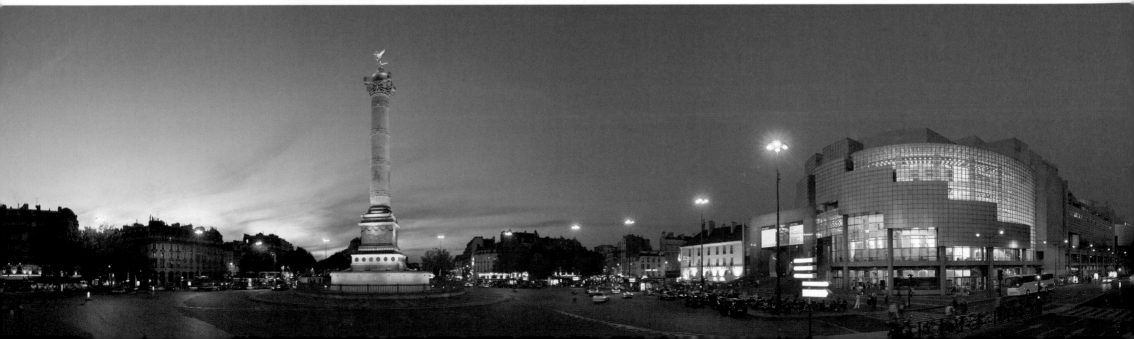

But the Opéra is no less a triumph of engineering than architecture. The builders had to overcome the discovery of an underground lake, fed by subterranean streams; by most accounts, the lake remains beneath the immense structure's sub-basements. The idea of this watery netherworld inspired Gaston Leroux, whose novel *The Phantom of the Opera* appeared in 1910 and began what has become a *Phantom* industry. When it came to his forays above ground, Leroux's grotesque hero could take advantage of a building so bizarrely honeycombed with passageways that it contains more than 1,600 doors. A good phantom, of course, would know the location of each of them, but if he's around today, he'd better be stalking *danseuses* instead of sopranos. Opera is now performed mostly at the new Opéra National de Bastille, a *grand projet* of the late President François Mitterand opened in 1989 and controversial not only because of its modernist design but because the stone tiles in its façade have a habit of slipping to the sidewalk. Garnier's "pastry," which is now reserved primarily for ballet, at least has retained all of its icing.

As it was acquiring its modern face and furnishings, Paris also reasserted its age-old importance in the cultural realm. In painting, Paris had long laid down the law when it came to the conservative academic tradition, but as the nineteenth century drew to a close, Parisian artists fell in line with controversial new movements. Impressionism—the word was first used derisively by critics—captured international attention through the works of artists such as Édouard Manet, Claude Monet, Auguste Renoir, and Camille Pissarro. Mary Cassatt and other American acolytes of the movement flocked to Paris, as did less easily categorized painters like James A. Whistler. Paris itself was a subject of the works of the later painter Maurice Utrillo, above whose Montmartre streetscapes loomed the eggshell dome of the church of Sacré-Coeur, built between 1875 and 1914.

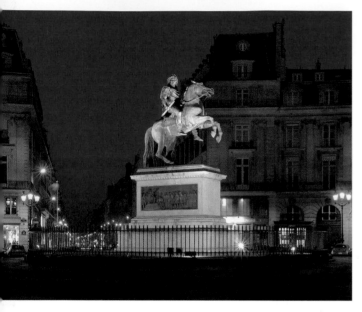

(ABOVE)

ROYALTY REDUX

Louis XIV rides again, in a replica of the Place des Victoires equestrian statue destroyed during the Revolution. Jules Mansart's design for the surrounding square was an inspiration for similar urban spaces throughout France.

(OPPOSITE, TOP)

A LION OF BATTLE

The bronze lion at the center of Place Denfert-Rochereau honors the Franco-Prussian war hero for whom the *place* is named. The sculpture is the work of Frédéric Bartholdi, creator of the Statue of Liberty.

(OPPOSITE, MIDDLE)

STRAIGHT AND WIDE

The Boulevard des Italiens is typical of the grand thoroughfares laid out by Baron Georges Haussmann during Napoléon III's redesign of Paris.

(OPPOSITE, BOTTOM)

THRESHOLD OF MONTMARTRE

Located at the southeast corner of the famed Montmartre quarter, busy Place de Clichy marks the spot where an ancient road to the village of Clichy passed through the city walls.

After 1900, the Fauvist school of Henri Matisse and Georges Braque shocked conventional sensibilities as had the Impressionists a generation earlier; and the Cubists, led by Paul Cézanne and the protean Spanish émigré Pablo Picasso, took painting on the path that led to twentieth-century abstractionism.

In the field of design, Paris made its own distinctive contribution to a brief but exuberant pan-European movement. Art Nouveau, characterized by stylized organic elements and lively whiplash curves, is best known to visitors to Paris through the lavish wrought-iron entryways to the Métro designed by Hector Guimard. But Guimard, who even designed furniture, also brought the lushness of Art Nouveau to buildings such as the synagogue on rue Pavée in the 4th Arrondissement.

In music, César Franck, Claude Debussy, and Igor Stravinsky were among the leading beacons of modernism. As much as cultural conservatives in the art world were put off by the Impressionists and the Fauvists, old-line music critics were shocked by performances such as Sergei Diaghilev's 1913 debut production of Stravinsky's ballet *The Rite of Spring*, featuring Vaslav Nijinsky. The audience reacted even more strongly than the critics, and staged a full-blown riot.

As it left the century of Hugo, Dumas, Flaubert, and Balzac behind, literary Paris encountered the realism of Émile Zola, famous not only for his novels but for his activism in the Dreyfus Affair involving the wrongful espionage accusation of a Jewish army officer; and Marcel Proust, who extolled the mnemonic value of the little cakes called madeleines at the beginning of his massive rumination on the psychology of a society in change, *Remembrance of Things Past*.

For all the accomplishments of native French writers, though, Paris in the decade following World War I is best remembered as a magnet for the expatriates (many of them American and British) attracted to the city in part by a spectacularly favorable exchange

rate, and by a society unfettered by such puritanical notions as Prohibition. "You are all a lost generation," Gertrude Stein said of the young, war-shaken writers and hangers-on flocking to Paris, but among those who found themselves here in the 1920s were Ernest Hemingway, F. Scott Fitzgerald, Ezra Pound, Archibald MacLeish, James Joyce, Ford Madox Ford, and the American journalist A. J. Liebling, who throughout his life and work drew on memories of the culinary glories of the capital. One of their favorite meeting places was Sylvia Beach's Left Bank bookshop Shakespeare and Company, now revived at a new location on rue de la Bûcherie.

Again in the 1950s, Paris was renowned as intellectual crucible. The cafés of that era were the haunts of existentialist students and philosophers, pondering humanity's choices in the face of the absurdity of existence. The most famous of the existentialists were Jean-Paul Sartre, author of *Being and Nothingness*, and his lover Simone de Beauvoir, who wrote the pioneer feminist manifesto *The Second Sex*. The pair were habitués of the Left Bank Café de Flore, whose proprietor once remarked, "My worst customer, Sartre. He spent the entire day scribbling over one drink." The bibulous heroes of the Lost Generation would weep that things had come to such a pass.

Ordinary Parisians, too, found a city reanimated, with new diversions and a fresh approach to the familiar, in the wake of the city's late nineteenth-century sea change. In a place where enjoying open space had long been the prerogative of the privileged few, green lawns and shaded pathways were now a Métro ride away. The great parks on the city's periphery, the Bois de Boulogne and Bois de Vincennes, had become pleasure grounds for the populace, with racetracks, playgrounds, and riding trails. Closer to the city center, the Right Banks' Buttes-Chaumont Park was another Haussmann creation; built on the site of a former quarry and refuse dump, it features an artificial lake for boaters, a fake Roman temple, and open-air puppet shows.

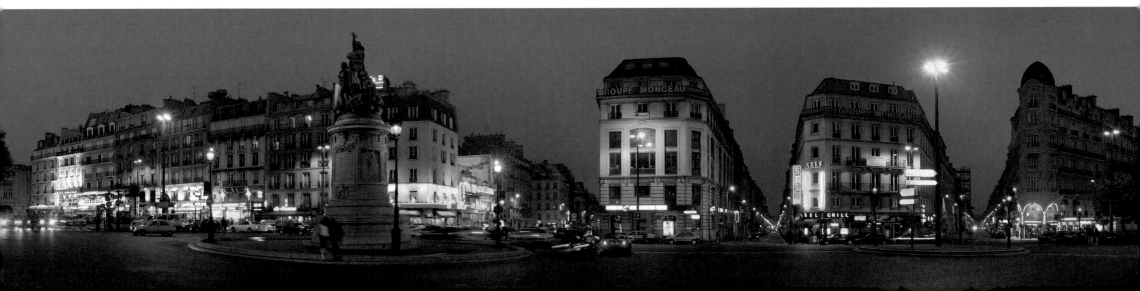

(ABOVE)

BUSY BOULEVARD
The Avenue des Champs-
Élysées—shown here looking
away from the Arc de Triomphe—
bustles with traffic more than
boulevardiers on a working day.

(OPPOSITE)

GRAND PARADE
Bastille Day, July 14, marks the
storming of the ancient symbol of
monarchy in 1789 and remains
France's most important national
holiday. Here, the Cavalry of the
Republican Guard leads the
annual parade down the
Champs-Élysées.

Even Père-Lachaise, the sprawling cemetery opened by
Napoléon I and harboring the remains of notables including
Balzac, Oscar Wilde, Sarah Bernhardt, Gertrude Stein, Marcel
Proust, and Jim Morrison (his is likely the most visited grave)
became a place where Parisians might take a quiet off-pavement
ramble. (Ramblers of a more macabre inclination can get even
more up close and personal with the dead by touring the bone-
stacked catacombs of Denfert-Rochereau, accessible at the *place*
of the same name.)

Some of the most pleasant spots for strolling and amusement
are the legacy of Paris's penchant for hosting what now seems a
vanished institution, the world's fair. The Grand Palais and Petit
Palais, built for the 1900 fair, are nestled in landscaped grounds
on the Right Bank at the foot of the Pont Alexandre III, which
bridges the Seine in a riot of gilded garlands, statues, and
candelabras; just across the river are the gardens of the Invalides.
A bit farther west, past a bend in the Seine, the Trocadéro
Gardens, with their ornamental pools, embrace a relic of the
1937 fair, the pseudo-classical Palais de Chaillot. The Palais,
which houses several museums and an aquarium, stands on the
footprint of the original Trocadéro, built for an earlier fair.

The greatest "leftover" of all Paris's world's fairs stands just
across the Seine from the Tuileries. The Eiffel Tower, Gustave
Eiffel's stupendous feat of iron-girder engineering, was built for the
1889 event. It was a horror to aesthetes such as short-story master
Guy de Maupassant when it first rose above the Champ de Mars,
and was nearly dismantled before being found to be useful for radio
transmission in 1909 (for a while, it was even used for advertising,
bearing lights that spelled out "Citroen"). The 984-foot Eiffel
Tower (1,054 feet with radio masts) was for many years the world's
tallest structure, and has become the enduring symbol of Paris.

World's fairs also left their mark on Paris's utilitarian
infrastructure. The Gare de Lyon, still one of the city's principal
railway stations, was built to accommodate visitors to the 1900 fair;

at the same time, the elegant glass-and-iron station that now
houses the Musée d'Orsay was constructed.

As the world came to tout its wares at all those international
expositions, Parisians took care of their more mundane shopping
at venues created during the late nineteenth-century building
spree, and at venerable locations updated to account for modern
tastes. Two vast department stores, the Galeries Lafayette and
Le Printemps, loom along Boulevard Haussmann behind the
Opéra Garnier like stately liners. True to their period, their
architectural flavor is Beaux-Arts, but the Galeries Lafayette has
a lovely Art Nouveau main hall capped with a stained-glass
dome. Galerie Vivienne and Galerie Colbert, opposite the old
Bibliothèque Nationale near the Place des Victoires, represent
the trend toward elegant shopping *passages* that presaged the
modern idea of the indoor mall as far back as the 1840s. Galerie
Vivienne, splendidly restored down to its mosaic floors and iron-
and-glass arcade roof, is now *trés* upscale with its stalls occupied
by art dealers and expensive boutiques.

Parisians of the late nineteenth century experienced a
tremendous amount of change—in the look and feel of their
city, in the way they moved within it, and in the ways they
played, shopped, and saw the world through art. Yet some
things remained stubbornly resistant to transformation.
Les Halles, the market district that Zola called "the belly of
Paris," still fed the capital from the stalls of its butchers and
greengrocers, located beneath handsome iron arcades erected
during the reign of Napoléon III. Those arcades would stand
for a century—and even after they came down, and the food
markets were moved to the city's periphery, the shops of nearby
rue Montorgueil remained to offer a whiff of the days when
each Parisian household knew its victualers by name. The
street's survival is a measure of just how much changed, and
how much did not, during the great upheaval that brought
Paris into the twentieth century.

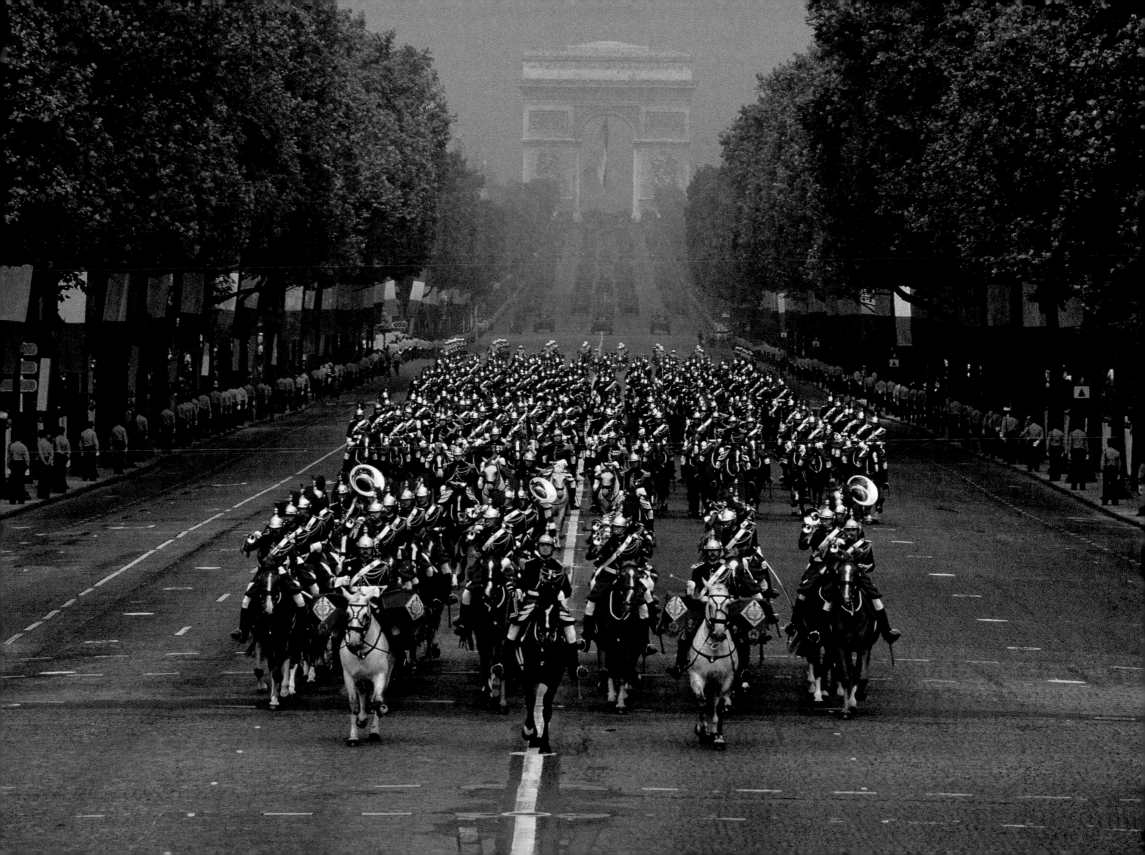

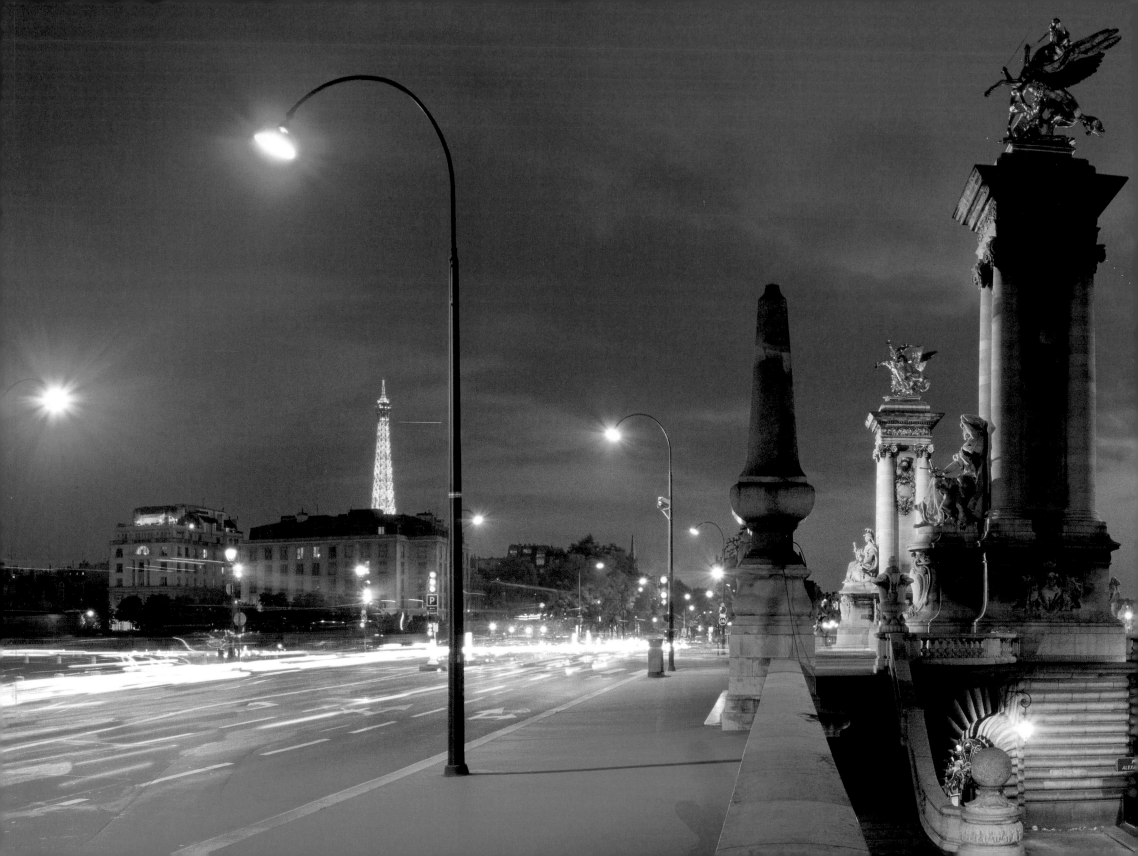

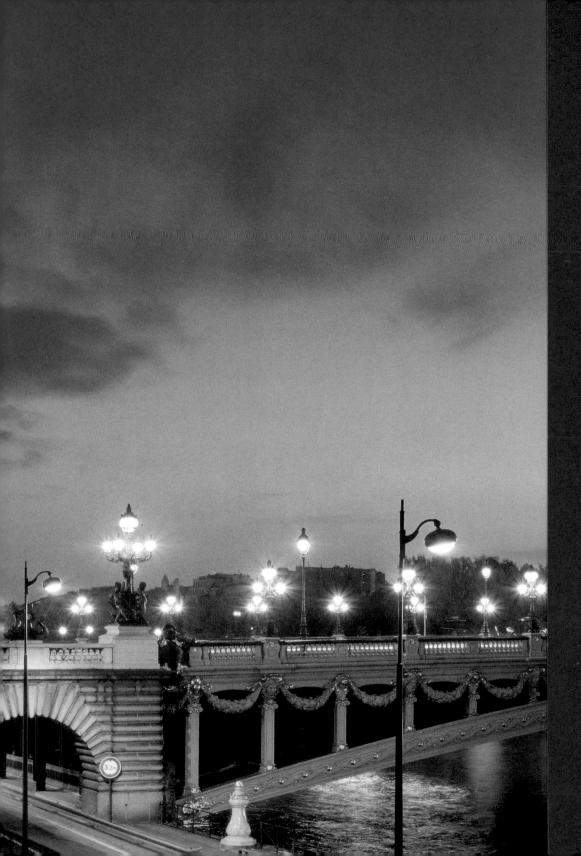

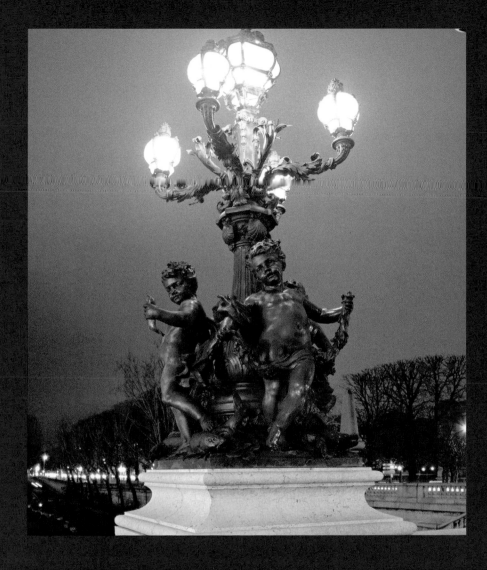

(PAGES 90–92)
GRACEFUL LEAP
Built between 1896 and 1900, the Pont Alexandre III was named in honor of Czar Alexander III of Russia. Richly ornamented with nymphs and cherubs, it spans the Seine in a single arch between the Esplanade des Invalides and the Grand and the Petit Palais.

(ABOVE)
FIT FOR A CZAR
The brilliantly lit Pont Alexandre III was completed in time for the 1900 World's Fair, for which the Grand and the Petit Palais were also constructed.

(PAGES 94–95)
BUILT FOR SHOW
Built to replace the old city hall burned by communards in 1871, Paris's Hôtel de Ville is a grand, Mansard-roofed reimagining of the Baroque. Its equally ornate interior features exquisite banquet and reception rooms as well as city offices.

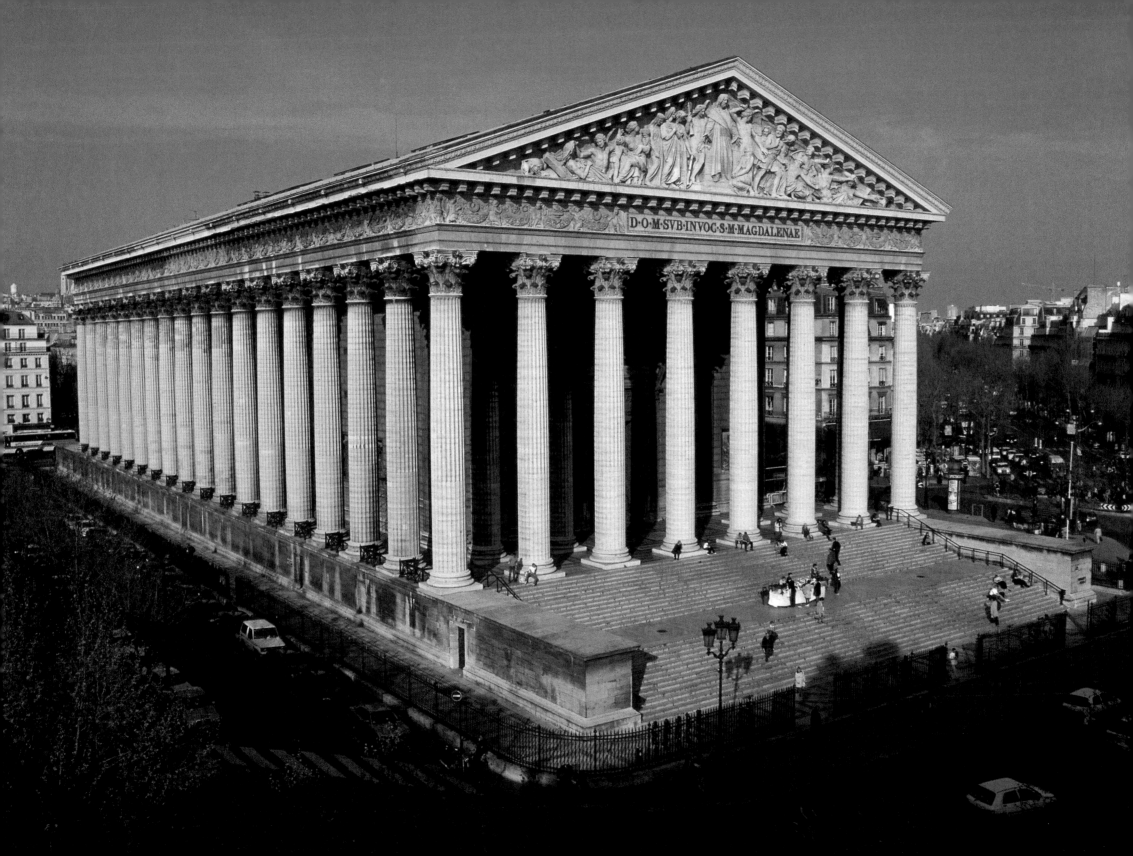

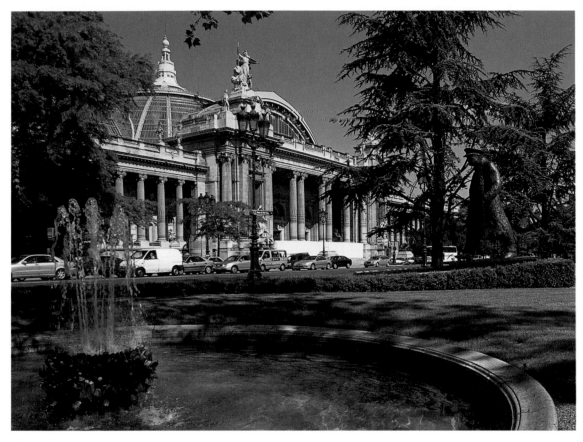

(ABOVE AND RIGHT)

PALACE OF ART AND SCIENCE

The Grand Palais, built in the Beaux-Arts style, hosts art exhibits and contains the Palais de la Découverte, a science museum. In the foreground at right is a statue of Sir Winston Churchill, for whom the avenue alongside is named.

(OPPOSITE)

CLASSICAL RIGOR

The church of Ste-Marie-Madeleine, built over the course of nearly a century, brings a cool Greek classicism to a city whose landmark churches are mostly Gothic, Renaissance, or Baroque.

(PAGES 98–99)

PARISIAN INSTITUTIONS

The vast bulk of the church of St-Eustache, a pastiche of Gothic and Renaissance architecture, looms over rue Montorgueil in the neighborhood that once housed the old food markets of Les Halles.

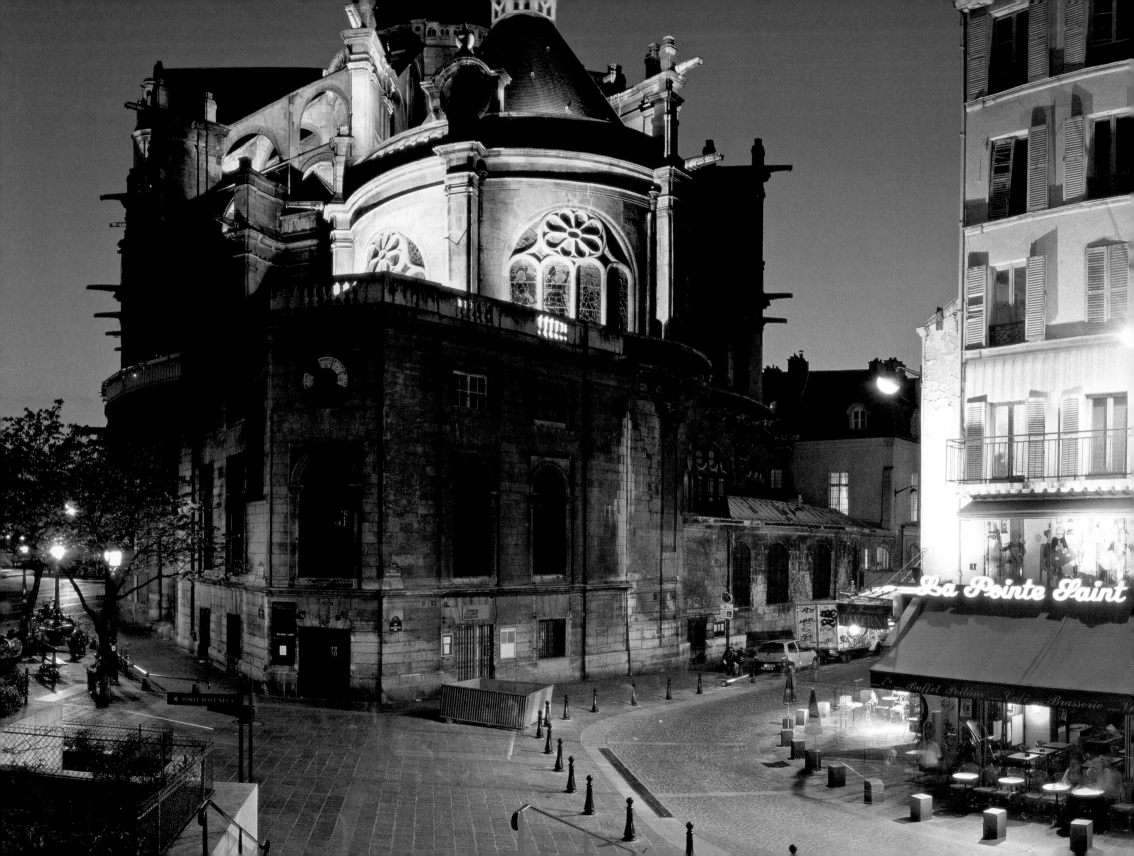

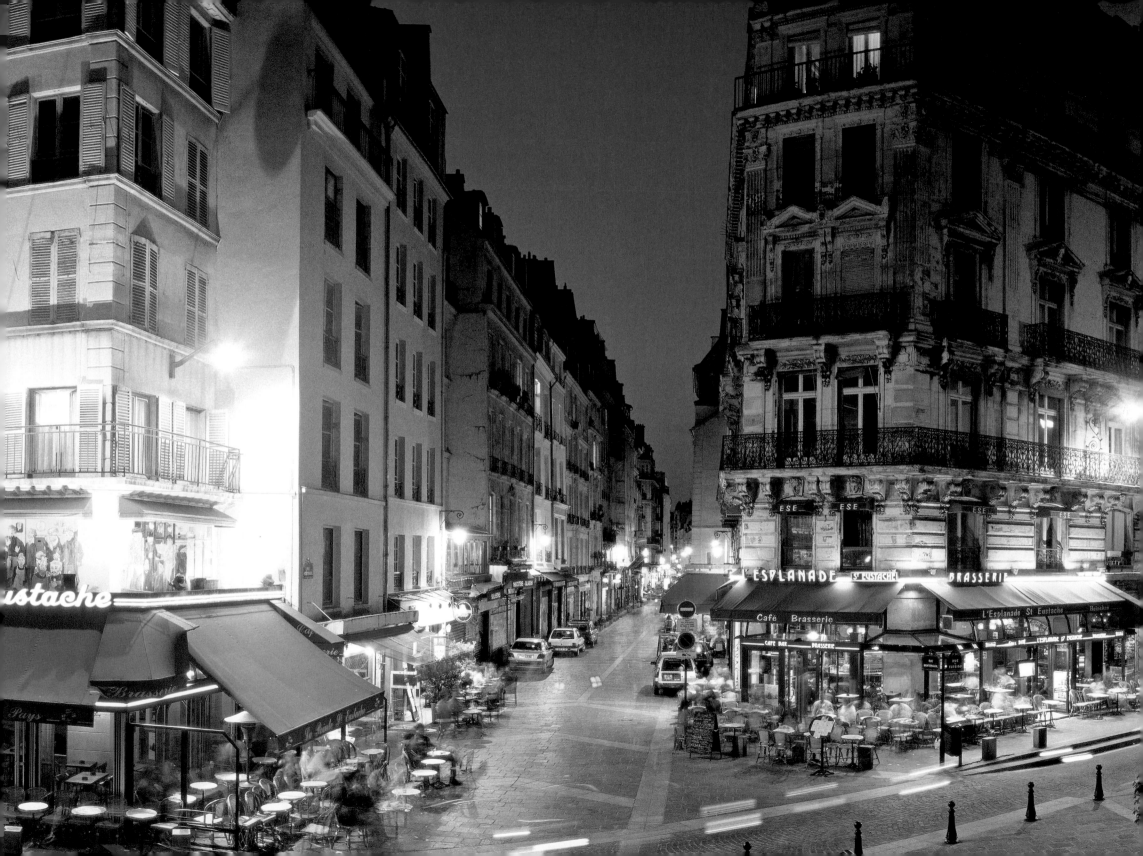

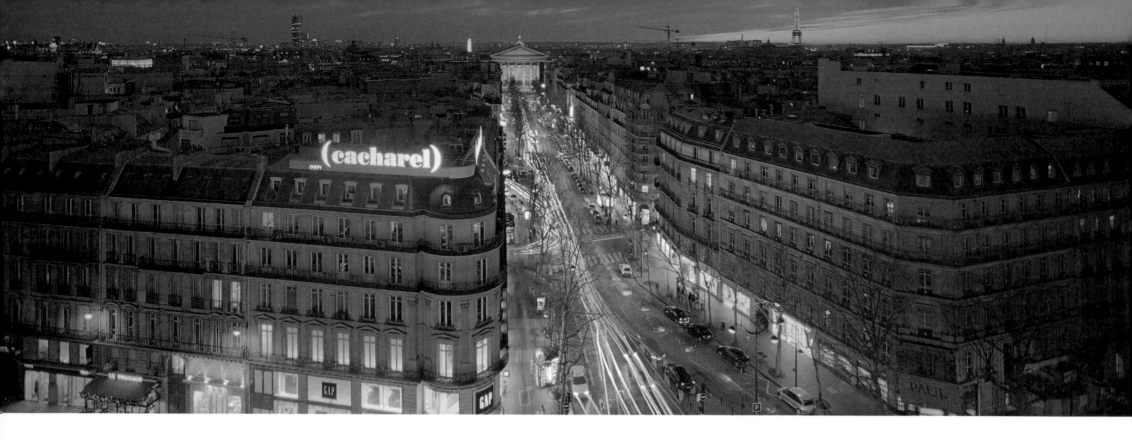

(ABOVE)

ONLY THE BEST

The *grands boulevards* of the Right Bank harbor some of the greatest names in fashion. Boulevard de la Madeleine, at center, extends from the church of that name to the Garnier Opéra.

(RIGHT)

RETRO CHIC

The galleries along Passage Vivienne are lined with upscale shops, in a revival of a shopping mode that became popular in the early nineteenth century.

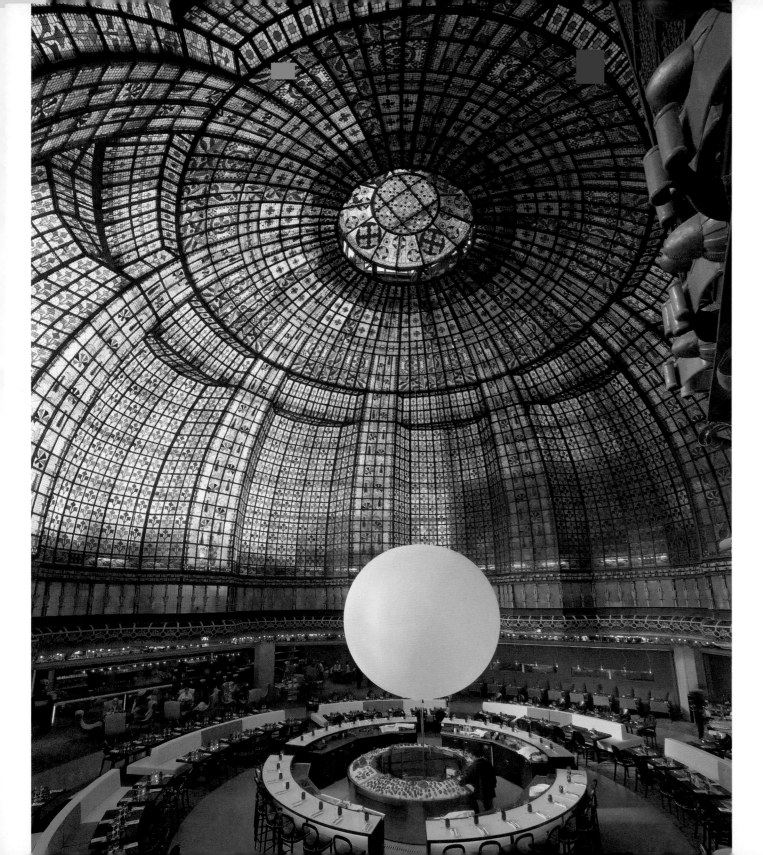

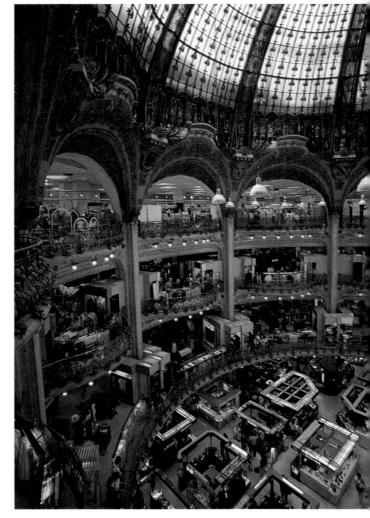

(LEFT)

GLASS EXTAVAGANZA

Sprawling through three separate
buildings specializing in men's,
women's, and home goods, the
grand magazin Le Printemps, on
Boulevard Haussmann, boasts
premises as alluring as any of its
merchandise. The great glass
dome that soars above Le
Printemps marries the Art
Nouveau aesthetic to a craft
that harks back to the era of
cathedral rose windows.

(ABOVE)

THE GRAND GALERIE

Near the Opéra Garnier at
40 Boulevard Haussmann looms
the flagship store of Galeries
Lafayette, where more than
80,000 fashion labels lure
shoppers from around the world.
Ten storys of balconies, arches,
and Art Nouveau staircases are
crowned by a magnificent steel
and glass dome that dates to 1912.

WORDS WITHOUT END

Shakespeare and Company, the English-language bookstore founded in 1921 by Sylvia Beach and revived at its present rue de la Bûcherie location in 1956, has counted among its clientele some of the past century's most famous writers.

(PAGES 104–105)

SYLVAN SETTING

The Trocadéro gardens, across the Seine from the Eiffel Tower, feature several museums and a lovely ornamental pool—but the gardens' lush greenery is perhaps their biggest draw in a city that treasures its green spaces.

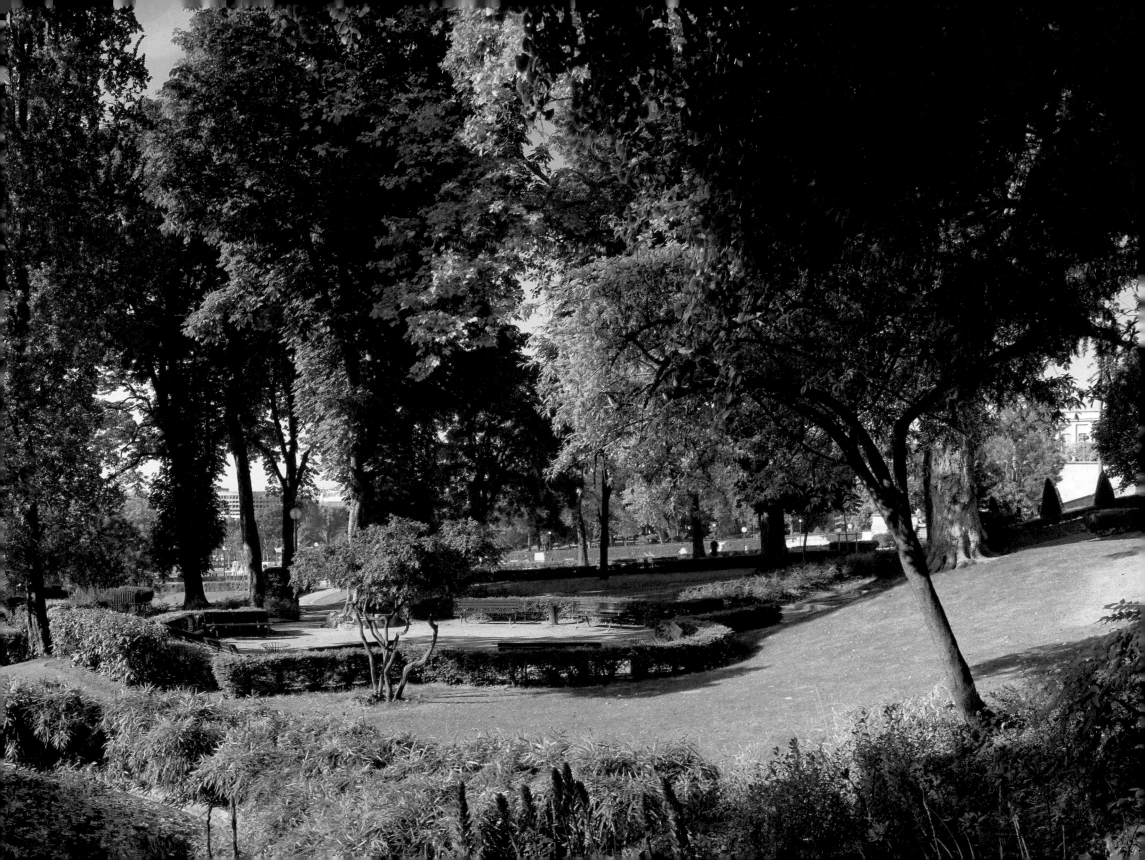

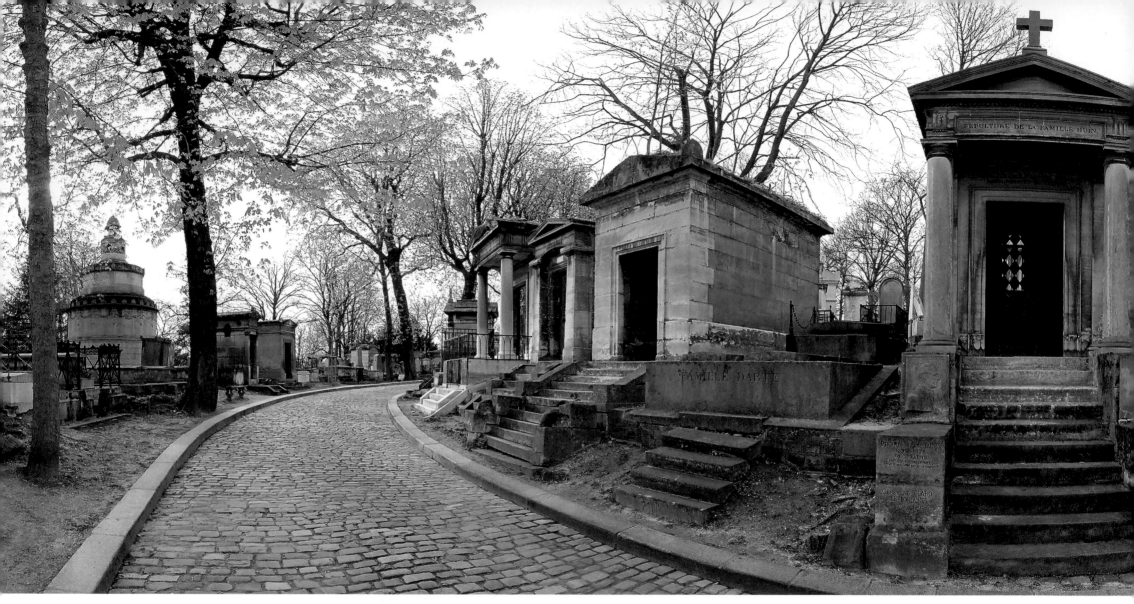

JAMES DOUGLAS MORRISON
1943 – 1971

ΚΑΤΑ ΤΟΝ ΔΑΙΜΟΝΑ ΕΑΥΤΟΥ

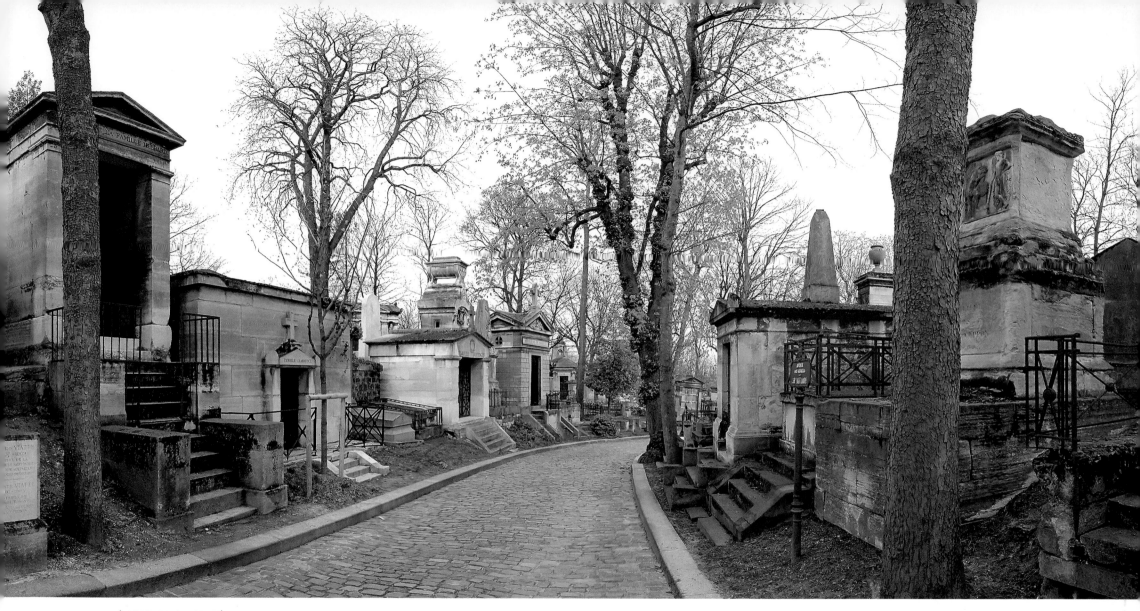

(ABOVE AND OPPOSITE)

FAMED NECROPOLIS
Crammed with dour mausoleums
and grim detail, the vast cemetery
of Père-Lachaise is the resting
place of the forgotten and the
famous. The latter range from
Oscar Wilde to Edith Piaf,
Frédéric Chopin to Sarah
Bernhardt—and, of course,
one Jim Morrison.

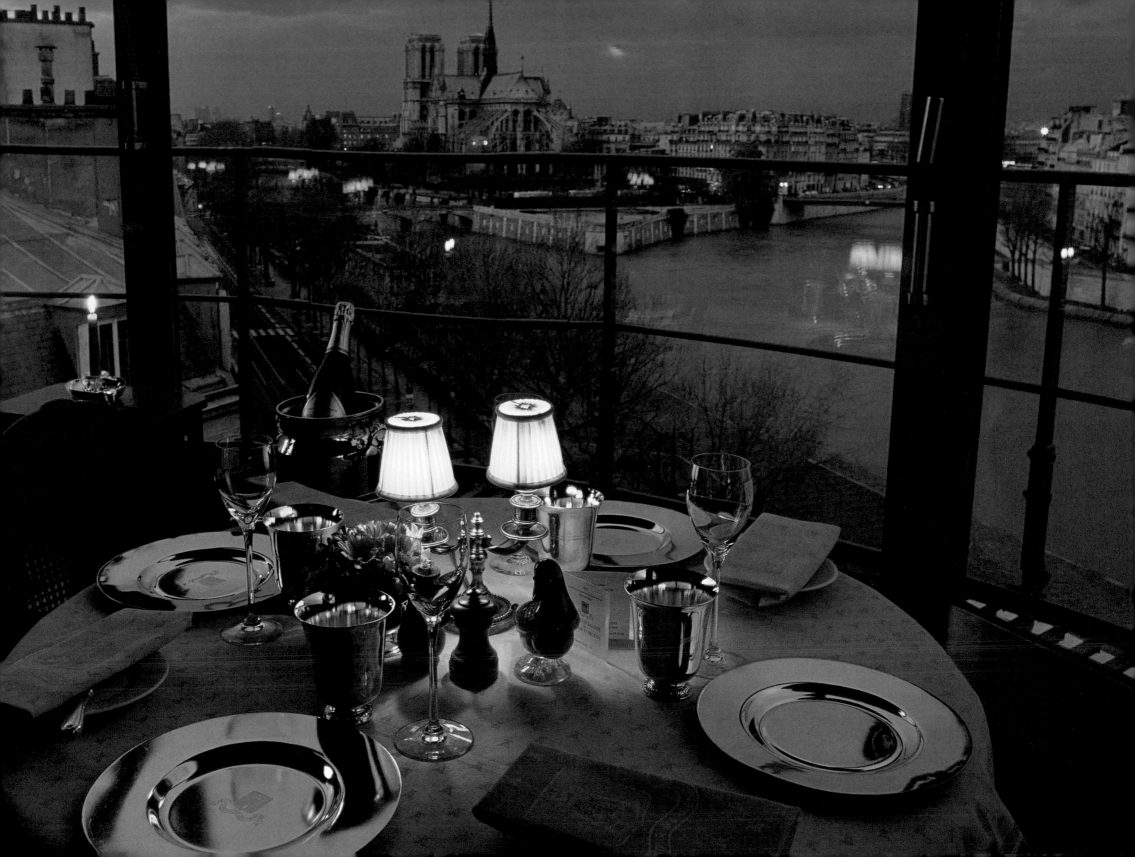

CITY LIFE

THE Parisians of today live their lives in a city that is at once ageless and ever-changing. The setting remains endearingly familiar: citizens of Paris can look out across the same jumble of ancient rooftops as their grandparents did, and see the same well-spaced landmarks rise above a skyline that remains, for the most part, reassuringly earthbound. Paris was never a vertical city, such as New York became in the twentieth century, and despite the heretical impulse of French president Georges Pompidou in the early 1970s, height restrictions in the central city have never been relaxed. The human dimension has never been abandoned, save where the very human kings and emperors of France have built on a grand formal scale that only makes nearby quarters seem cozier still.

Change in Paris has often been incremental and adaptive. The Canal St-Martin, for instance, was built to link Right Bank warehouses and factories with the Seine; today, the canal belongs to tour boats and pleasure craft, and its quais are lined with trendy shops and cafés. Or, familiar surroundings might become the scene of an odd juxtaposition—a glass pyramid at the entrance to the Louvre, a Ferris wheel at the Place de la Concorde, or a gilded reproduction of the American *Statue of Liberty*'s flame, poised only a few feet above street level at Place d'Alma. (In a traffic tunnel beneath this spot, 10 years after the "Flame of Liberty" was installed in 1987, Princess Diana was killed in what has become Paris's most notorious auto accident.)

On a grander scale, still strikingly modern though almost sedate in its visual impact, is the Institut du Monde Arabe, the Institute of the Arab World, on the Left Bank campus of the University of Paris opposite Ile St-Louis. For this tangible symbol of Paris's growing ethnic diversity following the implosion of France's North African empire, architect Jean Nouvel created a nine-story façade of glass, metal, and concrete, featuring a repeating motif of panels imitative of Islamic decorative art. But the panels have a decidedly modern twist: they incorporate photoelectrically controlled apertures that expand and contract to admit or restrict light.

Less successful, in the eyes of many Parisians, was the Opéra National de Paris Bastille. Although offering acoustics and lines of sight that improve upon the Garnier Opéra, the 1989 structure did have that problem of falling slate tiles, and even after the situation was corrected the dark hulking design of the place still occasioned faint praise. To many, it looks as if it might be inhabited by a dour sort of phantom, if a phantom were interested at all.

The closest true skyscraper to encroach upon central Paris is the Tour Montparnasse, a 59-story slab that lords it over the old railway station of the same name, looking as if it had lumbered in from Manhattan. The city's one truly ultramodern development, though, is La Défense, created during the 1980s as if in grudging acceptance of the fact that a modern city might

(ABOVE)
CULINARY PATRIMONY
With a name that translates as "Our Gallic Ancestors," this Parisian restaurant honors the earliest Celtic tribes that made the capital their home. Its earthy character and down-home fare distinguish it from the city's temples of *haute cuisine*.

(OPPOSITE)
TABLE ON THE SEINE
Views from the fabled restaurant La Tour d'Argent are a worthy accompaniment to the classics of *haute cuisine*, the finest French wines, and an exacting standard of service.

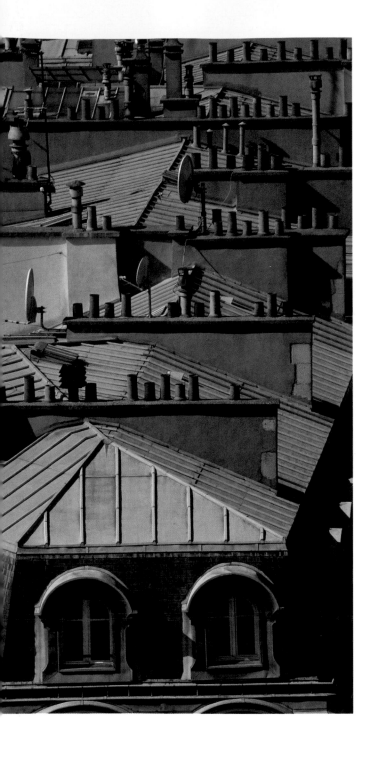

need coolly practical buildings—although they may as well be tucked at a discreet distance. The locale chosen lies west of the central city, and its glass and concrete complex of office, shopping, and entertainment structures rises behind a 330-foot Grande Arche that could swallow Notre-Dame. The only real visual excitement at La Défense will be provided by American architect Thom Mayne's meltingly swoopy 68-story office tower, scheduled for completion in 2012. At 984 feet, it's the tallest structure built in Paris since the Eiffel Tower.

Changes in the Parisian streetscape are seldom as shockingly abrupt as when Haussmann's great boulevards were rammed through medieval slums, and the bright bulging monolith of the Garnier Opéra first appeared. But in a city where a Stravinsky ballet could start a riot, and a visionary engineer named Gustave Eiffel shocked traditionalists with his lofty tracery of iron, a truly revolutionary building can still launch a controversy. More than a few Parisians at first did not know quite what to make of the Georges-Pompidou Center, known informally as the Beaubourg, a great treasury of modern art standing a few blocks north of the Seine and the Hôtel de Ville. Named for the late French president and opened in 1977, the museum at first garnered as much publicity for its design as for its impressive collections. The Beaubourg was designed by Richard Rogers and Renzo Piano with an important twist: all of its functional elements—its heating and cooling ducts, elevators, and utility conduits—were placed on the outside and painted in bright colors, so that the building appears inside-out. Like the Eiffel Tower, though, the Beaubourg has won the approval of Parisians and visitors alike. It's brightened a once-dowdy Right Bank neighborhood, and now ranks as one of the capital's most-visited attractions.

The popular Beaubourg is but one example of the democratization of culture in the Paris of the past 150 years. This is a trend perhaps best exemplified in the city's great variety of museums, heirs to what began with the opening of the royal art hoard of the Louvre in the days after the Revolution. Since the nineteenth century was characterized by an explosion in

scientific knowledge, it's not surprising that Parisian museums reached beyond the realm of human accomplishment in the arts to include the wonders of the natural world. The Jardin des Plantes, on the Left Bank, hosted a zoological gallery as early as 1889; today, the gardens are home to the Museum of Natural History and its Grand Gallery of Evolution. Farther afield, the Cité des Sciences et de l'Industrie, located in Parc de la Villette in Paris's far northeastern section, focuses on science and technology. Among the features of the ultramodern complex are a planetarium, simulated flight and virtual reality installations, a retired attack submarine, and the Géode, one of the world's largest geodesic domes, housing an Imax theater with a 1,000-square-foot screen.

For Parisians, of course, the edification available in the city's museums has to be tempered with the sheer pleasure of shopping in one of the world's retail capitals. Le Printemps and the Galeries Lafayette—those great old liners sailing along Boulevard Haussmann—still have their loyal clienteles, although they share Parisians' disposable euros with that twenty-first-century alternative to the traditional department store, the shopping mall. The Forum des Halles is a sleek if somewhat colorless underground example that occupies the patch of ground from which Paris was fed for 800 years. Along with its shops, it contains two cineplexes and a swimming pool—something the stallkeepers of old Les Halles never imagined was an accessory to shopping.

If the department stores and malls represent Parisian retail's middle ground, there are also the extremes. The boutiques of the great jewelers and couturiers along the Champs-Élysées and other Right Bank boulevards (and, increasingly, the Left Bank's Boulevard St-Germain) occupy one end of the scale; at the other are the second-hand shops of Village St-Paul, at the southern edge of the Marais, and the thriving ancient tradition of the flea market. Way in the north of the city, Parisians and visitors alike haggle with some 2,500 dealers in every conceivable variety of treasure and trash at the largest such institution, the *marché aux puce* de St-Ouen.

Parisians are reported to take their meals at home to a greater extent than the citizens of any Western metropolis. Readers of Georges Simenon's novels about the indefatigable Inspector Maigret will recall his looking forward to his wife's cooking at lunchtime even when he was hard at work on a criminal case—and even today, at least one economist has suggested that more jobs could be created in the food service industry if Parisians would only dine out more often. But those aren't only tourists at venerable bistros like La Coupole, on Boulevard Montparnasse, or at the Left Bank's rue Mouffetard with its cheap, busy snack shops tucked between old-fashioned food stalls—or at temples of haute cuisine such as La Tour d'Argent, scorned by cutting-edge types but renowned still for its pressed duck, encyclopedic wine list, impeccable formal service, and views across the Seine. Over on Ile St-Louis, locals also line up for Berthillon's sumptuous ice cream. And while traditional café life is said to be under assault from hurried lifestyles and from McDonald's, it will be a long time before the last café closes.

Where are the Parisians, when they're not working at La Défense, shopping at the Forum des Halles or Cartier, lunching at their favorite bistros, or giving a second thought to how much or how little they like the Beaubourg or the Bastille Opéra? Leisure in the capital is no less at a premium than in other modern cities, yet in Paris it is less compartmentalized, more organically a part of everyday life—it is, in fact, not so much "leisure" as it is simply living. The Parisian doesn't live *in* Paris, so much as he or she *lives* Paris. The flower gardens in the Bois de Vincennes, or the bookstalls along the Left Bank quais, are not diversions from city life; they are integral to the life of the city. When Parisians spend an afternoon on a bench at the Square du Vert-Galant on Ile de la Cité, watching boats and barges wander up and down the Seine, they are part of an ancient symbiosis between citizens and city, knowing and understanding their place—Left Bank, Right Bank, and the islands abreast the old river—as few of us know and understand any place, anywhere.

(ABOVE AND LEFT)
SMALL DETAILS
The visual richness of Parisian buildings—a glowering face carved above a doorway, a hand-forged iron balcony railing—repays the casual stroller in a city of endless detail and diversion.

(OPPOSITE)
ROOFTOPS OF PARIS
The formal architectural cadence of Paris at street level gives way to a whimsical jumble of roof tiles and chimney pots up above.

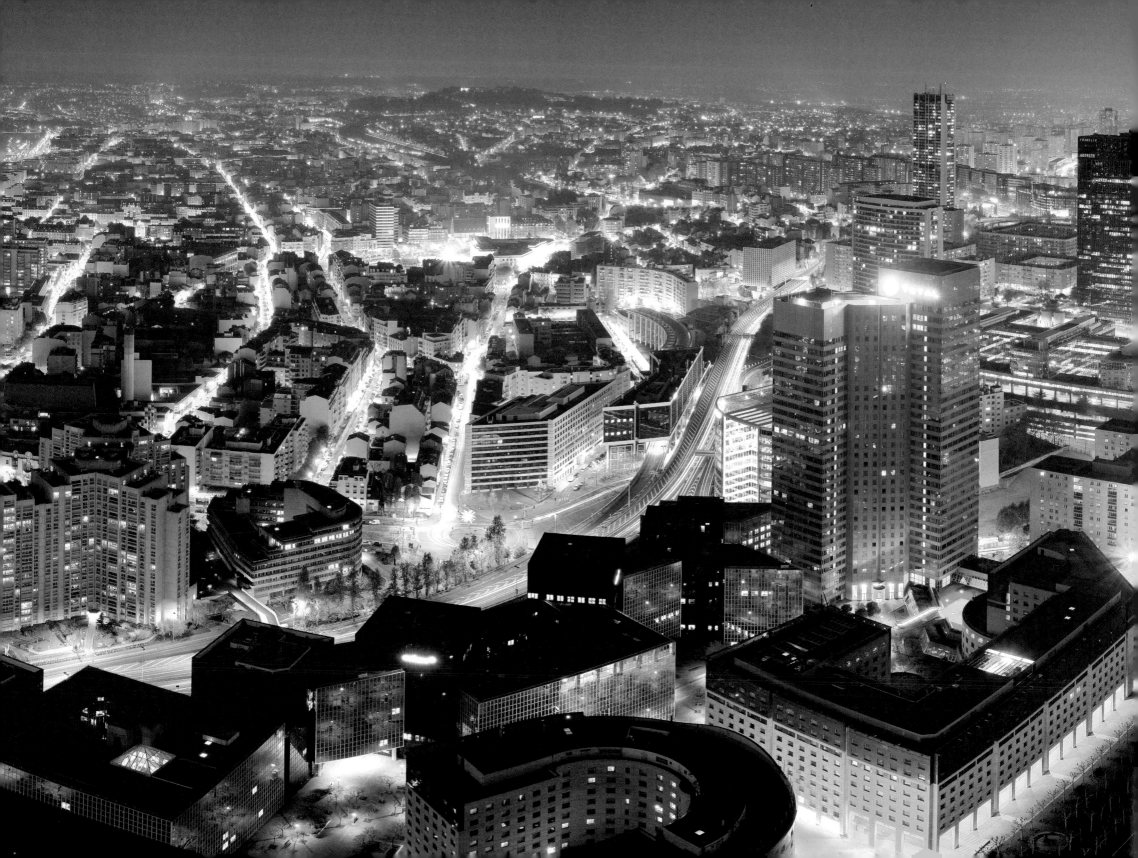

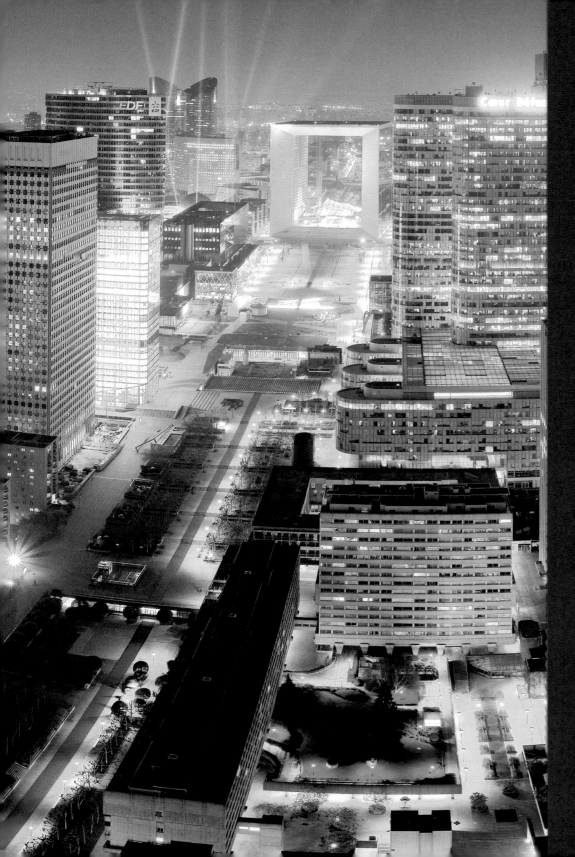

(PAGES 112–114)

A SECOND CITY
West of Paris proper, the business towers of La Défense rise in pragmatic counterpoint to the old city's architectural confections. At center stands the 330 by 330-foot Grande Arche. The Cathedral of Notre-Dame could fit within this massive gateway.

(ABOVE)

LIBERTY'S FLAME
At Place d'Alma on the Right Bank, a torch and gilded flame are replicas of the beacon held aloft by France's gift to the United States, the Statue of Liberty.

(PAGES 116–117)

A WELCOME SIGHT
A café at a Métro terminal (*brasserie* means "brewery," though few actually are) is a beacon in the night and a Parisian tradition, although "le hot dog" has made its inroads.

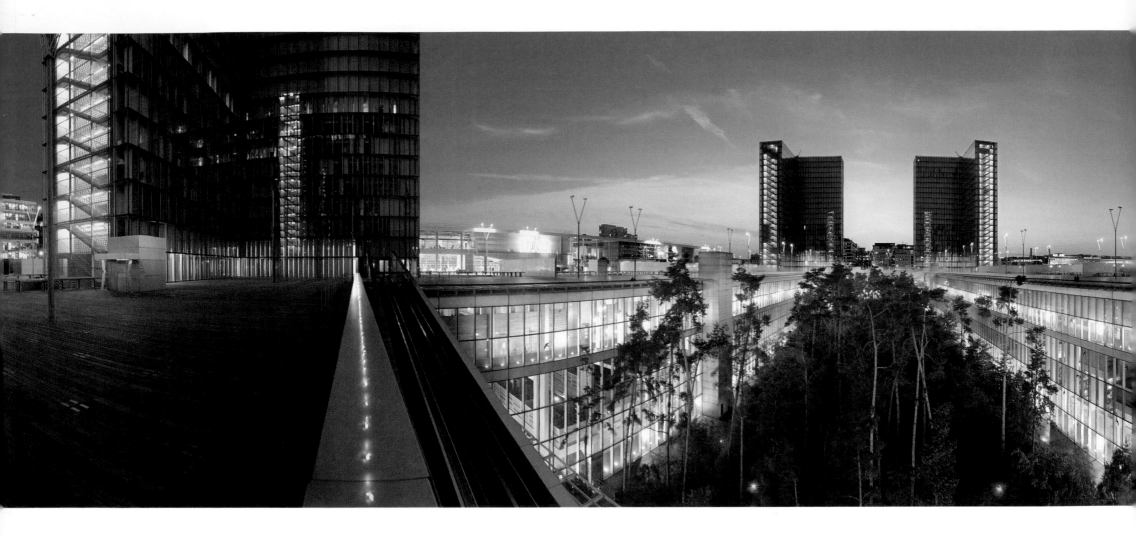

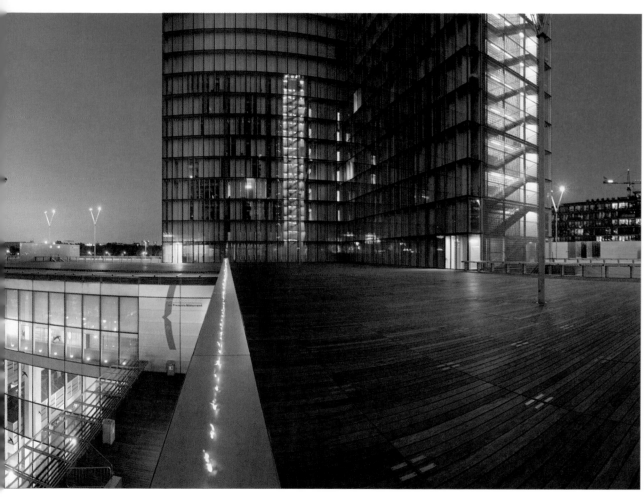

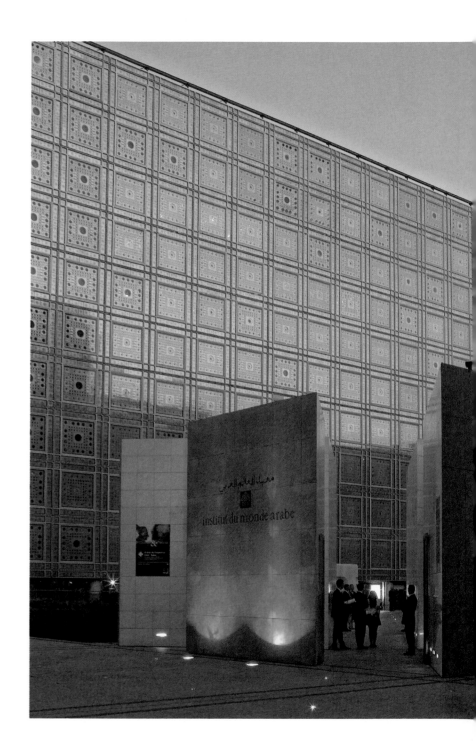

(ABOVE)

CULTURAL GUARDIAN
Designed to represent a pair of
open books standing on end, twin
300-foot towers punctuate the
sparkling new quarters of the
Bibliothèque Nationale. The
billion-dollar Left Bank showplace
houses every book published in
France since 1500.

(RIGHT)

HIGH-TECH ARABESQUE
Architect Jean Nouvel's design
for the Institut du Monde Arabe
incorporates light-sensitive prisms
that open and close with the
movement of the sun. The
building houses a museum of
Arab-Islamic art and culture.

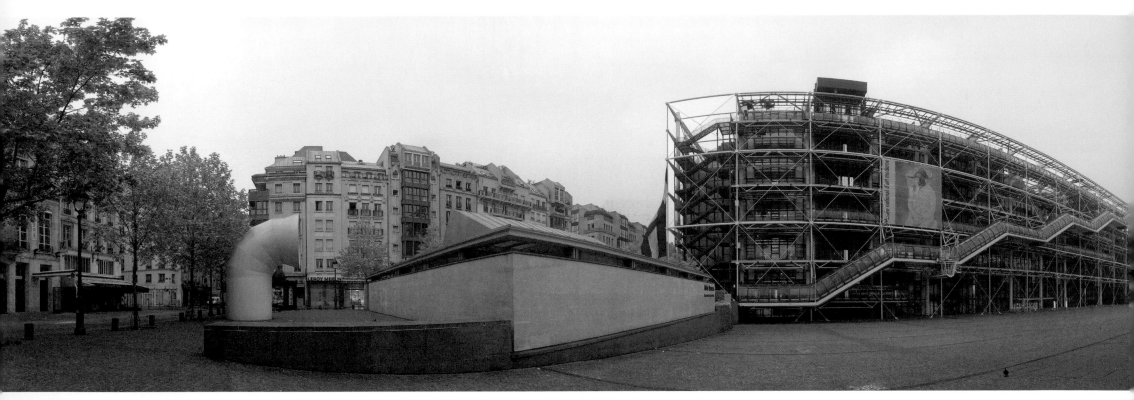

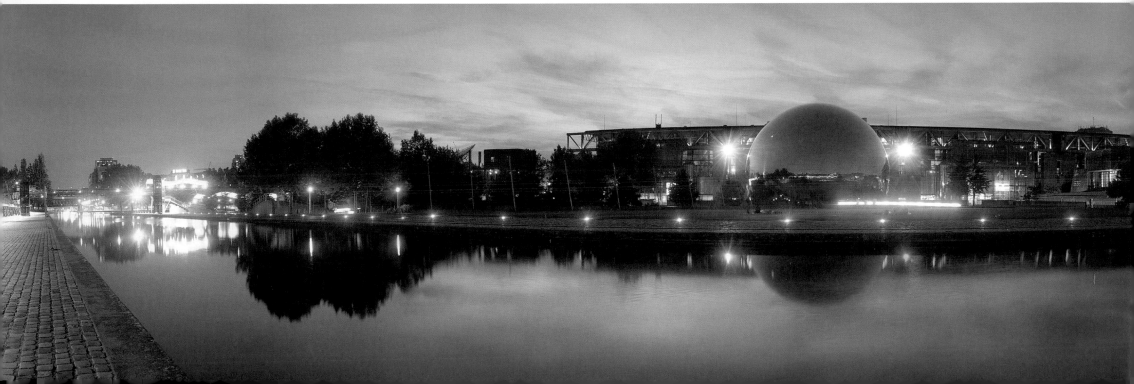

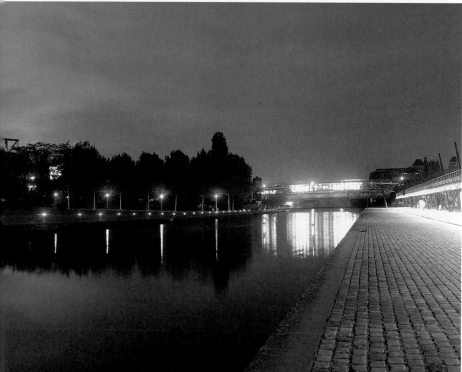

INSIDE OUT

The Pompidou Center, known informally as the Beaubourg, caused no end of controversy when it opened—but the museum's impressive trove of modern art has long since overshadowed its hide-nothing architecture.

(LEFT BOTTOM)

CITY OF SCIENCE

The immense geodesic dome called the Géode dominates the nighttime profile of the Cité des Sciences et de l'Industrie, northeast of the city center. The Géode boasts a 1,000-square-foot Imax screen.

(RIGHT)

ARTISTIC DIVERSITY

The strikingly colorful Musée du Quai Branly, designed by Jean Nouvel and located near the Eiffel Tower, opened in 2006. The museum focuses upon non-Western art, ranging as far as Australian aboriginal traditions.

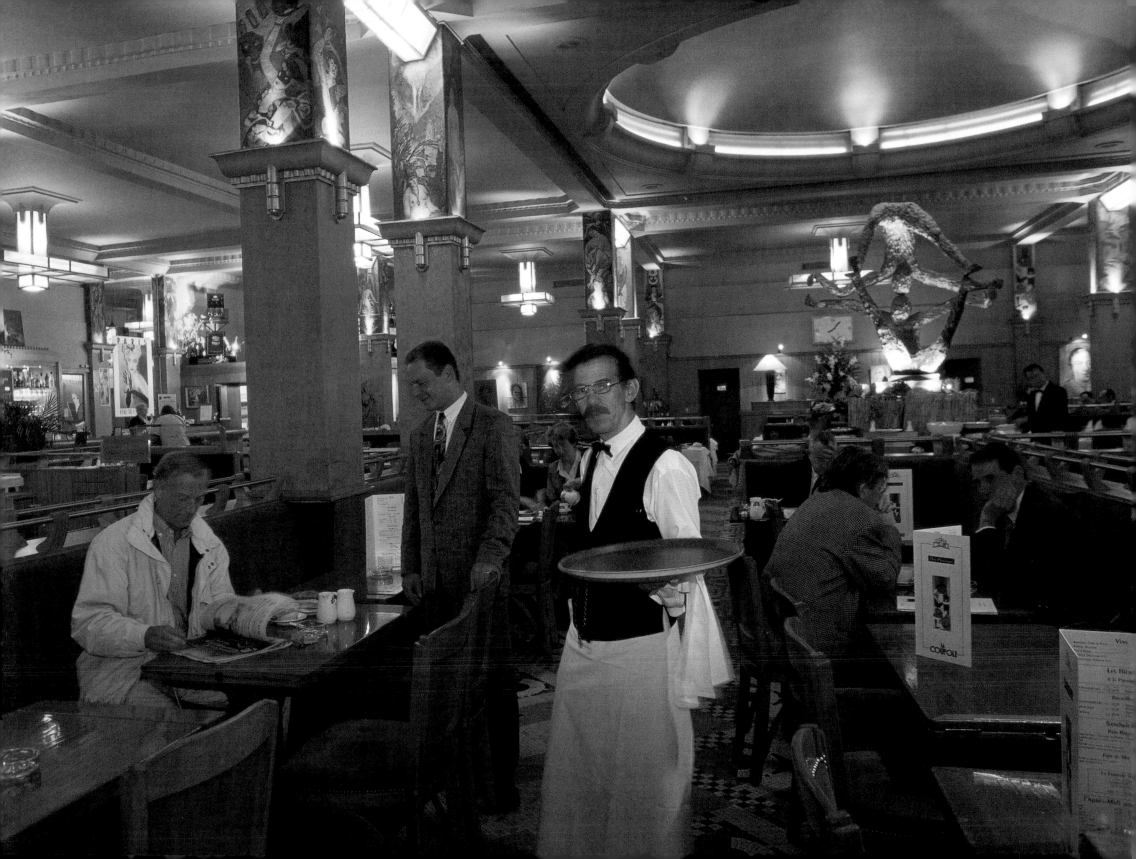

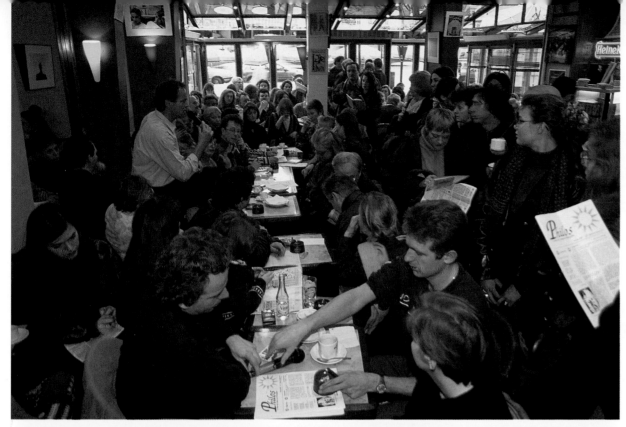

(THIS PAGE)

DELIGHTFUL OBSESSION

It's not just a cliché: Parisians care passionately about food, whether in a bustling café near Place de la Bastille, an Asian market in an outer *arrondissement*, or the formal, salonlike setting of an upscale restaurant.

(OPPOSITE)

TIMELESS

The Brasserie La Coupole, on the Left Bank's famed Boulevard Montparnasse, features Art Deco decor, a traditional menu, and waiters attired in classic floor-length aprons.

A POT FOR EVERY PURPOSE

A Parisian shopkeeper takes inventory of a stunning array of kitchenware. The great tradition of French cuisine demands the appropriate vessel or utensil for each specific purpose.

SOUNDS OF NATURE

Apartment-dwelling Parisians have long enjoyed the company of pet birds. Here, a girl and her mother look over the offerings in a shop on quai de la Megisserie. Another bird market, on the Ile de la Cité, is a beloved weekly fixture.

BARGAIN HUNTING

Thousands of dealers offer wares of every description at the St-Ouen *marché aux puces*, or flea market (left). The opposite extreme of shopping in Paris is typified by fashionable boutiques such as Hermès, in the posh Faubourg-Saint-Honoré (right).

Pain Mar Poilâne 3,76 €/kg

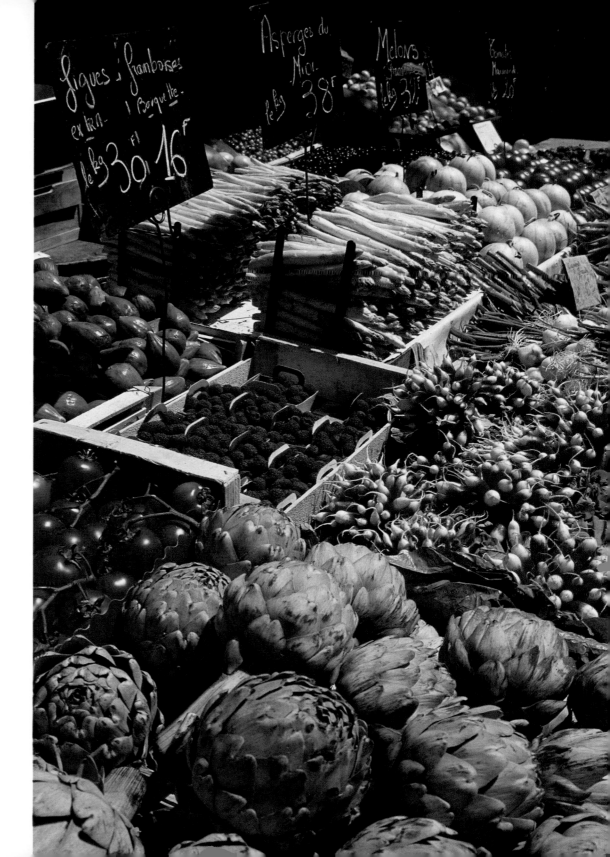

(OPPOSITE)

LIFE'S NECESSITIES

North American fast food may
have gained a foothold, but the
cornerstones of every Parisian
neighborhood are its bakeries,
confectioners, and custom
butcher shops.

(ABOVE)

SPLASH OF COLOR

Paris's flower markets are a
beloved institution in a city that,
for all its beauty, requires the
color of fresh blossoms to offset
its thousand shades of gray and
tawny stone.

(RIGHT)

PRODUCE FROM
THE PROVINCES

The markets of rue Mouffetard,
on the Left Bank, have long
supplied the bustling surrounding
neighborhood with fresh fruits
and vegetables from the French
countryside. France remains
western Europe's most
agricultural nation.

(OPPOSITE, LEFT, AND RIGHT)

TOUCH OF NATURE
Regarded as quintessential cosmo-politans, Parisians nonetheless treasure small corners of the city that have been carefully cultivated as reminders of quiet country living. Throughout the capital, hidden courtyards, garden houses, and more modest plant-filled sunrooms and balconies bring nature into the heart of the metropolis.

(PAGES 130–131)

WINTER COAT
A dusting of snow changes the character of Parisian rooftops, freshening the old tiles as an atmosphere of cold and calm descends.

(PAGE 132)

MORNING PAPERS
The great rose window of Notre-Dame's south transept beams like a stained-glass sun above a quai-side print stand.

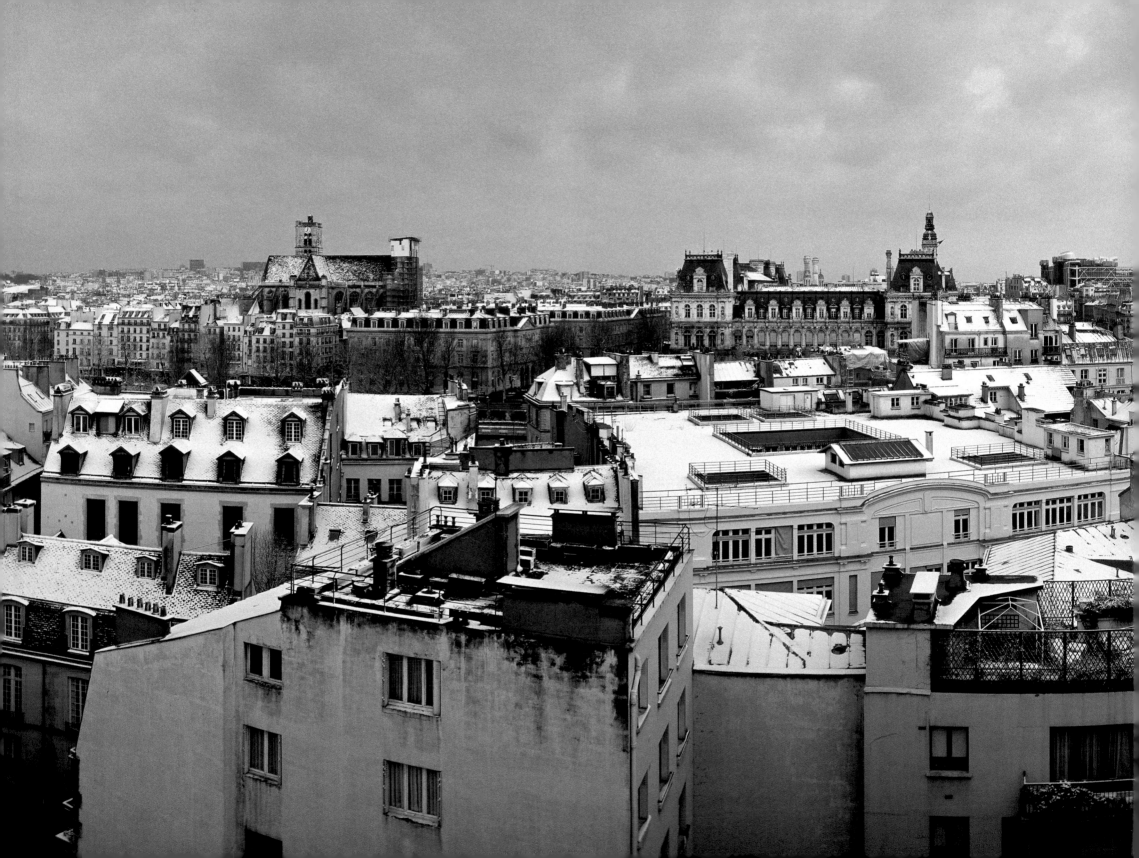

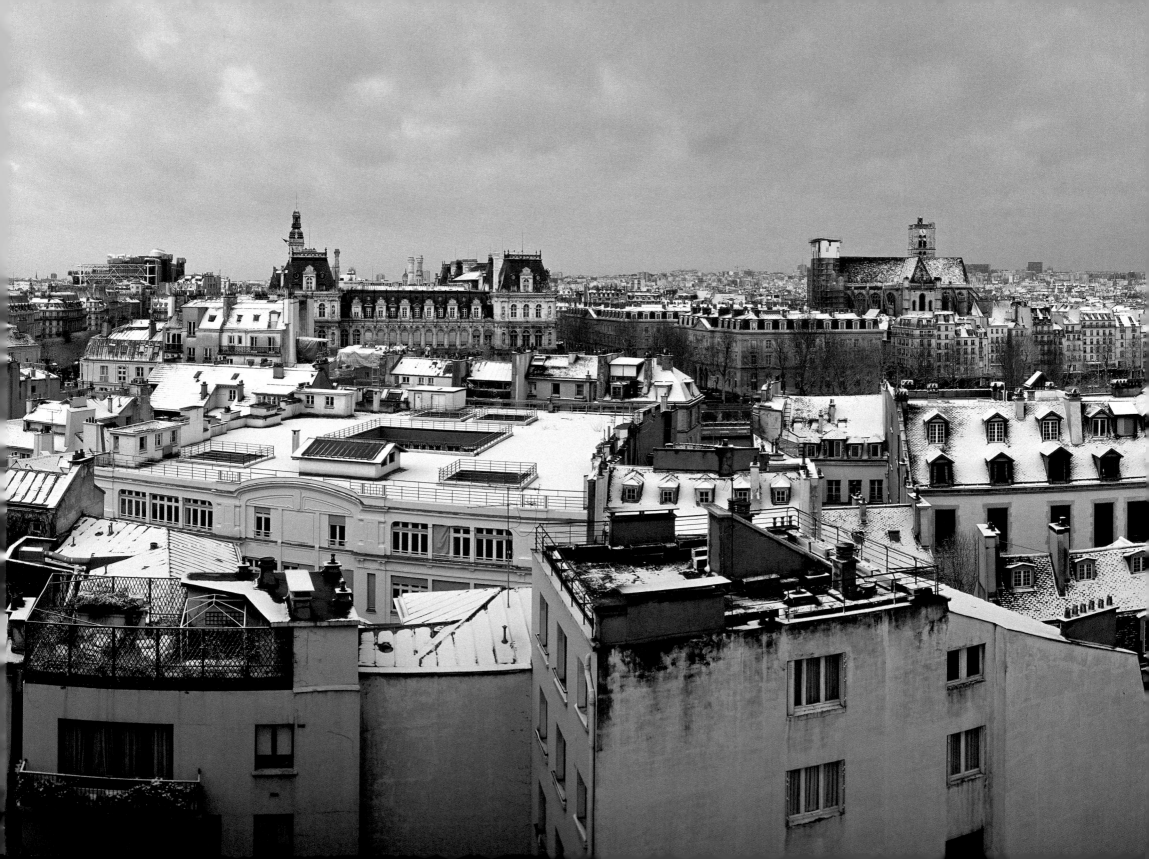

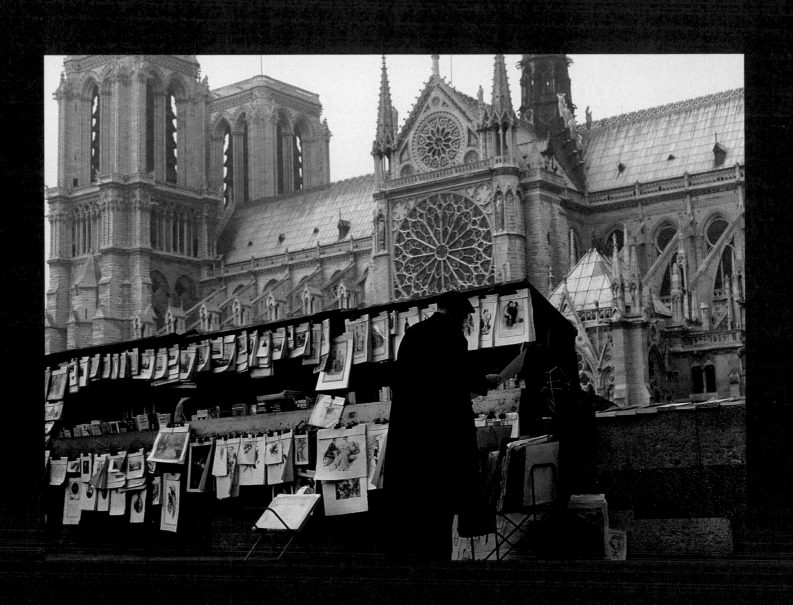